THE SUPERPOWERS
AND THE GLORY

JOE GEORGE

THE SUPERPOWERS
AND THE GLORY

A Viewer's Guide to the Theology
of Superhero Movies

CASCADE *Books* • Eugene, Oregon

THE SUPERPOWERS AND THE GLORY
A Viewer's Guide to the Theology of Superhero Movies

Cascade Books
An Imprint of Wipf and Stock Publishers
199 W. 8th Ave., Suite 3
Eugene, OR 97401

www.wipfandstock.com

PAPERBACK ISBN: 978-1-6667-3105-7
HARDCOVER ISBN: 978-1-6667-2315-1
EBOOK ISBN: 978-1-6667-2316-8

Cataloguing-in-Publication data:

Names: George, Joe, author.
Title: The superpowers and the glory : a viewer's guide to the theology of superhero movies / Joe George.
Description: Eugene, OR: Cascade Books, 2023. | Includes bibliographical references and index.
Identifiers: ISBN 978-1-6667-3105-7 (paperback). | ISBN 978-1-6667-2315-1 (hardcover). | ISBN 978-1-6667-2316-8 (ebook).
Subjects: LCSH: Superhero films—Religious aspects. | Superhero films—History and criticism. | Religion in motion pictures.
Classification: PN1995.9.R4 G46 2023 (paperback). | PN1995.9.R4 (ebook).

VERSION NUMBER 030123

To Dylan,
My superhero movie watching buddy

CONTENTS

ACKNOWLEDGMENTS

I'M NOT EXACTLY SURE where my love of superheroes comes from, or why after more than forty years and exposure to works from more "respectable" media, I always come back to the capes and tights.

But I think it has something to do with my dad building a fort in the living room to serve as a Hall of Justice and filling it with emergency rations. Or maybe it had something to do with my mom patiently helping me with my Batman Halloween costume, despite my complaints about it not looking quite right, or dropping me off at Scott's Comics & Cards while going shopping.

So my first thanks must to go to them, for never failing to be supportive, when I was an obnoxious kid, a moody teen, and whatever type of adult I am now. I also need to thank my brothers Rick and David, who not only read partial drafts of this book, but also indulged my geeky deep dives into the Justice League and the X-Men when we were kids. I love you all.

My early interest in superheroes turned into a love of comic books thanks in part to my friend Matt Jewett. I'm grateful for all the time we spent as teenage geeks and even more grateful that we're still friends today. I'm sorry it takes so long to text back.

This book would not be possible without the help of those who have challenged and encouraged me as a critic, especially wonderful editors such as John G. Potter, Bridget McGovern, Nicola Menzie, and John Squires. Despite his bad horror movie opinions, I owe deep gratitude to my podcast co-parent Blake Ian Collier. I owe great thanks to Josh Larsen, who consistently pushes me to do good work and has made me into the critic I am today. Finally, I want to thank my always inspiring TC colleagues JR. Forasteros, Abby Olcese, and Sarah Welch-Larson. Peace, friends.

I thank my editors at Cascade Books for their unending patience as I kept moving the goal posts on the draft of this book. I hope this is all worth it.

Thank you to my in-laws Ed and Carol Lietz, for being such amazing grandparents to my children and for supporting me in ways I could never expect. I thank my four fantastic children for the joy and pride they never fail to bring me. To Dylan, for sharing my love for all things superhero and for going to these movies with me. To Alyse, for never failing to ask the right questions and for being yourself. To Kierstyn, for always making the world brighter with your goofy dances. To Colin, for being Spider-Man or Black Panther and battling with me on the couch. I love you more than I can tell you.

Finally, and most importantly, absolutely none of this would be possible without my wife Cory. You believed in me long before I could believe in myself, and you have supported me with words, action, and sometimes tears. You are my match and my partner. I adore you, pretty bird.

I hope this book can bring you even a bit of the joy and pride you give to me every day.

—Joe

INTRODUCTION

Practicing Discernment in an Age of Heroes

*We demolish arguments and every pretension that sets itself up
against the knowledge of God, and we take captive every thought
to make it obedient to Christ.*

—2 Cor 10:5

PICTURE THIS: AN UNSTOPPABLE titan strides across the battlefield. Around him lie the shambles of every obstacle that stood in his path. His opponents, each a juggernaut in their own right, groan in defeat. The titan mocks his enemies, telling them in faux sympathy that they had no chance, their might could never match his. "I am inevitable," he boasts.

If you're reading this book, you probably know that I just described the climactic moment from *Avengers: Endgame*, in which the universe destroying Thanos (Josh Brolin) revels in his victory over Earth's mightiest heroes.

The scene could also be a metaphor for the way the movie *Avengers: Endgame* decimated its competition. Even in this age of endless streaming services, moviegoers still flock to theaters to see big-budget franchise pictures. Where the COVID-19 pandemic slowed ticket sales of most films in 2021, superhero movies *Black Widow*, *Venom: Let There Be Carnage*, and *Shang-Chi and the Legend of the Ten Rings* enjoyed high box-office sales, with *Spider-Man: No Way Home* becoming one of the highest-grossing movies of all time.

Simply put, these movies make gobs of money, watched by more people than you and I will ever meet in our lives. *Avengers: Endgame* outdid them all when it premiered in April 2019. It made over 1.2 billion dollars in its

first weekend and continued a Thanos-like march to earn a record-breaking 858.4 million dollars domestic and 1.939 billion dollars worldwide.[1]

Unprecedented as these numbers might be, they weren't exactly a surprise. *Endgame* completed a story that began with *Iron Man* in 2008 and continued through the following twenty-seven (at the time of this writing) interconnected movies that make up the Marvel Cinematic Universe (the MCU, hereafter). Audiences took to the shared universe model and quickly became invested in watching their favorite characters interacting with one another. So successful is the MCU that each of the twenty-seven entries has been a box office triumph, including nine movies among the twenty-five highest-grossing films of all time, and most have received positive reviews from critics. Just like Thanos, *Avengers: Endgame*'s titanic dominance was inevitable.

According to a 2018 survey, 53 percent of American adults aged eighteen and thirty-four years old have seen at least one Marvel movie, as have 48 percent of American adults aged between thirty-five and fifty-four.[2] In a country where more than 70 percent of the citizens identify as Christian,[3] that means a lot of believers watch superhero movies. Churches regularly advertise "Superhero Sundays," inviting kids and adults to attend while wearing Superman capes and Captain America shirts. Superhero devotionals and Vacation Bible School curricula reach out to children.

It's clear that Christians don't just enjoy superhero movies; we connect them to our faith. But should we?

Before I answer that question, we need to look at the genre of superhero movies, and how it differs from other types of cinema. And before I can do that, we need to look back at the inspiration for these films: comic books.

FROM FOUR COLOR PAGES . . .

Although illustrated storytelling has existed since the days of Egyptian hieroglyphics, comic books were born in 1934 when the Eastern Color Printing Company released *Famous Funnies*, an eight-page magazine that compiled syndicated newspaper strips. The gag strips, adventure stories, and romance tales that filled *Famous Funnies* were the norm for five years. That is, until writer Jerry Siegel and artist Joe Shuster introduced Superman in 1938's *Action Comics #1*.[4]

1. All box office stats from boxofficemojo.com.
2. Navarro, "Share of Consumers Who Have Watched."
3. Pew Research Center, "Religious Landscape Study."
4. Siegel, "Superman."

The first superhero, Superman captured the nation's imagination and inspired a tidal wave of costumed adventurers. Within a year, *Action Comics* publishers Detective Comics, Inc. (eventually shortened to DC Comics) debuted Batman, Wonder Woman, Green Lantern, and the Flash. In 1939, Fawcett Comics introduced Captain Marvel, the alter-ego of a boy who became a superhero when he said the magic word "Shazam." Over the next two years, Namor the Submariner, the Human Torch, and Captain America arrived in books from Timely Publications, the company that would become Marvel Comics in the early 1960s.

Interest in superhero comics waxed and waned over the next twenty-five years, but the genre grew to the powerhouse we know today with the publication of *Fantastic Four* #1 in 1961.[5] Like their predecessors, the members of the Fantastic Four possessed amazing abilities. But writer Stan Lee and artist Jack Kirby added an all-new element to the time-tested superhero formula. Kirby's dynamic visuals lifted the genre to sensational heights, while Lee's melodramatic prose brought real pathos to their costumed crusaders.

The characters created by Lee and his collaborators Kirby, Steve Ditko, and John Romita redefined superhero storytelling, marrying high-concept action to mundane life. Spider-Man, Daredevil, and the Hulk might save the universe, but they still had to maintain relationships, hold down day jobs, and pay for apartments in New York.

The Fantastic Four and Marvel Comics breathed new life into the superhero genre, forcing DC Comics to rethink its approach to well-established characters like Superman and Green Lantern, and inspiring countless imitators to make their own heroes. With these innovations, superheroes transformed from garish characters who appeal to only a niche audience of comic book readers to dramatic figures suitable for mass media.

. . . TO THE SILVER SCREEN

So powerful were superheroes that they could not be held to just comic books. Within a couple of years, Superman, Batman & Robin, Captain Marvel, and others broke into toys, radio shows, and movie serials. Produced by Republic Pictures, these serials constituted the first live-action appearances of costumed superheroes, whose adventures were presented in sixteen-to-thirty-minute chapters shown before feature films. Even when sales of superhero comics dipped after World War II, radio programs and, eventually, television series kept heroes going strong.

5. Lee, *Fantastic Four* #1.

A master hype-man, Marvel editor Stan Lee was never satisfied with just making comic books.[6] Emboldened by the way Superman, Batman, and Captain Marvel branched out to radio and serials, Lee never missed an opportunity to pitch his ideas to filmmakers in Hollywood and television producers in Burbank. For the most part, these efforts resulted only in cheap and disappointing programs, such as the 1966 series *The Marvel Super Heroes*, which added rudimentary animation to panels from Captain America and Spider-Man comic books. The *Incredible Hulk* TV series starring Bill Bixby and Lou Ferrigno, which aired eighty episodes from 1977 to 1982, resonated with audiences, but a live-action Spider-Man series (1977 to 1979) and a pair of TV movies in 1979 featuring a motorcycle-helmeted Captain America failed to bring Marvel prestige.

Even before the publisher became a subsidiary of conglomerate Warner Brothers in 1969, DC Comics outdid its competitors when it came to other media. The 1966 Batman series for ABC, starring Adam West and Burt Young, became a campy sensation. It may have been short-lived, airing only 120 episodes over three seasons, but *Batman* made in-roads for not only a series of cartoons starring the Justice League but also live-action series about Wonder Woman (sixty episodes, 1975 to 1979) and the twenty-five episode series *Shazam!* (1975 to 1977), featuring Captain Marvel.

Between this larger cultural footprint and its backing from Warner Bros., not to mention the sometimes-questionable efforts from powerful Hollywood producers, DC Comics characters debuted on film with much higher budgets and (just as importantly) much stronger marketing teams. Although both properties would later be diminished by lackluster sequels, both *Superman: The Movie* in 1978 and *Batman* in 1989 were genuine pop-culture phenomena, selling millions of dollars in tickets and merchandising, and bringing Hollywood icons such as Marlon Brando and Jack Nicholson into the world of comic book heroes.

Superman: The Movie and *Batman* ushered in the first wave of superhero movies, which lasted up through 1998. While there was plenty of variety during this period, not all of them resonated with audiences. Movie studios tried to replicate the success of *Batman* by filling cineplexes of the 1990s with movies based on pulp noir heroes, films such as *Dick Tracy*, *The Shadow*, *The Phantom*, and *The Rocketeer*. When superheroes did make their way to screen, they tended to be lesser-known characters, who failed to make a larger impact. *Supergirl* had none of the charm of the Christopher Reeve movies, and neither *Steel* nor *Spawn* could match the success the characters enjoyed in the comics. In fact, outside of *Superman* and *Batman*,

6. Howe, *Marvel Comics*, 113–19, 332–38, 354–56.

the only comic book movies that really found an audience were those that were largely divorced from their four-color origins, movies such as *Men in Black* and *Timecop*.

After their first big screen outing resulted in the legendary 1986 flop *Howard the Duck*, Marvel scored a surprising hit with its second attempt, the 1998 horror action movie *Blade*. Although relatively modest compared to what would follow, *Blade*'s popularity signaled the second wave of super-hero movies, which quickly gained traction with 2000's *X-Men* and direc-tor Sam Raimi's brightly colored melodramas *Spider-Man* and *Spider-Man 2*. On the other end of the scale, Christopher Nolan's "realistic" approach in 2005's *Batman Begins* effectively washed away the bad taste left by *Batman Forever* and *Batman and Robin*. But for every win in the second wave, there was a *Daredevil* or a *Green Lantern*—a movie that failed to translate the comics' absurd premises and over-the-top emotion for a mainstream audience.

All of that changed when the third wave of superhero movies began in 2008. In that year, Nolan's second Batman movie *The Dark Knight* earned critical praise, thanks to its gritty crime thriller aesthetic and a bombastic performance by Heath Ledger as the Joker. The MCU debuted that same year with *Iron Man*, an instant smash that left audiences hungry for twenty-seven more movies about Marvel heroes.

These movies not only brought superheroes into the mainstream but also made them into an undeniable force. Once obscure characters like Rocket Raccoon and Harley Quinn have become household names. *The Dark Knight*, *Black Panther*, *Joker*, and *Spider-Man: Into the Spider-Verse* have all won Academy Awards. Legendary actors, such as Anthony Hop-kins, Angela Bassett, Robert De Niro, and Robert Redford have played characters who made their debut on the comic book page. Even critically panned entries like *Suicide Squad* and *Venom* make millions of dollars and develop rabid fan bases.

THE WATCHER'S RESPONSIBILITY

If you're reading this book, you know that this rabid fanbase includes Chris-tians. But the question I asked earlier still remains: *should* Christians love superhero movies?

Throughout the next few chapters, I'm going to argue that the answer is an unequivocal "yes," but maybe not for the reasons you'd expect. I'm not going to argue that you should watch superhero movies because they're good. Enjoyment often comes down to matters of taste, which aren't that

interesting to talk about. Instead, this book focuses on themes. Every movie, good or bad, has a perspective, and that perspective deserves attention because it tells us about what the movie considers normal, moral, and valuable.

In my experience, Christians are keenly aware of this fact. When I was growing up in the eighties and nineties, my local church hosted talks and distributed pamphlets about the themes of movies and TV shows. From a young age, my church taught me how to be aware of the worldviews found in even the most frivolous pieces of pop culture.

My teachers' approach tended to follow Phil 4:8: "Finally, beloved, whatever is true, whatever is honorable, whatever is just, whatever is pure, whatever is pleasing, whatever is commendable, if there is any excellence and if there is anything worthy of praise, think about these things." Some may argue that superhero movies fit into these categories. After all, heroes fight for truth and justice, they look out for the little guy, and they have fun doing it! What could be more noble and admirable and praiseworthy?

Those might be good things, but it's also important to recall the warning the poet T. S. Eliot gave about religious literature. When a Christian reads books (or, in this case, watches movies) that purport to share our perspective, we might get "a false sense of security in leading [us] to believe that books which are *not* suppressed are harmless."[7] In other words, if we're not careful, some reprehensible beliefs can sneak in under the guise of orthodoxy.

Whatever their advantages, superhero movies pose several challenges to Christian moviegoers. As critic Siddhant Adlakha reported in his series for *Slashfilm*, movies in the MCU are made with the help of the US military, functionally serving as propaganda for the American armed forces. He writes, "The possibility of military partnership isn't a bug in the Marvel machine. It's a feature, and it's one we haven't really stopped to grapple with as the Marvel Cinematic Universe has grown in global influence."[8] Although superhero movies directed by and featuring women and people of color have been produced, the large majority of the films in this genre privilege white male perspectives and sometimes engage in racist caricatures and over-sexualization of female characters.

More often, superhero movies, like the comics they're based on, devolve into power fantasies. Supporting characters may deliver reams of exposition about the inherent decency of Superman, and Captain America may insist that he doesn't want to fight, but by the time third act kicks into gear, our paragons of virtue get just as violent as the baddies. And despite

7. Eliot, "Religion and Literature," 101.

8. Adlakha, "'Iron Man' Built the Foundation."

some gestures to save the villain, their goodness ultimately manifests in the fact that they've beaten the bad guy into submission. More often than not, might makes right.

In many cases, that violent righteousness ties directly to the fantasy aspect of superhero stories, in which the heroes who get amazing abilities begin their stories as put-upon weaklings or dejected outsiders. When, for example, a smirking macho man's eyes widen in horror after punching Wolverine's metal skull in *X-Men* or when Clark Kent decides to intimidate a trucker who bullied him at the start of *Superman II*, we viewers revel in our heroes' revenge.

CRITICAL THINKING IS CAPTIVE THINKING

So if superhero movies fail to meet the standards of Phil 4:8, does that mean they're off-limits for Christians?

I'm sure that some people would say yes, but I don't agree, partially because I don't think Phil 4:8 makes for sound aesthetic criticism. Paul doesn't talk about art or literature at any point in his letter to the Philippians, especially not in the closing comments collected in chapter 4. Furthermore, if the verse was literally teaching us to avoid stories that aren't true, honorable, just, pleasing, etc., then Christians would have to skip over a lot of stories in the Bible. After all, what is good and admirable about genocide in Canaan (Deut 7; Josh 11), the rape of Bathsheba (2 Sam 11), or even the crucifixion of Jesus? These stories have value even though they describe acts of horrific evil. They tell us something about the nature of humanity and of God, and therefore deserve attention.

A better guide verse might be 2 Cor 10:5, which tells us to "take captive every thought to make it obedient to Christ." Or perhaps Rom 12:2, which urges Christians to be "transformed by the renewing of your mind." These and many other passages call not for evasion but for critical engagement. We need to be aware of the perspectives we encounter and consider them in light of Christ's example.

That's easier said than done, of course. When we see something bad, we can too quickly pronounce it as wrong and ignore it. And we see something good, we can too easily accept it. We never consider the context or the consequences of the ideas.

If we judge films according to simple binaries of good/bad or right/wrong, we miss opportunities to think about our human experience, even in superhero movies. We fail to see how fallen earthly kingdoms drive Killmonger in *Black Panther* or the way that *Spider-Man 2* celebrates the

overlooked and unimpressive. That approach does not discern the selfishness motivating Iron Man's goodness or the emotional damage that drives Batman. As film critic Josh Larsen contends, there is a "common grace" at work in movies, in which "an agnostic artist, by God's favor, can capture the glory of his creation—flowing from the screen."[9] A simplistic approach to film criticism misses opportunities to work out our faith (Phil 2:12), even when we're watching entertaining movies.

HOW TO THINK CRITICALLY ABOUT SUPERHEROES

All movies are unrealistic in some way, but none more so than superhero movies, in which exposure to radiation results in fantastic powers and people use their time donning brightly colored costumes to help others. And yet, as Sarah Welch-Larson reminds us, "Science fiction provides a useful framework for considering our own world in the context of another" allowing us to "lift a concept—inequality, prejudice, gender, fear of nuclear fallout, the value of human life—and drop it into a new and strange setting."[10] To that end, superhero movies can be more than just escapist entertainment. They can be a way of engaging with the real world.

The Superheroes and the Glory teaches you how to be discerning while watching superhero movies. We'll look at some of the most important and influential films in the genre, from 1966's Batman: The Movie to 2021's Spider-Man: No Way Home. Except for occasional comparisons made between Christ and Superman, none of these movies claim to be Christian, nor do I pretend that they are. They each have their own worldview and themes, but these themes can be put in conversation with the Christian perspective.

This book seeks to teach you how to think critically about these films, how to recognize the perspectives driving some of the most popular movies of our generation, and how to examine their messages in light of Christ's teachings. More than a mere theoretical exercise, this book will give you practical tools and discussion questions, to help you become more engaged with modern American culture and to find new ways of imagining your faith.

Each chapter in this book is devoted to a series of movies with similar themes or characters. The first few chapters look at a single hero's movies, those of Superman, Batman, Spider-Man, Iron Man, and Captain America. The next set of chapters examines several movies together, bound by similar

9. Larsen, Movies Are Prayers, 11.

10. Welch-Larson, Becoming Alien, xi.

ideas or approaches. The final chapters look at teams such as the Avengers, X-Men, and the Guardians of the Galaxy.

Because we need film criticism to hold deeper conversations about these films, I'll provide models of interpretation for every movie discussed in the book. With these models, you'll be able to better understand how movies spread ideas to audiences. Each chapter ends with discussion questions to be used in groups, on your own, or online. These features will teach you how to grow your faith while watching superhero movies.

To get the most out of this book, consider taking the following steps.

1. **Watch the movie first**—Although I provide a synopsis of each film and discuss some scenes in detail, I won't talk about every little thing that happens in the movie. To understand my interpretation and to start forming your own, you need to know exactly what happens in a movie and how it happens.

2. **Read my interpretations of the films**—You don't have to agree with what I think about the movies (in fact, it's more interesting when you don't!), but pay attention to how I make my interpretation. Look at the claims I make and the evidence I provide. Ask yourself, "Do I agree with this evidence? Is there any evidence he missed?"

3. **Stay for the Post-Credits**—Post-credit scenes have become a mainstay in superhero movies, exciting little teasers that continue the story or set up a new adventure. In this book, Post-Credits are discussion questions in your small group, with friends, or on the *Superpowers and the Glory* forums at joewriteswords.com. Compare and contrast your interpretation into conversation with those of others, and with your readings from the Bible.

4. **Act**—Although we watch superhero movies for fun, we analyze them to deepen our faith. And when we deepen our faith, we change our behavior in the world. The interpretations we build together will help us find new ways to act out our faith, to enact the love and mercy that Jesus modeled.

While this book at least touches on nearly every major superhero movie of the past forty years, it is no means exhaustive. It largely avoids movie serials or television series about superheroes, such as the classic *Batman: The Animated Series* or the beloved shows on the CW Network. The lone exceptions here are the MCU shows produced for Disney+ in 2021, such as *Loki* and *WandaVision*. This book does not address superhero movies about original creations or homages, including *The Incredibles* and *Hancock*.

Finally, I don't get into movie adaptations of non-superhero characters like *Jonah Hex*, *Red*, and *Cowboys vs. Aliens*. There are sure to be other movies I miss and points I fail to make, but that's okay because this book only starts the conversation. The skills you'll find here will help you and your group mates to analyze your favorite flicks.

And that's the central point of *The Superpowers and the Glory*: superhero movies deserve thoughtful consideration and can deepen your walk with Christ.

BLACK PANTHER

Wakanda Forever, Amen

Jesus replied: "'Love the Lord your God with all your heart and
with all your soul and with all your mind.' This is the first and
greatest commandment. And the second is like it: 'Love your
neighbor as yourself.' All the Law and the Prophets hang on these
two commandments."

—Matt 22:37-40

Wakanda will no longer watch from the shadows. We cannot. We
must not. We will work to be an example of how we, as brothers
and sisters on this Earth, should treat each other.

—T'Challa, *Black Panther*

Two fighters face off at the basin of an African waterfall. On one side,
armies representing each warrior keep watch, their spears holding the com-
batants in the battle. On the other side, water cascades down a cliff.

A gathering of witnesses stands on rocks surrounding the duo, the
greens and reds of their traditional garb contrasting with the worry darken-
ing their faces. They had come to watch an important, but largely ceremo-
nial, ritual. Their king T'Chaka (John Kani) has died during a diplomatic
trip, and the leaders of four tribes of the fictional African nation Wakanda

have come to coronate his son, Prince T'Challa (Chadwick Boseman). Following the customs of their people, spiritual leader Zuri (Forest Whitaker) invited any attendee to challenge T'Challa for the title in ritual combat. But as expected, no one accepted.

No one, that is, until shouts signaled the arrival of Wakanda's fifth tribe, the Jabari. Their leader M'Baku (Winston Duke) asserted that his mountain people have been neglected by the other tribes, that the country will weaken under T'Chaka's son, that he can better protect Wakanda. T'Challa accepts the challenge and the two men begin to fight.

In a fury of splashes, the fighters grapple with one another, evenly matched until M'Baku catches T'Challa in a mighty bear hug. "No powers! No claws! No special suit," mocks M'Baku, squeezing harder with every declaration. "Just a boy, not fit to lead."

Fear clouds T'Challa's once proud eyes. He can withstand M'Baku's crushing arms, but there's something in his opponent's words that rings true. For an instant, he sees himself as M'Baku sees him—a boy masquerading in his father's shadow. T'Challa's doubt lingers until he hears his mother Ramonda (Angela Bassett) call from the crowd, "Show him who you are."

And he does.

T'Challa recovers his strength and breaks free from M'Baku, pinning his opponent to the ground. When the defeated M'Baku demands that T'Challa kill him, as tradition requires for an opponent who will not surrender, the prince refuses. "You have fought with honor," T'Challa tells his would-be enemy. "Now yield," he pleads. "Your people need you."

In that moment, T'Challa shows the world who he is. They've already seen his prowess and his respect for his people's traditions, but here he shows them his humanity. He chooses grace and dignity over violence.

Black Panther features fantastic battles between supervillains and superheroes, including spaceship dogfights, spy car chase sequences, and even armored rhinos. But the movie's real power is the way it explores identity. It asks both hero and audience, "Who are you? What identifies you? How do you show yourself to the world?"

At the beginning of the film, T'Challa finds it easy to answer those questions. He is the Black Panther, the king of Wakanda. Wakanda is no mere country, even if the rest of the world dismisses it as isolationist and uncivilized. The country's main natural resource, a super-metal called Vibranium, has made it the most technologically and socially advanced country on Earth. Because of this, T'Challa recognizes that he, and the other Wakandans, are more than what other people see. They are citizens of a great kingdom, a kingdom that can lead the world toward peace and prosperity—if they so desire.

POWER FANTASIES AND KINGDOM PROPHECIES

The portrayal of Wakanda makes *Black Panther* unique not only among superhero films, but among cinema and culture in general. The very existence of a highly advanced African country, uncontaminated by colonialism or the slave trade, contradicts the white supremacy baked into American and European social structures. For many people of color, *Black Panther* isn't just a movie. It's a celebration of affirmation and imagination. Against centuries of stories that denigrated Black people, *Black Panther* shows the world who they are, in all their beauty and complexity.[1]

This recognition has been a long time coming in the world of superheroes. From its inception, the American comics market has been controlled by straight white men. A few outliers exist, most notably the *Milestone* line launched by Dwayne McDuffie and other Black creators in 1993, but too many comics have reflected the race of their creators and not that of their highly diverse readership.

Black Panther debuted in 1966 in *Fantastic Four* #52, written by Stan Lee and illustrated by Jack Kirby.[2] T'Challa's white creators meant well, trying to insert a Black character into the otherwise caucasian Marvel Universe, but significant problems marked the character's early years. Black Panther would only occasionally deal with racism, as in writer Don McGregor's 1976 story in *Jungle Action* #21, which pitted the hero against the Ku Klux Klan.[3] But more often than not, creators would avoid talking about race with Black Panther, even having the character occasionally take the name "Black Leopard" or "The Panther," to avoid association with the Black rights group feared by some Americans. In fact, while Black artists Denys Cowan and Dwayne Turner did work on the character, no Black writer wrote Black Panther solo adventures before Christopher Priest in 1998, a full thirty-two years after his first appearance.[4]

And yet, readers still loved Black Panther. Fans found in the character a hero who embodied dignity and intelligence, whose outrageous adventures could show the real world who they were. We can see that love in the real-world response to the film *Black Panther*, from Black fans tearfully explaining the joy of seeing a superhero who looks like them to viral videos of children at Ron Clark Academy in Atlanta, Georgia dancing at the news that they've been given free tickets to the movie's premiere. The untimely

1. Carvell, "Why 'Black Panther' Is a Defining Moment"; Tillet, "'Black Panther' Brings Hope"; Johnson, "Black Panther."

2. Lee, *Fantastic Four* #52.

3. McGregor, *Jungle Action* #21.

4. Priest, *Black Panther* #1.

death of Chadwick Boseman at age forty-three has only reinforced to all the importance of the character. For evidence, look no further than a *Washington Post* article that describes Black parents struggling to explain to their children that Boseman, who young people equated with the hero himself, had died.[5]

To be sure, some of the movie's ability to inspire stems from the sheer skill of the creators involved. It features excellent direction from Ryan Coogler and a top-notch cast that includes established legends like Whitaker and Bassett alongside actors sure to become household names, including Danai Gurira and Michael B. Jordan.

But it's also the fact that a Black character has finally received the full superhero treatment, even more so than the *Blade* films of the late nineties. *Black Panther* is a proper entry in the MCU, made largely by people of color, with a full production and promotional budget. It embraced Afrofuturism, a form of storytelling that imagines Black people unencumbered by colonialism or slavery and placed it in in the world of Captain America and the Avengers.[6] Like most superhero movies, *Black Panther* is a power fantasy. But it's a power fantasy that proclaims the inherent dignity of a people too often despised by Western structures.[7]

THE WAKANDAN EMPIRE
AND THE KINGDOM OF HEAVEN

According to Howard Thurman, the beauty of the despised and power of the dismissed is central to the religion of Jesus. While the larger Christian church has "tended to overlook its Judaic origins," Thurman reminds us that "Jesus of Nazareth was a Jew of Palestine . . . a member of a minority group in the midst of a larger dominant and controlling group."[8] As such, when Jesus reveals the Kingdom of Heaven, he does so against the backdrop of Rome, one of the most all-encompassing empires in human history.

Like all empires, Rome maintained its power by telling its subjects who they are in the eyes of the law. According to Rome, both its citizens and its oppressed were dependent on the empire: the empire brought peace by conquering all neighboring nations and holding them under Roman law, brought security by placing heavily armed legionnaires throughout their

5. Alexander, "Parents of Young 'Black Panther' Fans."

6. Jackson and Moody-Freeman, *Black Imagination*; Anderson and Johnson, *Afrofuturism 2.0*; "On Black Panther, Afrofuturism, and Astroblackness."

7. See Reyes, "Black Panther's Vision of Zion."

8. Thurman, *Jesus and the Disinherited*, 16–17.

territories, brought wealth and prosperity through inequality. All it asked in return is that its occupants know their place and pledge fealty.

But the kingdom that Jesus described in Roman-occupied Judea was completely different, as demonstrated by the parables he told. The kingdom of God values not what the rich can horde, but what can only be uncovered by seekers who give up all they own (Matt 13:44). This kingdom grows not like the sword-wielding empires of earth, but like an unremarkable mustard seed that spreads silently among its boastful kin (Mark 4:30–32). This kingdom rejects the peace of Roman conquest and celebrates like a wedding banquet attended by outcasts (Luke 14:15–24). Most importantly, the kingdom Jesus comes to inaugurate is where people operate not as citizens and subjects, the privileged and the oppressed, but as sons and daughters of God (2 Cor 6:18).

For Thurman, Christ's focus on the powerless means that Christianity presents a direct message to the "masses of men with their backs constantly against the wall . . . the poor, the disinherited, the dispossessed."[9] That message tells both the powerful and the powerless that they are all children of God, and their material status in no way affects their value to God. Once the oppressed recognize that God loves them, they are free to be completely sincere, argues Thurman. They no longer must buy into the lies of the powerful, of wealth inequality and white supremacy.

More than a "mechanism of defense against the strong," Thurman argues, sincerity leaves those representing the controlling forces without defense, taking away "the status upon which the impregnability of their position rests," replacing a "relation between the weak and the strong" with "merely a relationship between human beings." Awareness of such a relation, Thurman writes, "marks the supreme moment of human dignity."[10] Once we understand that every single human has been created by a God who loves and celebrates us equally, then we'll no longer accept the lies taught by earthly systems of power. Only then can we see clearly, not through the murky glass of oppressive governments and capitalist systems.

That's hard to imagine, even for a writer as skilled as Thurman. He tells us the truth of our relationship to God and to each other, but he can't tell us how we get to the point where we can act sincerely within one another. How do we step outside of our current political systems? Can we disentangle our identities from those determined by established forms of power? Where is the roadmap to our shared humanity?

9. Thurman, *Jesus and the Disinherited*, 13.
10. Thurman, *Jesus and the Disinherited*, 72–73.

 Black Panther points to answers to these questions. The story of a people defined by, and trying to re-define, the nations to which they belong, *Black Panther* illustrates the struggle between systems and sincerity with superhero bombast. In particular, we see this in the battle between T'Challa and the villain Erik Stevens aka Killmonger, played with magnetic intensity by Michael B. Jordan.

BECOMING YOUR ENEMY

Killmonger may have an in-your-face moniker, but Coogler and co-writer Joe Robert Cole use him to present a nuanced vision of the connection between kingdom and identity. Killmonger is a man without a nation, completely defined by the countries that rejected him. Born and raised in the United States, Killmonger is in fact N'Jadaka, the son of Wakandan prince N'Jobu (Sterling K. Brown) and cousin to T'Challa. After T'Chaka executed his younger brother N'Jobu for treason, he and other Wakandan leaders abandoned the boy. From the streets of California, N'Jadaka (now called Erik) became an elite member of the American military special forces, where his proficiency earned him the nickname Killmonger. When he comes to Wakanda to challenge T'Challa, he doesn't consider himself an outside invader. In his eyes, he's a prodigal, returning to claim the birthright T'Chaka denied to him.

 Killmonger storms into the throne room and dares T'Challa and the leaders of the tribes, "Ask me who I am." Killmonger needs the Wakandans to know his lineage so he can challenge for the throne.

 But more importantly, he needs them to recognize him, to acknowledge him as a son of Wakanda. Killmonger has never known that "supreme moment of human dignity" described by Thurman. When T'Chaka killed his father, N'Jadaka had to look elsewhere to find his identity. The systemic racism he experienced in the US told him that he was worthless. His educators at MIT and Annapolis told him he was part of a strategy. The American military and CIA told him that he was a weapon. The people of Wakanda told him that he wasn't one of theirs.

 Killmonger arrives in Wakanda to show them who he is, and he does it in the same waterfall basin where T'Challa beat M'Baku. Preparing for ceremonial combat against T'Challa, Killmonger strips off his shirt to reveal a body covered with scars, a hashmark for each of his victims. "I've lived my entire life waiting for this moment," Killmonger exclaims, celebrating the tools of oppression that he's used to gain the power of Wakanda:

I trained, I lied, I killed—Just to get here. I killed in America, Afghanistan, Iraq. I took life from my own brothers and sisters, right here on this continent. And all this death, just so I could kill you.

When the camera catches Jordan's body, we see a person physically twisted by the systems around him. The athleticism and beauty of his movements become grotesque when applied to war. In the same way that the wages of sin lead to death, the oppressor's tools of exploitation and power have corrupted Erik. The reunion between cousins turned into a struggle for dominance.

After winning the ritual and becoming king, Killmonger ties his identity to the systems that made him, applying Wakanda's technology to an imperialist model. "I know how colonizers think, so we're gonna use their own strategy against them," he boasts.

We're gonna send Vibranium weapons out to our War Dogs. They'll arm oppressed people all over the world so they can finally rise up and kill those in power, and their children, and anyone else who takes their side. It's time they know the truth about us! We're warriors! The world's gonna start over, and this time, we're on top. The sun will never set on the Wakandan empire.

Under Killmonger's rule, the kingdom of Wakanda just copies other, more oppressive kingdoms, the empires of America and Europe and Rome. The leadership may change, but the treatment of people will be the same. Now in the role of power, Wakandan people can only be "warriors," while the new disinherited have only two options: accept their powerlessness or be killed.

RESTORATION INSTEAD RETRIBUTION

Before Killmonger arrived in Wakanda, T'Challa never had to face the realities of oppression, the questions of identity that plague Killmonger. He knows that he is the noble son of the noble King T'Chaka, rightful heir to the throne and to the mantle of Black Panther. But the existence of Killmonger calls that identity into question, a walking reminder of his ancestors' failures.

Instead of rethinking his identity in light of the fact of Killmonger, T'Challa chooses to defend his selfhood by rejecting his cousin. That rejection repeats the wrongs committed by his ancestors.

T'Challa distances himself from his cousin, rebutting Killmonger's plans for a Wakandan empire by reminding him that "[i]t is not our way to be judge, jury, and executioner to people who are not our own" and implying that he is not "our own" because he is not Wakandan. When Killmonger reveals that he is N'Jadaka, T'Challa remains quiet and lets the elders interrogate him.

When T'Challa rejects Killmonger, he contradicts his benevolent performance in the basin. He's not just a noble leader of a powerful country. He's also a man who benefits from the suffering of others. He's a man who inherited the sins of his ancestors.

To be sure, T'Challa remains a "good" person. After all, we've seen him choose reconciliation over revenge in both his fight with M'Baku and in the capture of his father's killer at the end of *Captain America: Civil War*. But none of that changes the fact that he participates in the isolationism that allows Wakanda to flourish while people around the world suffer, even people with blood ties to him. T'Challa might be a citizen of a great kingdom, but it's a kingdom that has committed great wrongs. That fact is part of his identity.

T'Challa expresses as much on his second visit to the afterlife, where he confronts T'Chaka after learning the truth about N'Jobu and Killmonger. "You were wrong! All of you were wrong to turn your backs on the rest of the world," he tells his ancestors, before accepting his own complicity. "He is a monster of our own making," he confesses.

This statement reframes Black Panther's climactic battle with Killmonger. It isn't just a matter of good guy versus bad guy. It's a matter of responsibility. T'Challa's ancestors left N'Jadaka to be transformed into Killmonger, and T'Challa must prevent that harm from spreading.

For that reason, Black Panther doesn't take glory in defeating Killmonger. Instead, he carries him outside so they can both watch the sun rise over Wakanda. As the camera slowly pushes in from behind, we see T'Challa gently set Killmonger on the ground, their bodies blending in silhouette against the sun ascending an orange sky. T'Challa kneels down, looks at his cousin with compassion, and offers, "Maybe we can still fix you."

Killmonger refuses by delivering the film's most powerful line: "Just bury me in the ocean with my ancestors who jumped from the ships, because they knew death was better than bondage."

Pain creases Boseman's face as T'Challa watches Killmonger's life slip away, revealing more than just mere sympathy. He now recognizes that his cousin was right, that he was a victim of Wakanda's refusal to use its gifts to improve the world. He recognizes that he needs to do more than just defend his country and beat up bad guys.

In that moment, the two move past the deception so often required by oppressive systems and into the sincerity that Thurman described. By showing Wakandans who he is, Killmonger allows T'Challa to see himself for who he is: someone who can right his ancestors' wrongs.

That act of caring for his enemy, literally carrying his enemy, lets T'Challa work that model on Killmonger. Loving the enemy, Thurman argues, allows the individual to "emerge as a person." Jesus urges the oppressed to take "the initiative in seeking ways by which you can have the experience of a common sharing of mutual worth and value. It may be hazardous, but you must do it."[11]

It may seem like Thurman ignores political reality by insisting that we love our enemies, but his discussion about the relation between Jews and Rome reminds us that loving an enemy is a political act, one that establishes a new politics. As pastor Brian Zahnd argues, Jesus's command to love your enemy is "not just giving individuals a personal ethic; [it] is striking at the very foundation of the world!" Against the violence and scapegoating on which most nations are made, Jesus insists that the world be "arranged around love and forgiveness. The fear of our enemy and the pain of being wronged is not to be transferred through blame but dispelled through forgiveness. Unity is not to be built around the practice of scapegoating a hated victim but around the practice of loving your neighbor as yourself—even if your neighbor is your enemy."[12]

Wakanda might be a world of pure fantasy, but we can use it to think about these relationships. It's an imaginative way of showing the world who we are, who we were created to be: image bearers of God.

Such is the message of Christianity, one described by no less than eminent New Testament scholar N. T. Wright: "Humans were made to be 'image-bearers,' to reflect the praises of creation back to the Creator and to reflect the Creator's wise and loving stewardship into the world."[13]

LOVING YOUR NEIGHBOR BY LOVING YOUR ENEMY

Even more than his superpowers and his cool suit, Black Panther's greatest ability is the way he learns from other people. But to learn, he must first make mistakes.

Think about the first action scene in the movie, when Black Panther thwarts mercenaries trafficking kidnapped women. Without question, it's

11. Thurman, *Jesus and the Disinherited*, 95, 100.

12. Zahnd, *Farewell to Mars*, 85–86.

13. Wright, *Day the Revolution Began*, 99.

good that Black Panther rescued those women, but we quickly learn that they were not his first priority. Instead, he came to extract the spy Nakia (Lupita Nyong'o), who had been embedded among the kidnapped.

Why does T'Challa break Nakia's cover and disrupt her mission, one that could stop even more traffickers? Because he wants her to be his date at his coronation. He made his crush on Nakia more important than her wishes and the safety of other exploited women.

T'Challa's attitude puts him at odds with Nakia, who loves her country and reciprocates his romantic feelings toward her but puts others before herself. As a spy for Wakanda, Nakia goes undercover all over the world and sees suffering beyond her nation's borders. She urges T'Challa to welcome refugees into Wakanda and to share its resources with the rest of the world. Although she remains committed to service to her country, Nakia cannot ignore the needs of people around the world. Indeed, she sees no conflict between loving her people and loving her neighbors.

By the time we get to the movie's ending mid-credit sequence, T'Challa has learned much from Nakia. The scene finds her accompanying T'Challa to a conference at the United Nations. When T'Challa announces that Wakanda is ready to share its gifts with the rest of the world, the assembled representatives snicker. They know Wakanda only as a backwards African nation. One representative sums up the world's dismissal when he asks, "With all due respect, T'Challa, what can a nation of farmers have to offer the rest of the world?" The scene ends on T'Challa's smirk, as the Wakandans exchange knowing glances.

We viewers smile just as brightly as T'Challa, and not just because we know the answer to that question. We smile because we know what it took to get T'Challa to this point. Through most of *Black Panther*, he happily continued his ancestor's tradition of isolation. Like Wakandan kings before him, he did not consider the rest of the world his responsibility, in part because he knew the racism that the nation would encounter. The rest of the world aren't just "not his people"; they are enemies of Wakanda, willing to loot and destroy his country.

By sharing resources, T'Challa shows love for his enemy. Crucially, that's a skill he learned not just from allies like Nakia, but from Killmonger as well. In his fight with Killmonger, T'Challa discovered all of who he is, the good and the bad, and realized that he needed to take responsibility to make sure no one else meets N'Jadaka's fate.

In the movie's final scene before the credits, T'Challa and Shuri arrive at the housing project where Erik grew up. Kids still play basketball here, as they did in 1992, and the playground conditions have only deteriorated over the following twenty-six years. But where the projects were once brick

buildings for the government to segregate Black Americans from the wider community, they are now the property of T'Challa, which he will use to open the first Wakandan Research Center. Where a Wakandan ship once hovered above the projects, refusing to reveal itself to outsiders, another now lands on the court so Shuri can invite the children over and allow them to examine the piece of technology.

A boy who reminds us of Erik breaks off from his friends to speak with T'Challa. "Is this yours?" he asks, before asking the more pertinent question. It's the question the movie has been asking throughout its 137-minute runtime.

"Who are you?"

That's the question of the movie, one that recalls a more pressing question, one that the disciples asked of Jesus, "Who is my neighbor?"

Many know that in Luke 10, Jesus answers that question with the parable of the Good Samaritan. When we retell that famous parable, we sometimes forget the teaching that prompts the question. An expert in the law asks Jesus, "What must I do to inherit eternal life?" and Jesus answers by directing him to the main point of the Hebrew Scriptures: "'Love the Lord your God with all your heart and with all your soul and with all your strength and with all your mind'; and, 'Love your neighbor as yourself'" (Luke 10:25, 27).

By end of the movie, Black Panther lives out that second commandment. But he could only do that when he accepted that his neighbor was the rest of the world. And he could only do that when he recognized that his enemy was his cousin. Only when he sees them can he properly and fully show the world who he is.

CREDITS:

Black Panther (2018)

Director: Ryan Coogler

Screenwriters: Ryan Coogler and Joe Robert Cole

POST-CREDITS

Themes: Identity and Responsibility

Key Biblical Passage: Luke 10:25–37

Questions:

1. Throughout *Black Panther*, characters must show one another who they are. How do you show people who you are? How do you identify others based on their words/actions? What is our responsibility as Christians to both show ourselves and to see others?

2. Part of *Black Panther*'s power comes from its depiction of Wakanda. Can you think of other fictional nations or communities that help you think about the kingdom of God? How can these fictional communities help us enact the kingdom of God here on Earth?

3. Many people find Killmonger an exciting villain precisely because he raises so many valid points about white supremacy and global inequality. Do you agree with his complaint? How should Christians respond to these evils?

4. As this chapter argues, the Black Panther demonstrates a surprising ability to learn from others. Why is that so hard for people? What are some lessons that you've learned from others? How did these lessons enrich your faith?

5. Howard Thurman writes about sincerity as a tool of the oppressed, arguing that it strips away the power of the oppressor. How does Christ's teaching help us to be more sincere with one another? Can superhero movies help us become more sincere with one another, or does fantasy obscure things?

PART I

THE ARCHETYPES

Superman
Batman
Spider-Man

2

SUPERMAN, SUFFERING, AND BELIEF

You will believe that a man can fly!

—Tagline for *Superman: The Movie*

I consider that our present sufferings are not worth comparing
with the glory that will be revealed in us.

—Rom 8:18

At some point, anyone who watches these movies begins to think, "It would be cool to live in a world with superheroes." I admit, it *would* be pretty exciting to see the Bat-Signal illuminating the clouds or to hear news reports celebrating Iron Man's latest inventions. But if we looked a little closer, we'd notice that unless we're one of the people flying around in bright spandex, life in a superhero movie isn't so great.

Look at what happens to regular folks in *Superman* movies. Superman is the perfect superhero, a tireless do-gooder with virtues even greater than his amazing powers.

But regular people? They get thrown from a helicopter when an errant cable catches the chopper's ski. They plummet toward the ground when the engine on an experimental jet explodes. They huddle together on rooftops to escape rising floodwaters. And time after time after time, the schemes of madmen threaten their lives.

In this way, Superman's world is not too different from our own. Every day, regular people have to deal with senseless accidents, natural disasters,

and harmful humans. But unlike the victims on the screen, we don't have Superman to come to the rescue.

That's a hard fact for Christians to accept. We don't believe in Superman, but we do believe in an all-powerful and loving God, a God who plays an active role in everyday life. But when pressed about what theologian Mary McCord Adams calls "horrendous evils," horrible things that happen because people do bad things or because of random acts of nature, we Christians can get stumped. We have trouble answering the simple question that so many have asked: why would a loving God let bad things happen?

That question comes from a long-established theological branch called "theodicy." The subject has its roots in the proposition put forward by the ancient Greek philosopher Epicurus, who reasoned, "Either God wants to abolish evil, and cannot; or he can, but does not want to. If he wants to, but cannot, he is impotent. If he can, but does not want to, he is wicked. If God can abolish evil, and God really wants to do it, why is there evil in the world?"[1]

Superman movies don't exactly answswer that question, but they do help us deal with it. They remind us that, no matter how bad the real world might be, we can always imagine ways to improve it. More than a distraction for actual suffering, these acts of imagination are a better response than pursuing power or seeking security. Through acts of imagination, we can continue the work Christ has commissioned of us.

THE NEVER-ENDING BATTLE BEGINS

"Superman, who can change the course of mighty rivers, bend steel in his bare hands, and who, disguised as Clark Kent, mild-mannered reporter for a great metropolitan newspaper, fights a never-ending battle for truth, justice and the American way."

These lines from the TV series *Adventures of Superman* (1952 to 1958) solidified the public perception of the hero, that of a being so powerful, so unimpeachably good, that he's actually quite boring. But Superman didn't start out that way. Writer Jerry Siegel and artist Joe Shuster originally conceived of Superman as a tyrant who forced others to follow his orders. By the time the character made his comics debut in 1938's *Action Comics* #1, Siegel and Shuster changed him into a champion of the downtrodden who took on corrupt landlords and mafiosos.

A smash hit in the comics, Superman almost immediately made the jump to other media. *The Adventures of Superman* radio show launched in

1. Cited in Meister and Dew, "Introduction," 10.

1940 and expanded the character's influence. Superman hit the big screen in a series of animated shorts that ran from 1943 to 1944, live-action serials in 1948 and 1950, and the feature film *Superman and the Mole Men* in 1951. Since then, Superman has appeared in every medium and on every type of imaginable merchandise, from T-shirts to chocolate milk cartons to credit cards. No superhero has better transformed from "popular culture to folk culture, from mass media to folklore."[2]

Because the superhero genre began with Superman, it follows that the first wave of superhero movies would also begin with 1978's *Superman: The Movie*. Although a bit clunky by today's standards, *Superman: The Movie* became its own sensation, one that made superheroes a viable film subject long before the Marvel Cinematic Universe came to be.

As has happened in every other medium in which he's appeared, Superman's popularity has since been overshadowed by other silver-screen superheroes. But even the weakest of the character's eight movie appearances still manages to capture audiences' imaginations. From the child-like optimism of *Superman: The Movie* to the nostalgia of *Superman Returns* to the cynicism of *Man of Steel* and *Batman v. Superman: Dawn of Justice*, every Superman movie fundamentally deals with an all-powerful person trying to help people in a dangerous world.

IMAGINING GOODNESS IN PAIN

In his classic text on theodicy *The Problem of Pain*, C. S. Lewis recalls the answer he would give to those who asked him about the goodness of God. After noting all the natural evils of the world, all the pointless violence committed by humans, and all the wrongs perpetrated by religious figures, he would conclude, "If you ask me to believe that this is the work of a benevolent and omnipotent spirit, I reply that all the evidence points in the opposite direction. Either there is no spirit behind the universe, or else a spirit indifferent to good and evil, or else an evil spirit."

Despite that steadfast position, there is one question Lewis says his younger self never considered: "[i]f the universe is so bad, or even half so bad, how on earth did human beings ever come to attribute it to the activity of a wise and good Creator?"[3] Such an imaginative power goes beyond most people, Lewis contends. We may be fools, he says, but that's too foolish. To even consider the existence of a good God, in the face of such evidence to the contrary, requires more creativity than any human possesses.

2. Peretti, *Superman in Myth and Folklore*, 17.
3. Lewis, *Problem of Pain*, 13.

Unsurprisingly for an author best known for his children's books, Lewis places quite a bit of importance on imagination. Because we can imagine God, Lewis reasons, God must exist. This line of argument suggests that imagination is a conduit for understanding things that seem contradictory, that imagination is an act of faith.

It's worth noting, then, that *Superman: The Movie* starts by reminding us that we're watching an imaginary story. The film begins with the spritely notes of legendary composer John Williams's title music, accompanied by a shot of black and white curtains, the type you would see in front of a theater stage. The curtains part to reveal a movie screen, on which is projected comic book read by a young child. The camera zooms into a panel depicting the Metropolis skyline and dissolves to a shot of the "real" Metropolis before panning up to the night sky. There, the opening titles blast forth, out of the movie screen, beyond the curtains, and to the edges of the actual film frame.

That's three levels of artifice before we get to the movie we're actually watching: the theater curtains, the movie screen, and the comic book page. It's clear that director Richard Donner and his screenwriters want us to know that we're dealing with something imaginary.

Imaginary, but not fake. *Superman: The Movie* might not be realistic, but that doesn't mean it's divorced from the real world. In fact, it demands that we accept the fantastic images on the screen as somehow plausible. It's so important that we understand the reality of the world Donner built that the movie poster declares, "You will believe a man can fly."[4]

The poster's boast partially reflects pride in the film's special effects, which producers Ilya and Alexander Salkind insisted be state-of-the-art. More importantly, the movie's emphasis on belief and imagination dares us to accept that when circumstances look bad, help is on the way. When Clark Kent (Christopher Reeve) sheds his civilian disguise and takes to the skies to rescue Lois Lane (Margot Kidder) from a helicopter accident, the stirring John Williams' score makes sure that we take notice. When Superman plucks Lois from the air, he assures her, "Easy, Miss. I've got you."

Her response? "You've got me? Who's got you?"

The helicopter rescue comes halfway through the two-hour film and marks the first appearance of Superman, setting off a montage of good works. Superman flies through the sky, thwarting burglars and armed bandits, catching crashing planes, and even saving a kitten from the tree.

4. According to filming accounts, director Richard Donner wrote the word "verisimilitude" on signs hung around the set. He used this word to remind members of the cast and crew that, despite the movie's fantastic elements, the characters must believe in the reality of their own world. See: Bettinson, *Superman* and Weldon, *Superman*.

Donner pairs each act with reaction shots from astounded civilians. The best one comes from the pilot of the crashing plane, who looks at what was the wreckage of an engine decimated by a lightning strike to see Superman holding the wing aloft. "We got something," he tells his co-pilot. "I don't know what, but just . . . trust me."

Bad things happen in the movie, some catastrophic and some trivial. But they never mean the end. Somehow, when all seems lost, Superman saves the day.

This is all, of course, unbelievable. Like the bystanders awestruck by Superman's feats, we viewers remain skeptical that anything could rescue us from such evil. But in the movie's best moments, we believe it nonetheless.

Superman: The Movie plays on this tension between the believable and the fantastic in its most infamous scene, the movie's climax. In his plot to increase the value of his desert real estate properties, criminal mastermind Lex Luthor (Gene Hackman) launches two rockets toward the US and shackles Superman with Kryptonite, the element that strips away his powers. Although he escapes in time to stop one rocket, the other hits its target, destroying the coast and killing Lois Lane in the process.

Horrified at a loss both vast and personal, Superman drops to his knees. For the first time, the Man of Steel looks like a man of sorrow, defeated. But then, in defiance of warnings from both his Kryptonian father (Marlon Brando) and his Earthling father (Glenn Ford) about intervening too much in the lives of humans, Superman flies against the orbit of the Earth and reverses time. Waters flow back into place as destroyed dams repair themselves. Rocks run uphill to return to where they once rested. And a car backs out of the cracked ground with Lois inside, completely safe and unaware of what could have killed her.

The science is, of course, ridiculous. But the emotions are real.

None of us have turned back time, but all of us have been overcome with grief and shouted with anger at the sky. Every one of us has felt utterly powerless when something has gone wrong. We've raged at the God who promises to love us and still lets us endure all manner of senseless suffering. It might be silly to think about Superman flying around the globe, but it's not silly to want God to make a miracle. After all, aren't we told that with God, "all things are possible" (Matt 19:26)?

According to C. S. Lewis, the problem of pain stems from the conflict between our belief in an all-powerful, all-loving God and the fact of suffering. Pain would be no problem at all, Lewis writes, "unless, side by side with our daily experience of this painful world, we had received what we think a

good assurance that ultimate reality is righteous and loving."[5] But because we believe in a loving God and because we know from lived experience that pain is real, we have a problem.

Surprisingly, Lewis sees pain as evidence not of God's absence, but of God's love. God created a world for us and desired to be loved by us. But because coerced love is no love at all, God allows us to do what we wish with creation; we can even reject God's design. Working against God's design and creation results in pain, both for us and for others.

Lewis builds his argument on the first chapters of the book of Romans. Paul begins that book by describing the creation and fall of humanity, in which people turn away from God and pursue their desires, even to their own destruction. In Rom 4–6, Paul describes redemption in the form of Christ, who arrives to model God's plan for humanity. The earthly powers at the time, namely the Roman Empire and its sympathizers, oppose Christ's message and create more agony—the agony of crucifixion.

But Paul does not end the story there. Rome may have refused God's plan and killed Jesus, but death is not the end. Through the resurrection, Jesus disarms death and disarms any earthly force that would harm others. The rulers of the world may win minor battles, and those victories may cause pain, but they'll never overcome God's sovereignty.

For that reason, Paul ties hurting to hope. "I consider that our present sufferings are not worth comparing with the glory that will be revealed in us," he writes, because, "hope that is seen is no hope at all" (Rom 8:18, 24). We suffer now because we're living in a world filled with people who reject God's design. Even when we adhere to that design, by loving others and prioritizing the weak, we are opposed by the strong, who throw all sorts of violence against us.

But despite that violence, we have hope. And that hope calls to our imagination. And, as an act of faith, we imagine goodness in a hurting world.

So when a movie imagines a man who can fly, who rescues kittens from trees and turns back time to undo catastrophe, it's performing an act of hope and an act of faith. It's preparing us to deal with real problems in the real world.

IMPOSSIBLE HOPE AND INCESSANT SUFFERING

In the beginning of *Batman v Superman: Dawn of Justice*, Superman (Henry Cavill) battles the evil Kryptonian General Zod (Michael Shannon) through the city of Metropolis. The scene retells the climax of the preceding

5. Lewis, *Problem of Pain*, 21.

movie *Man of Steel*, this time from the perspective of regular humans on the ground. The fight looked exhilarating in the first film, which focused solely on Superman and Zod, but it's utterly terrifying when viewed as a bystander. Buildings fall, people die, and everyone is covered with dust. The scene looks exactly like New York City on September 11, 2001.

Where *Superman: The Movie* establishes itself as a work of imagination, writer/director Zack Snyder opens his movies by reminding us of the harsh truths in the real world. The three movies directed by Snyder—*Man of Steel*, *Batman v Superman*, and *Zack Snyder's Justice League*—portray Superman as an outsider almost as terrified of his abilities as others are of him. These are deeply cynical films, in which characters deal with pain not by imagining better, but by pursing power or hiding in fear.

Nothing captures this worldview better than a speech delivered by Lex Luthor (Jessie Eisenberg) in *Batman v Superman*. Throughout the movie, Luthor manipulated events to draw Batman (Ben Affleck) and Superman into a contest that will destroy them both. He explains his motivations in a rambling rant that compares Superman to God. "God is tribal, God takes sides," Luthor proclaims. "No man in the sky intervened when I was a boy to deliver me from Daddy's fist and abominations." Even as a child, Luthor reasoned that "if God is all-powerful, he cannot be all-good. And if he is all-good, then he cannot be all-powerful."

Luthor's complaint paraphrases Epicurus's definition of theodicy and recalls the position espoused by C. S. Lewis in his atheist days. But where Lewis eventually concluded that God must be real because God's goodness supersedes human imagination, Luthor decides the opposite. He cannot imagine hope in his pain; therefore, that pain has no point. For him, the only logical response is to pursue power. He sees Superman as a stand-in for the God who did nothing to prevent misery. If he can control Superman, he can give meaning to the misery.

The bad guys aren't the only ones who think this way. Batman fights Superman in *Batman v Superman* because he's driven by the trauma of his parents' random murder. Instead of the awe they showed in *Superman: The Movie*, governments and the general public in *Man of Steel* react to Superman's appearance with fearful skepticism, sending the military to track his actions.

Not even Pa Kent (Kevin Costner) is immune from such cynicism. A flashback scene in *Man of Steel* captures the fallout of young Clark (played as a child by Dylan Sprayberry) using his powers to lift a crashed bus full of children from a roadside lake. The act of heroism earns Clark not praise from his father, but a rebuke. Sitting in a broken truck outside of a cornfield, Pa explains to Clark why he can't use his abilities, even for good.

"There's more at stake here than just our lives or the lives of those around us," Pa tells his son. "When the world finds out what you can do, it's going to change everything . . . our beliefs, our notions of what it means to be human . . . everything."

There's tension in the construction of this scene. Even though the shaky camera suggests anxiety, everything else about the moment feels reassuring. Warm brass instruments fill the Hans Zimmer score that plays as father and son converse, and cinematographer Amir Mockri shoots the cornfield surrounding them in grainy, rustic colors. Moreover, the mother of one of the survivors who comes to speak with the Kents about what Clark has done doesn't seem angry or worried. In fact, she seems grateful, calling his feat an "act of God."

But Pa looks at the woman and sees someone "scared" about what she "doesn't understand." The rest of the film bears out Pa's interpretation. People in *Man of Steel* (and the other two Snyder *Superman* films) believe that the world is full of misery. Any attempt to change that fact is met with resistance. So when Clark thinks about the kids he saved and asks, "Should I have let them die?" Pa answers, "Maybe."

Costner delivers the line with bitterness, revealing Pa's frustration. He wants to live in a world where children don't have to die in a school bus accident, but he can't believe it. He lacks faith and imagination strong enough to overcome the fear for his children. He holds to this perspective even to the point of his own destruction, as when he allows himself to die in a tornado instead of letting Clark rescue him.

As these and other scenes illustrate, Superman's ability to rescue people isn't enough to give significance to bad things. In contrast to the heroic montage of Superman saving the day in *Superman: The Movie*, *Batman v Superman* lays thick and dreary strings under its scenes of Superman pulling families away from floodwaters and shielding children from explosions. This Superman wears a wearied expression, especially as he looks at the people worshiping him in thanks. In these movies, the existence of Superman isn't enough. Nothing can ease their suffering.

Bleak as this perspective may be, there's a lesson for Christians even in this. It may not be what one wants in a superhero fantasy, but Snyder and his co-writers are correct to say that evil exists. Horrible things happen for no apparent reason, and these movies retain that truth even when telling stories about an all-powerful hero.

In her book *Horrendous Evils and the Goodness of God*, Mary McCord Adams surveys the various approaches to human suffering to argue that God won't make the agony go away, but God can help humans see the value within it. Recalling Isa 53, Adams finds that value in the incarnation of

Christ, and specifically Christ's suffering. She writes, "Divine love chooses to identify with material creation by assuming a particular human nature, by becoming a particular human being, because it is in human nature that the cost of joining spirit to matter, personality to animality is most keenly (because most self-consciously) felt, most prominently in human vulnerability to horrors."[6]

By taking a body, God becomes subject to the same horrendous evils that we accuse God of refusing to stop, and God experiences them through torture on the cross. Affirming both the full humanity and full divinity of Christ, Adams argues that "Christ, in His human nature, participates in a representative sample of horrors sufficient to guarantee His appreciation of the depth of their ruinous potential."[7]

Suffering matters because God can experience pain in the human body of Christ. Because humans feel pain in our bodies, our bodies matter as well.

Adams titles the chapter in which she lays out that claim "Resources to the Rescue." The resources to which she refers are mostly centuries of theology, pointing to the long line of thinkers who have wrestled with the problem of pain. These theologians look at actual suffering in the world, and try to reconcile it to their beliefs about God's nature. They acknowledge that some seek control and some seek safety, but they ultimately come down on the side of hope. For Adams, church history is full of people who insist that suffering matters because it allows us to imagine our relationship to God.

As you might guess, I would add *Superman* movies to the list of resources to help us make sense of pain. While all *Superman* movies feature bad things happen to regular people, they also remind us that we do not find refuge when we seek only power or safety. We find it only in hope.

A key scene towards the middle of *Man of Steel* makes this point. In an attempt to prevent Zod's attack, Superman agrees to be brought into the custody of the US government, with the stipulation that he speak with Lois Lane.

It's no accident that Superman's decision to submit follows a conversation that Clark Kent has with a priest. Wracked with indecision about Zod's threat, Clark tells the priest that he doesn't think Zod can be trusted to spare Earth, even if he gives up. "The problem is," he continues, "I'm not sure the people of Earth can be [trusted] either."

As Clark ponders the decision to surrender himself to the humans who fear him, we see behind him a stained-glass window on the wall of the church. It portrays Jesus kneeling in prayer at the garden of Gethsemane,

6. Adams, *Horrendous Evils*, 166.

7. Adams, *Horrendous Evils*, 174.

considering his sacrifice. It's a heavy-handed shot, but as it reminds us that God chose sacrifice for the sake of humans, it also reminds us that there's power in sacrifice. By incarnating in Jesus and allowing himself to die on the cross, God didn't lose a battle against evil. Rather, God demonstrated for all of us that the powers and principalities of the world never have the last word. That sacrifice, no matter how weak it may appear, will overcome.

There's a hint of that idea in the conversation Superman and Lois have while he's in military custody. Noticing the insignia on his chest, Lois asks, "What's the 'S' stand for?"

"It's not an S," answers Superman. "On my world, it's a symbol for hope."

"Well here," Lois responds with a little snark, "It's an S."

One could argue that this conversation reinforces these movies' pessimistic perspective, in which something as powerful as hope can be misinterpreted and dismissed as just a letter. But the fact that it occurs during an act of sacrifice, in the middle of a movie interested in mining the depths of sorrow, the conversation feels strong and inspiring.

Even movies that insist on reminding us of real-world evils imagine the existence of hope. They show us that we need not seek power or retreat for security. They tell us that we can use imagination to face the real world, in all of its nastiness.

WHY WE NEED (TO BE) SUPERMEN

What then should we do about suffering? Is it enough to know that it exists, to know that it has meaning, and to use imaginary stories to make sense of it? I find an answer to that question in what I consider the best *Superman* movie.

After the four Superman movies starring Christopher Reeve and before Zack Snyder's reboot *Man of Steel* came a quasi-sequel to *Superman: The Movie* and *Superman II*. 2006's *Superman Returns* finds Superman (Brandon Routh) returning to Earth after a five-year absence. He discovers that humanity has moved on without him, particularly Lois Lane (Kate Bosworth). Still a crack investigative reporter for the newspaper *The Daily Planet*, Lois has become a single mother to her young son Jason (Tristan Lake Leabu) and is engaged to fellow reporter Richard White (James Mardsen). More surprisingly, she's been the leader in the post-Superman world, writing a Pulitzer Prize-winning editorial entitled, "Why We Don't Need a Superman."

The movie seems to reject Lois's premise with a stand-out scene that recalls the helicopter rescue from *Superman: The Movie*. Instead of a news chopper, Lois now rides a commercial space shuttle carrying a group of reporters into orbit. The flight begins well, despite Lois's hard-hitting questions, but as always happens to her, things go wrong and an engine bursts. As the plane plummets down to earth, a blue and red blur shoots past the windows and the plane begins to lift.

The fuselage crumbles in Superman's hands, but nothing deters him. Holding the shuttle together, Superman brings it down gently in the center of a crowded baseball field, where thousands witness his return. Unfazed by the cheers raining down on him, Superman walks into the plane to comfort the passengers, repeating a line from the first movie: "I hope this experience hasn't put you off flying. Statistically speaking, it's still the safest way to travel."

Again, we might be tempted to read this moment as a repudiation to Lois's award-winning editorial. Turns out, she did need Superman—otherwise, she would be dead.

But the scene ends by proving the opposite. Before Lois can say anything to Superman, he looks at her with a smile and flies away. The scene cuts to the buzzing *Daily Planet* newsroom, where Editor-in-Chief Perry White (Frank Langella) shouts orders to his reporters, "Is he back for good? Where has he gone? Does he still stand for truth, justice, and the American way?"

As Perry's questions suggest, Superman may have returned, but he's liable to leave again. His presence is not assurance, but a persistent quandary. Everyone knows about Superman, and he's touched the lives of thousands. But nobody knows who he is and nobody knows his mind. In short, the point of Lois's op-ed remains sound: humans cannot wait for Superman to fix everything for them. We need to do it for ourselves.

The second half of *Superman Returns* builds on this theme. When Lex Luthor (Kevin Spacey) traps Lois and her son on a yacht, it's not Superman who sets them free, but young Jason. When Luthor's thugs pummel a Kryptonite-riddled Superman and toss him overboard, it's Lois's non-powered fiancé Richard who pulls him from the sea. In case we missed the point, a reprise of John Williams's score from *Superman: The Movie* punctuates the moment Richard's hand breaks through the water to take hold of Superman. Saving the world can't just be a job for Superman. It has to be a job for everyone else, too.

Christian theology has always held that God incarnates as Jesus to establish the kingdom of heaven, to show humans how to embody God's plan.

But that belief has always left questions about why Jesus had to go in the first place, why the ascension was necessary.

For many, the Great Commission provides an answer. When Jesus sends his followers out into the world, he also enables us to act as he acted and love as he loved. We are to be God's presence on Earth, embodying God through our actions.

Theologian Catherine Keller addresses this idea when she argues that God's presence in Christ "does not signify the one and only Incarnation relationally softened up and diversified for flesh-affirming postmodern Christians," but rather, "a redistribution." Keller finds this in both the Gospel and the first epistle of John.

> The prologue of John's gospel may be read as announcing . . . the logos, principium, word, of all materialization. . . . In its historical context, the enfleshment of the one God in a particular body enacted a radical provocation, finally intolerable to the sovereign powers.[8]

In other words, it's our job as humans to become the work of God, to do the work of God on Earth.

Keller's theory of incarnation has direct relevance to the issue of theodicy because it answers its central question, "Why does God allow bad things to happen?" She contends that we don't deal with horrendous evils by waiting for God to send a messiah. We can't wait to "replay" the "singular incarnation" of God in Jesus. Rather, she calls for "earthbodied intercarnation"[9]—human beings on Earth following Christ's example by working together to make the world a better place. Only by using our bodies to do God's good work can we heal horrendous evils. We don't cower from danger, we don't pursue power to control bad things, and we certainly don't wait around for God to save the day. God gave humans the responsibility of making God's presence known.

It's hard to understand complex theological terms like "earthbodied intercanation," but we can find a good example of what Keller means by looking at *Superman Returns*. Late in the film, we learn that Superman is the father of Lois's son Jason. The movie ends with Superman coming to visit Jason as he sleeps, repeating to him the same messages Jor-El played for Kal-El in his rocket to Earth. "You'll be different. Sometimes, you'll feel like an outcast," Superman tells his son. "But you'll never be alone. You'll

8. Keller, *Intercarnations*, 10.
9. Keller, *Intercarnations*, 285.

make my strength your own." The pseudo-biblical language of the scene is punctuated by a choir singing with John Ottman's score.

For Christian viewers, Superman's monologue recalls the language used in the Great Commission recorded in Matt 28:18–20. Jesus begins the passage by reminding his disciples that "[a]ll authority in heaven and on earth" has been given to him, and from that authority, he orders his followers to "go and make disciples of all nations, baptizing them in the name of the Father and of the Son and of the Holy Spirit, and teaching them to obey everything I have commanded you." In other words, they're told to live out the lessons he's taught them, to continue his work far beyond just Judea. The Commission closes with Jesus's assurance that God's power goes beyond the physical threats they face, beyond the suffering they endure, beyond even their imagination. "And surely I am with you always," he tells them, reminding that his incarnation is in them, "to the very end of the age."

A JOB FOR ALL OF US

It's not always easy to do Christ's work, especially in a world where horrible things happen. We want so badly to proclaim the God of love that we either ignore the agony of others or jump to God's defense, blaming the victim in the process.

But *Superman* movies perform that tremendous act of imagination that C. S. Lewis described. With these films, we imagine a powerful person going around helping other people. It's tempting to say such a person doesn't exist, but then we remember that Jesus has called upon the authority of God to send us out into the world. We can make meaning out of pointless suffering, we can embody the love of Christ for humanity. We can save the day.

CREDITS:

Superman: The Movie (1978)
Director: Richard Donner
Screenwriters: Mario Puzo and David Newman and Leslie Newman and Robert Benton

Superman Returns (2006)
Director: Bryan Singer
Screenwriters: Michael Dougherty and Dan Harris

Man of Steel (2013)

Director: Zack Snyder

Screenwriter: David S. Goyer

Batman v Superman: Dawn of Justice (2016)

Director: Zack Snyder

Screenwriters: Chris Terrio and David S. Goyer

POST-CREDITS:

Theme: Suffering

Key Biblical Passage: Isa 53

Questions:

1. Everyone experiences some kind of suffering. The theologians we read in this chapter help us think about why suffering exists and how we should deal with it, but what do you think? Why does suffering exist? What does the fact of suffering tell us about the nature of God?

2. Both *Superman Returns* and *Man of Steel* have scenes that draw strong analogies between Superman and Christ. In what ways does Superman help us think about Jesus? What are some of the important differences between Superman and Jesus?

3. No one in these movies finds themselves in more trouble than Lois Lane. She's the person Superman rescues the most, but that never deters her from chasing after the story. What can Christians learn from Lois Lane's model? How does her relationship with Superman relate to our relationship to God?

4. This chapter argues that Superman stories are an imaginary response to the fact of suffering. Is imagination a useful tool for dealing with "horrendous evils"? How do imaginary stories help us confront suffering? Or do imaginary stories distract us from the work that needs to be done?

5. Obviously, none of us have Superman's powers, but we do have abilities that allow us to help and serve others. After watching and thinking about these Superman movies, what are some ways that we can look for and help people who are hurting?

3

BATMAN

The Dark Knight's Dark Night of the Soul

Be pleased, O Lord, to deliver me;

O Lord, make haste to help me.

Let all those be put to shame and confusion

who seek to snatch away my life;

let those be turned back and brought to dishonor

who desire my hurt.

—Ps 40:13-14

And why do we fall, Bruce? So we can learn to pick ourselves up.

— THOMAS WAYNE, *BATMAN BEGINS*

WHO IS THE BATMAN?

Sure, he's Bruce Wayne, millionaire playboy, son of the murdered Thomas and Martha Wayne. But what kind of person is Batman?

The answer to that question depends almost entirely on which movie you're watching. If it's Zack Snyder's *Batman v Superman: Dawn of Justice*, then Batman is growling and anti-social. In the serials from 1943 and 1949, Batman is an American superspy. In the 1966 movie, a direct continuation of the TV series that aired from 1966 to 1968, Batman and his eager sidekick Robin are morally upright social servants in a day-glow Gotham. The

Batman of the Tim Burton and Joel Schumacher films of the late eighties and nineties is a black-clad weirdo battling arch-oddities, while the Batman of the Dark Knight Trilogy is largely grounded, battling the mob with borrowed military technology until he can safely retire. In 1993's animated film *Batman: The Mask of the Phantasm*, the hero longs for a better life, while the arrogant jerk of *The Lego Batman Movie* couldn't imagine being anyone less awesome.

As this short list indicates, Batman is a remarkably mutable character. He can be silly or serious, psychologically dense or gleefully two-dimensional.

And yet, no matter how many portrayals he goes through, one thing remains constant about Batman. He is a figure of trauma. In every incarnation, Batman is the direct manifestation of the tragedy experienced by young Bruce Wayne, when his parents were gunned down in front of him. At that moment, Bruce Wayne became the Batman, driven to put on a Batsuit and contend with evildoers in Gotham City. The millionaire playboy persona would forever be a show, a jest to distract from his nocturnal activities.

Because they deal with a character defined by tragedy, Batman movies can help Christians think about our relationship to personal suffering. As we discussed in the previous chapter, theologians have long wrestled to reconcile the idea of an all-powerful, all-benevolent God to the fact of horrendous evils. In Batman movies, that suffering becomes more personal. We see a person who goes through a horrible experience and finds a way to make their pain matter by serving others. By looking at movies about the Dark Knight, we get a glimpse of the experience of the Dark Night of the Soul.

THE BIRTH OF THE BAT

Batman was born in 1939, in response to National Comics' (soon to be renamed DC Comics) search for a superhero who could capitalize on the success of Superman. Illustrator Bob Kane came up with the idea, but his initial sketch barely resembled the hero we now know. Kane's creation wore bright read stockings and a domino mask, with batwings modeled after Leonardo da Vinci's flying man strapped to his back. Drawing inspiration from pulp heroes such as the Shadow and the Spider, as well as Bela Lugosi's Dracula, writer Bill Finger[1] redesigned the character, stripping away all the colorful accoutrements of Kane's drawing, save for a pair of garish purple gloves.

1. Bill Finger is one of the most tragic figures in comics. Although he was responsible for shaping the character we know today, and for creating some of Batman's most important villains and supporting characters, all of the characters are solely credited to Bob Kane. As a result of Kane's maneuvering, Finger died in obscurity, buried in a

Initially, Finger's scripts closely hewed to the pulp model. The Batman who debuted in 1939's *Detective Comics* #27 carried a gun, laughed at criminals' gnarly deaths, and fought to protect the upper class of Gotham City from the indigent.[2]

Fairly soon, however, Finger and Kane lightened up the hero's adventures, first by adding teen sidekick Robin, and then by telling mystery stories, in which Batman's detective skills took precedent over his bloodlust. Finger and artists such as Jerry Robinson filled out his rogue's gallery with complex and colorful baddies such as the Joker, Catwoman, and Two-Face.

Over the years, Batman has been a lone vigilante, part of a mystery-solving duo, a visitor to alien planets, a globetrotting superspy, an urban legend, a comedy figure, a team player, and even an infallible god. And while there are some complaints each time from those who prefer one take on the character over another, each of these versions is always Batman.

A surprising example of this truism can be found in *Batman: The Movie*. The rare feature film before the first wave of superhero movies, *Batman: The Movie* was rushed into production after the first season of the Batman TV series proved to be a smash hit and released in 1966. Adam West stars as a dry, moralistic Batman and Burt Ward plays a spunky Robin, broad depictions that underscored the show's camp approach, complete with brightly colored sets and graphics that punctuated every punch with "biff!" and "pow!"

And yet, as silly as this take is, the series still uses Bruce Wayne as a false identity, put on by Batman to serve his mission. West modulates his acting as Wayne to draw out the villains Riddler (Frank Gorshin), Penguin (Burgess Meredith), and the Joker (Cesar Romero). When the criminals burst into the apartment of Miss Kitka (a disguised Catwoman, played by Leigh Meriwether), Batman drops the smooth, poetry-quoting persona he had been using as Wayne to return to his true, heroic self. "You filthy criminals!" he intones, before taking to fisticuffs against the bad guys.

A later comedy, *The Lego Batman Movie* makes a joke that puts a finer point on the distinction. As Alfred (Ralph Fiennes) drives Batman (Will Arnett) to a social event, he must remind his charge to remove his cape and cowl. The movie cuts to an image of Batman, wearing both his mask and a white tuxedo, crossing his arms in belligerence until Alfred finally convinces him to remove it. With a pop, the cowl comes off and a well-coiffed

pauper's grave. Today, it is widely acknowledged that Kane was merely the spokesperson and copyright holder of Batman, while Bill Finger—and Kane's ghost artists Jerry Robinson and Dick Sprang—shaped the character.

2. Finger and Kane, "Case of the Chemical Syndicate."

'do replaces Bruce's mask-mussed hair, signaling the adoption of his Bruce Wayne identity.

These two examples remind us that every actor who plays Batman must in fact give several performances. There is the Batman role, of course, but there's also the Bruce Wayne role, in which the actor plays Batman pretending to be a millionaire playboy. Every Bruce Wayne portrayal must be, in some way, a feint, because the "real" Bruce Wayne died on the same night that a criminal murdered Thomas and Martha Wayne.

THE FOUNDING TRAUMA

Like most long-running superheroes, Batman has accrued several nicknames, including the World's Greatest Detective and the Caped Crusader. But no nickname encapsulates the character better than "the Dark Knight."

Although there's no evidence to suggest that Bill Finger had it in mind when he first used the phrase in 1940's *Batman* #1, the nickname calls to mind the poem "La noche oscura del alma" or "Dark Night of the Soul," written by sixteenth-century Spanish mystic St. John of the Cross.[3]

In the popular imagination, the dark night of the soul has come to signify an existential crisis. When we think of such an event, we picture a person pacing back in forth in agony, forced to make a decision that will unavoidably change the direction of their life. Readers may be surprised by the tone of the actual poem that inspired the phrase. The story of a soul sneaking out in the cover of darkness to reunite with her true love God, "Dark Night of the Soul" is filled with lines such as,

O night, that guided me!
O night, sweeter than sunrise!
O night, that joined lover with Beloved!
Lover transformed in Beloved![4]

Believe it or not, this romantic language does not contradict the popular notion of an existential crisis. As St. John explains in the two book-length expositions he wrote, the dark night is a period of abnegation, through which the soul loses all the sensory and spiritual impediments between herself and God. From the perspective of the soul who has connected with God, these losses are good, as they bring the soul into the full calling of the beloved. But in the moment, St. John explains, the process is painful. The soul "does not notice the spiritual delight" moving toward God because her "tastes are

3. Finger and Kane, *Batman* #1.
4. St. John of the Cross, *Dark Night of the Soul*, 27.

accustomed to those old sensory pleasures, and she remains on the lookout for them."[5]

In other words, the dark night of the soul is a process of transformation, a painful moment as all that once defined the person falls away, and they are brought into a new calling. The poem helps us see that personal suffering is not meaningless, but rather a process of becoming.

This idea of a painful process of transformation makes the Dark Knight such an apropos name for Batman. More than any other character in popular culture, Batman embodies the dark night of the soul, a night that began when Thomas and Martha Wayne were murdered in front of their young son Bruce. From that point on, Bruce experienced a process of becoming, one that begins by stripping away everything from his identity that wasn't Batman.

For that reason, nearly every portrayal of Batman on film has included a scene of the Wayne's murder.[6] More so than other heroes' founding traumas, such as the destruction of Superman's home planet Krypton or the murder of Spider-Man's Uncle Ben, the Waynes' murders is reimagined and revisited to set the tone for each interpretation of Batman.

Take for example, the Batman played by Ben Affleck in *Batman v Superman: The Dawn of Justice*. This older and bitter Batman has a despairing outlook, which leads him to go to war against Superman.

Batman v Superman sets the stage for this take on the character in the film's opening scene. "There was a time above, a time before," growls Batman in voice-over, accompanied by overhead shots of two caskets being carried to a sarcophagus. "How things fall, things on Earth, and what falls is fallen," Bruce continues, as the film flashes back to the Waynes exiting a theater. "In the dream, they took me to the light. A beautiful lie."

Following the tone of the narration, Snyder puts weight on every aspect of the Waynes' fateful night. The camera holds close on each smiling face of the Wayne family before dissolving to black, engulfing their joy in darkness. The murderer here is less a person than an indefinable force, first moving into the frame almost in silhouette, and then appearing in the next shots as nothing more than a gun attached to a hand. The film lingers on the carnage, with slow motion shots of bullets hitting the ground and another

5. St. John of the Cross, *Dark Night of the Soul*, 63.

6. Of all the film adaptations, only *Batman: The Movie* altogether ignores the Wayne's murder. *The Lego Batman Movie* alludes to the murder with a photograph of the Wayne family standing in front of Crime Alley, the street where the killing took place. The animated comedy *Teen Titans Go! To the Movies*, which stars the sidekick Robin as a main character, features a set-piece that makes wry reference to the Wayne murders, even foregrounding Martha Wayne's pearl necklace.

of the gun getting wrapped in Martha's pearl necklace. The pearls explode toward the screen in slow motion as the gun fires, and then fall like snow around Martha's dead body.

Snyder intercuts the sequence with scenes of young Bruce running away from the funeral and falling into an empty well. Bats swarm him at the bottom of the well, lifting Bruce up toward the light with an almost religious ecstasy.

By languishing in the violence and in Bruce's bat-ascension, Snyder's version of the Wayne murders is straightforward. His Batman is born in a world where joy and safety are fleeting, ready at any moment to be torn away by a dark mass of evil. He fights for good not because he believes good can win, but because his loss has no meaning without it.

This Batman never leaves the dark night of the soul. He remains constantly struggling in the darkness, perpetually suffering the loss of his parents. But other takes on Batman have offered quite a different vision.

In these versions, the dark night of the soul is not necessarily perpetual, nor a means to itself. As Glen Weldon observes in his book *The Caped Crusade*, "Batman's status as a creature born of ongoing serialized narrative makes him essentially a bold, open-ended, simple idea: a guy who wants to prevent what happened to him from happening to anyone else." For that reason, the best Batman stories don't look at the character's suffering as merely personal, but as the place where the personal meets the global. "For Batman to work," Weldon contends, "his mission must be larger than the act, and the criminal, who set him on it."[7]

In the stories that understand this fact, Batman shows ways of dealing with the dark night of the soul. None of them erase the pain or suffering, but they do give it meaning by connecting personal tragedy to greater good. For Christians, Batman stories remind us of God's salvation, even in the darkest night.

BRUCE WAYNE, THE HOLY FOOL

Early in *Batman* (1989), photographer Vicki Vale (Kim Basinger) weaves her way through a charity fundraiser at stately Wayne Manor. She recognizes many of the Gotham dignitaries in attendance, including Commissioner Gordon (Pat Hingle) and District Attorney Harvey Dent (Billy Dee Williams). But she cannot find the host, millionaire playboy Bruce Wayne.

"Excuse me," she asks, tapping the shoulder of a nondescript man in a tuxedo. "Could you tell me which of these guys is Bruce Wayne?"

7. Weldon, *Caped Crusade*, 210.

We viewers recognize the man who turns around as Wayne himself, played with nervous energy by Michael Keaton. "Well, I'm not sure," he mutters, and watches as Vale walks off.

That's hardly the only strange thing Bruce Wayne does in the film, from observing party guests via his mansion's surveillance system to walking through a killing spree on the steps of city hall to face the Joker (Jack Nicholson).

But Wayne's dodge is not exactly a lie. Throughout the four Batman movies of the eighties and nineties—the Tim Burton-directed *Batman* and *Batman Returns*, and the Joel Schumacher-directed sequels *Batman Forever* and *Batman and Robin*—Bruce Wayne is least himself when he's Bruce Wayne. Even when Schumacher replaces the diminutive comedian Keaton with more conventional movie stars Val Kilmer and George Clooney in the lead role, the Bruce Wayne of these films is the consummate outsider, never comfortable until he's back in his Bat-costume.

A key scene between Vicki and Wayne emphasizes that point. After numerous blown dates and inexplicable reactions, Wayne visits Vicki to tell the truth. Calling upon his well-honed comedy chops, Keaton plays the scene like a nervous suitor in a romantic comedy. He enters Vicki's apartment with a rose in hand, ignoring her obvious frustration as he makes ineffective small talk.

The scene shifts when Wayne snaps, "Shut up." Prioritizing Vicki's perspective, the camera looks up at Wayne as he stumbles over his words. Rocking on his heels and waving his hands, looking increasingly uncomfortable in his three-piece suit, Wayne contrasts himself to a normal person. But since his idea of a normal person is someone who "gets up, and goes downstairs, and eats breakfast, and kisses somebody goodbye, and goes to a job," it's clear that Wayne doesn't really know much about normal lives.

Try as he might, nothing Wayne says answers Vicki's primary charge. She's not mad about his constant disappearances or his attempts to avoid her. She's upset because she doesn't know who he is.

She doesn't know who he is because she cannot reconcile the Bruce Wayne before her, a handsome and nicely dressed man who runs a business and holds society parties, with the weirdo who inexplicably lies about his identity.

Most people share Vicki's frustration, the viewers included. Bruce Wayne does not act like a normal person. But we viewers know something that Vicki has to learn through investigation: Bruce Wayne suffered severe childhood trauma.

Burton portrays that trauma in a stylized flashback, beginning with a worm's-eye view of the Waynes and young Bruce walking out of a theater,

smiles across their faces. Haunting ambient music mixes with Danny Elf-man's yearning score, communicating the sadness Wayne feels as he re-members. Characters move in slight slow motion and the footsteps of the men following the Waynes echo loudly. All but the sound of howling wind drops out of the soundtrack as everything stops in the moments before the Waynes are attacked, as if Bruce is trying to hold onto his parents for just a second longer. The actual shooting occurs quickly, and the scene ends with young Bruce, his face half obscured in shadow, looking off at the men who killed his parents.

At the end of the flashback, Burton cuts to a closeup of adult Wayne, sitting alone in his Batcave, dressed in black. Although the cut serves a plot function, as Wayne realizes that his parents' killer would later become the Joker, it also has thematic import.[8] The boy in shadow has grown up to be Batman, a man who lives in the shadows.

In the eyes of most people, Bruce Wayne is a fool. His unusual behav-ior marks him as someone who doesn't belong in society, despite having the name of one of Gotham's most prestigious families. But it's that inability to belong that makes Batman the only person who can save the city from the villains who assail it. His outsider status is the key to Gotham's salvation.

When going through the dark night of the soul, one necessarily be-comes a type of outsider. In the early parts of the night, "the soul is stripped of senses and accommodated to pure spirit."[9] That stripping away of senses involves the rejection of all comforts, everything that the spirit once con-sidered clear and comprehensible. As a result, a person in the dark night becomes strange, alienated from the life they once lived.

The Russian Orthodox church has a term to describe Christians whose faith makes them outsiders in society: holy fools. Holy fools embody Paul's teaching that "the message about the cross is foolishness to those who are perishing, but to us who are being saved it is the power of God." Further-more, God chose "what is foolish in the world to shame the wise; God chose what is weak in the world to shame the strong; God chose what is low and despised in the world, things that are not, to reduce to nothing things that are, so that no one might boast in the presence of God" (1 Cor 1:18, 27–29).

According to Priscilla Hunt, holy fools embody this teaching by acting "irrational and dangerous" in the "eyes of the world," to provoke response and repentance on the part of the audience. Hunt contends that the holy fool "assumes a guise of madness in order to be persecuted or misunderstood." When the fool "humbles his own pride and exposes the pride of those who

8. British character actor Hugo Blick plays younger Joker in the flashback.

9. St. John of the Cross, *Dark Night of the Soul*, 58.

subject him to rebuke," the fool creates "a provocative scenario aimed at opening [others'] eyes to spiritual Truth."[10] To be a holy fool is not to be merely eccentric, but to defy the norms of society for the good of others.

That's literally what happens in every Batman film. By making himself into a freak of the night, Batman can draw attention to the inhumane machinations of the Joker and other villains. But crucially, he can embody this foolishness only with tragedy. He must go through the dark night that began with his parents' death to become divorced from normality enough to be Batman.

FALLING DOWN TO GET BACK UP

By the time we hit the midway point of *The Dark Knight*, Batman has lost. The second film in the Dark Knight trilogy from director Christopher Nolan, *The Dark Knight* finds Bruce Wayne (Christian Bale) on the precipice of getting everything he wanted. New District Attorney Harvey Dent (Aaron Eckhart) promised to be the "White Knight" he could never be, someone willing and able to take down the Gotham mob without an outlandish costume. With his Batman persona behind him, Bruce finally had the opportunity to marry Rachael Dawes (Maggie Gyllenhaal), the love of his life. Even maniacal new villain the Joker (Heath Ledger) was in police custody, thanks to a complex operation that involved Commissioner Gordon (Gary Oldman) faking his death. For a moment, Bruce Wayne finally saw a way toward a new identity, out of the life that was decided for him the night his parents were killed.

But the capture turned out to be part the Joker's plan to sow chaos in Gotham. With the help of some corrupt cops, the severely mentally ill, and a great deal of planning, Joker managed to turn his arrest into his crowning victory. By the end of the evening, he not only escapes, but also destroys Gotham's police department, kills an informant (thereby securing himself a great deal of money from the mob), murders Rachael, and badly scars Dent.

At the end of a sequence showing the primary characters reeling from the events, Wayne's butler Alfred (Michael Caine) tries to console his charge. Nolan bathes the scene in blue light and his camera slowly pushes in from a low angle, as if we the audience are catching a glimpse of something we should not see.

That unseeable thing is Batman, slumped in a chair, his mask and gloves dropped carelessly to the floor. Gone is the determination in Bruce's eye, the steely resolve that allowed him to transform into Batman, as is the

10. Hunt, "Holy Foolishness as Key," 3–4.

glint of hope he had when Harvey Dent spoke. In its place, an empty stare, an unblinking gaze Bruce casts out onto the city he fights so hard to preserve.

The scene may be among the most potent in the trilogy, but it is hardly rare. Each of the three films directed by Christopher Nolan follow a similar structure, with Batman daring to hope, only to have that opportunity stripped away and forced to persevere again. But unlike the episodic nature of most superhero stories, in which the hero only temporarily saves the day until a new villain arrives, the Dark Knight trilogy tells a complete story. It starts with the death of Bruce Wayne's parents and the establishment of the Batman persona in *Batman Begins*, continues with Batman forced to become an outlaw after any other hope for Gotham is destroyed by the Joker in *The Dark Knight*, and ends with Batman coming out of retirement and making the ultimate sacrifice in *The Dark Knight Rises*.

With its dour tone, the *Dark Knight* trilogy reminds us that the dark night of the soul hurts. The soul who speaks of the "exquisite risk" of the night that "joined lover with beloved" does so from the state of "perfection," St. John tells us.[11] Having "attained absolute union in love with God," she can now recognize the value of the "intense tribulations" she endured.[12]But until then, those tribulations continue to sting.

As with the other Batman films, the dark night of the soul begins with the death of Thomas and Martha Wayne, depicted in *Batman Begins*. While Martha (Sara Stewart) is as underwritten as ever, Nolan and co-writer David S. Goyer devote a surprising amount of attention to Thomas. Played with warmth by Linus Roache, Thomas is a kindly doctor who spends his time serving the underprivileged of Gotham at his clinic and using the old money he inherited to support enhancement projects, such as a train system running through the city.

Accordingly, Nolan version of the Wayne's death scene emphasizes his father's calm and empathetic demeanor. Walking his family home from the opera, Bruce (played as a child by Gus Lewis) and his parents are accosted by the criminal Joe Chill (Richard Brake). Fast cuts from the Waynes to Chill emphasize the robber's twitchy behavior, underscored by a string sting in the soundtrack. Conversely, Thomas remains calm, softly saying, "That's fine, take it easy." The camera cuts between several aspects of the scene, including closeups on Bruce burying his face into his mother's side and on Chill's shaking gun. But every time it returns to Thomas, the low angle shot finds him unhurried. Even after the Waynes are shot, an event related with

11. St. John of the Cross, *Dark Night of the Soul*, 24.
12. St. John of the Cross, *Dark Night of the Soul*, 28.

frantic and disorienting cinematography, Thomas looks up at his son to tell him, "Don't be afraid."

To be sure, the death of the Waynes in *Batman Begins* is tragic. But Nolan shows us how Thomas has prepared his son for the inevitability of such horrors. The death scene comes at the end of a flashback involving Bruce's first interaction with bats. While playing on the grounds at Wayne Manor, Bruce falls into a well, connected to a cave. Throughout the sequence, the camera takes the perspective of Bruce at the bottom of the well. Looking up, Bruce sees the top of the well as a distant circle of light, far from the darkness that envelops him.

The first time Bruce looks up from the well, he sees young Rachael (Emma Lockhart), his playmate on the grounds, looking down on him and then disappearing. Although we viewers know that she's gone to get help, the camera sees only emptiness at the top. Bruce feels alone, abandoned.

The second time Bruce raises his head, he's surrounded by a swarm of bats, who have flown out from a cave next to the well. In this shot, the light at the top is completely obscured as bats drown out any sign of escape.

But the third time, Bruce looks up to see his father, lowering down to retrieve him. Instead of holding steady at the well's opening, an impossible point of escape, the camera follows Thomas as he grows closer. Even though the well is darker at the bottom, Thomas's face illuminates as he makes his way toward Bruce. As Thomas reassures his son, "You'll be okay," the camera cuts to a close-up of Bruce's hand grasped by his father, the light bright upon them.

As the scene ends, Thomas carries Bruce back inside Wayne Manor, with Alfred on his side. While James Newton Howard's score shifts to gentle strings, Alfred asks, "Took quite a fall, didn't we Master Bruce?" But Thomas does not follow the butler's sympathetic line, turning instead to a life lesson that will prove to be important.

"And why do we fall, Bruce?" he asks, not expecting an answer. "So we can learn to pick ourselves up."

This idea that falling is part of the process of getting back up becomes a defining element of the Dark Knight trilogy Sometimes, the scene is expressly referenced, as when Bruce's first outing as Batman in *Batman Begins* ends with him beaten and drugged with fear gas after an encounter with the Scarecrow (Cillian Murphy). Mirroring the scenes of young Bruce, Nolan cuts from a shot of Batman, in full costume, looking up toward the sky, to that of Thomas, lowering himself back into the well. Sometimes, it is only implied, as in the aforementioned defeat scene from *The Dark Knight*, when Alfred encourages Bruce to endure the suffering that he currently experiences.

The strongest echo of Thomas's words occurs in *The Dark Knight Rises*. Set several years after *The Dark Knight*, when Batman has retired and Bruce Wayne has become a recluse, *The Dark Knight Rises* finds the hero called back into service when Gotham is under attack by the brutal mastermind Bane (Tom Hardy).

Out of practice and betrayed by Catwoman (Anne Hathaway), Batman is handily defeated by Bane. Bane throws the broken Batman into an ancient prison, where he constantly hears news about the conquest of Gotham. Fashioned as a giant pit, with an opening at the top, the prison operates as the worst type of torture. "There's a reason why this prison is the worst hell on Earth," Bane explains. "Hope." The opening at the top of the prison tantalizes prisoners, making them believe that if they just worked hard enough, if they just struggled enough, they could make their way out. "I learned here that there can be no true despair without hope," insists Bane.

Bale plays the broken Batman writhing in pain, barely able to speak, suggesting little hope. But as the camera moves under the hole to peer at the light gleaming from the top, we viewers feel a sense of recognition. The pit is just one more well into which Bruce has fallen. And as his father has taught him, we fall to pick ourselves back up.

The process of falling and getting back up matters a great deal to St. John of the Cross. After the soul has gone through the first dark night, the night of sense, that teaches her to let go of sensory things, she enters the night of spirit. In the night of spirit, God purges from the soul the spiritual limitations that have kept her from God.

Because of the intensity of this purging, God will sometimes temporarily allow the night to relent, like a "blacksmith who pauses in his labor to withdraw the iron from the forge and examine the craftsmanship."[13] During that time, the soul might think that the night has ended, that she has reached communion with God. However, impediments still exist, so God must recommence the night, "in yet a deeper degree of darkness, more severe and wrenching than ever before." Although the soul may fear that "this second degree of anguish will [never] lift," the soul can retain hope as long as she focuses on the call of God through the night.[14]

Some viewers cannot sanction the sequence in which Bruce Wayne heals his back by doing pushups and escapes from the pit, dismissing it as an unforgivable leap for a superhero series that considers itself relatively grounded. Regardless of its realism, Wayne's escape carries thematic weight. The first time Wayne attempts to climb out of the pit, he fails. His body

13. St. John of the Cross, *Dark Night of the Soul*, 116.
14. St. John of the Cross, *Dark Night of the Soul*, 111.

dangles from a rope and covers the light from the opening. As he's lowered back down, he grows darker, descending into blackness.

The second time Wayne attempts the climb, the camera gives us only glimpses of the light at the top. The frenetic editing snaps around Wayne, as his grunts mingle with prisoners chanting "Rise" and energetic strings on Hans Zimmer's score. When he falls, which happens almost immediately, the camera rests on his hanging body, a mere silhouette against the light above.

With the sound of a bat's wings pushed into the soundtrack, a match cut replaces Wayne's dangling body with that of Thomas Wayne, coming into the light as he's lowered to rescue his son. A quick insert shot of Thomas's hand covering that of young Bruce is paired with the father softly asking, "Bruce, why do we fall?"

When Wayne awakens, he's ready to answer his father's question. Convinced by a fellow prisoner that the only way to escape the prison is to fear death, to climb without a rope, Wayne attempts a third time. Again, the camera begins in darkness, panning up toward the light. But instead of going straight toward the hole at the top, the camera follows Wayne as he ascends, slowly moving over to reveal the light as he grows closer. As he approaches the final jump, the space where he had failed twice before, a swarm of bats fly from a hole and the Zimmer's majestic theme fills the soundtrack.

Watching Wayne ascend, Christian viewers may recall verses from Ps 40:

> He drew me up from the desolate pit,
> out of the miry bog,
> and set my feet upon a rock,
> making my steps secure. (Ps 40:2)

A song of deliverance, Ps 40 praises God as a deliverer, a deity who hears the cry of the downtrodden and brings salvation. For the first half of the psalm, it sounds like the speaker has already been saved, that they have survived their dark night and are recalling their tribulations.

In verse 11, the tense changes, suggesting an ongoing tumult. The psalmist now prays,

> But may all who seek you
> rejoice and be glad in you;
> may those who love your salvation
> say continually, "Great is the Lord!"
> As for me, I am poor and needy,
> but the Lord takes thought for me.
> You are my help and my deliverer;

do not delay, O my God. (Ps 40:16–17)

As these last lines reveal, the psalmist has not yet been delivered. Yet despite still languishing in the pit, the psalmist knows who God is. God has pulled the psalmist from the pit before and will surely do so again.

Such depth of faith does not come from a sunny optimist, but from someone who has endured a dark night and is enduring again, someone who has fallen and knows that they will be lifted up once more.

REDEEMING THE PAST

I lost myself. Forgot myself.
I lay my face against the Beloved's face.
Everything fell away and I left myself behind,
Abandoning my cares
Among the lilies, forgotten.[15]

The final stanza of "Dark Night of the Soul" underscores the contentment the soul feels, having made it through the abnegation and found rest in God. But despite the beauty of the language and the strength of St. John's analysis, these words do not properly capture the fear and bewilderment we experience when going through the night.

With their operatic themes and portrayals of a person trying to transform their trauma into good works, Batman films capture the experience in striking fashion. The purest example of this quality may be the 1993 animated movie *Batman: Mask of the Phantasm*. Directed by Eric Radomski and Bruce Timm, *Mask of the Phantasm* carries over the creative team from the critically and commercially successful *Batman: The Animated Series* television show, including Kevin Conroy as Batman and Mark Hamill as the Joker. The theatrically released movie tells a standalone story in which socialite Andrea Beaumont (Dana Delany) returns to Gotham, years after she broke off her engagement with Bruce Wayne.

In between investigating a series of mob killings by a new supervillain called the Phantasm, Bruce reminisces about a pivotal moment in his early life. His romance with Andrea coincided with the beginning of his career as Batman, putting two possible paths before him. These possibilities filled Bruce with anguish, caught between the vow he made in memory of his parents and the possibility of a "normal" life with Andrea. When he can take no more, Bruce visits his parents' grave to make a confession.

15. St. John of the Cross, *Dark Night of the Soul*, 25.

Digging deep into the character's gothic origins, the scene begins with lightning flashing behind a weathered tree. Over an insert shot of rain falling on muddy ground, we hear Wayne speaking to his parents' grave. "It doesn't mean I don't care anymore," Wayne pleads over the thunder and rain. "I don't want to let you down, honest, but . . . but it just doesn't hurt so bad anymore." Cutting to a shot looking down on Wayne from behind the gravestones, accentuating the immense weight of expectation that he feels, we watch as Wayne rationalizes his choice, promising to give money to civic projects. Thomas and Martha do not answer their son, but with an organ sting, the movie cuts to a shot of the gravestone, the name briefly illuminated by a crack of lightning.

"Please! I need it to be different now," begs Wayne as he drops to his knees and buries his head against the gravestone. "I didn't count on being happy," he admits.

In that moment, Wayne sees a way out of his dark night. He could marry Andrea, another Gotham heiress, and resume the life he had before his parents' death, the life he thought he earned.

But such happiness was never meant to be. Because of her father's connections to the mob, Andrea suddenly breaks off her relationship with Wayne and goes into hiding, never speaking to him until she returns to Gotham to punish her father's killers as the Phantasm.

To some, *Mask of the Phantasm* puts Batman in a bleak and hopeless world, not unlike the nihilism Zack Snyder would bring to the character decades later in *Batman v Superman*. But I contend that *Mask of the Phantasm* shows Wayne's ability to find meaning in the dark night, meaning made through memory.

In his book *The End of Memory*, theologian Miroslav Volf explores the relationship between identity and memory. Acknowledging that memories, especially those of past injustices and traumas can shape us, Volf also argues that "we ourselves shape the memories that shape us."[16] To do justice to those memories and to find healing, we must be faithful to those memories. This faithfulness involves not only remembering rightly—doing our best to be accurate in recalling the facts of the past event—but also in properly interpreting those events.

According to Volf,

> healing will come about not simply by *remembering* but also by viewing the remembered experiences in a new light. Put more generally, the memory of suffering is a prerequisite for personal healing but not a means of healing itself. The means of healing

16. Volf, *End of Memory*, 41.

is the interpretive work a person does with memory. So salvation as personal healing must involve remembering, but mere remembering does not automatically ensure personal healing.[17]

For Christians, Volf argues, this interpretation involves understanding past events on the horizon of Christ's forgiveness and conquest over death. "Learning to remember well is one key to redeeming the past," he writes, "and the redemption of the past is itself nestled in the broader story of God's restoring of our broken world to wholeness—a restoration that includes the past, present, and future."[18]

> That restoration means that the past need not be a dead-end, our sole defining trait. Rather, we can interpret past traumas through the light of God's goodness, as a tool to do Christ's work on Earth: showing solidarity with victims, seeking justice, and giving grace.

Although it uses the action vernacular of superhero stories, we see a similar interpretation of the past in *Mask of the Phantasm*. Bruce Wayne does not die with his parents. Rather, their death serves as an event that calls for a new identity, that of Batman. But in his works as Batman, Wayne interprets his past as an opportunity to see injustice and to devote himself to making things right for others.

As Glen Weldon puts it, the oath that Batman makes to his parents is "a *choice* . . . an act of will," which give "his life purpose and launch him into an existence entirely devoted to protecting others from the fate that befell him." Rather than a figure of darkness, Weldon sees Batman as "a creature not of rage but of hope," devoted to the "simple, implacably optimistic notion *Never again*."[19]

Wayne still suffers because of his parents' death. He's still a dark knight in the dark night. But rather than languish in that suffering, Batman seeks new ways of doing good, of helping others.

From a personal tragedy, Batman finds salvation, not just for himself, but for the world.

17. Volf, *End of Memory*, 44.
18. Volf, *End of Memory*, 60.
19. Weldon, *Caped Crusade*, 29. Italics original.

CREDITS:

Batman: The Movie (1966)
Director: Leslie H. Martinson
Screenwriter: Lorenzo Semple Jr.

Batman (1989)
Director: Tim Burton
Screenwriters: Sam Hamm and Warren Skaaren

Batman: Mask of the Phantasm (1993)
Directors: Eric Radomski and Bruce W. Timm
Screenwriters: Alan Burnett and Paul Dini and Martin Pasko and Michael
Reaves

Batman Begins (2005)
Director: Christopher Nolan
Screenwriters: Christopher Nolan and David S. Goyer

The Dark Knight (2008)
Director: Christopher Nolan
Screenwriters: Jonathan Nolan and Christopher Nolan

The Dark Knight Rises (2012)
Director: Christopher Nolan
Screenwriters: Jonathan Nolan and Christopher Nolan

Batman v Superman: Dawn of Justice (2016)
Director: Zack Snyder
Screenwriters: Chris Terrio and David S. Goyer

The Lego Batman Movie (2017)
Director: Chris McKay
Screenwriters: Seth Grahame-Smith and Chris McKenna and Erik
Sommers and Jared Stern and John Whittington

POST-CREDITS

Theme: Trauma

Key Biblical Passage: Ps 40

Questions:

1. According to St. John of the Cross, the dark night of the soul can last a long time and take many forms. We see that in the variety of Batman movies, which sometimes imagine the hero as a dark avenger and sometimes as an optimistic do-gooder. What does the dark night of the soul look like to you? How do you respond to it?

2. Some interpretations of Batman imagine the character as inherently broken, never able to find peace. Others portray him as giving meaning to tragedy by caring for others and becoming a hero. Why is it so hard to get over past traumas? Can any good come from trauma?

3. When reading St. John of the Cross, it can be tempting to glorify suffering as a good unto itself. Worse, it can be tempting to negate the reality of our very human disappointment, anguish, and unhappiness. Batman movies repeatedly remind us that Bruce Wayne was hurt by his parents' death, and that hurt matters. How can Christians honor the reality of hurt while still remaining focused on seeking God through our suffering?

4. In the Dark Knight trilogy, Thomas Wayne tells his son that we fall down to pick ourselves back up. But Bruce never picks himself up. Instead, he's lifted back up through the aid of those who love him, whether it be Alfred, Lucius Fox (Morgan Freeman), or Thomas himself. How can scenes of people helping one another inspire us as Christians?

5. Miroslov Volf argues that we must remember rightly and through the lens of Christ's redemption. Where do in these movies do we see Bruce Wayne remembering his past rightly? What lessons do these scenes have for Christians?

4

SPIDER-MAN

Great Power, Great Responsibility, and the Great Commission

But the Lord said to Samuel, "Do not look on his appearance or on the height of his stature, because I have rejected him; for the Lord does not see as mortals see; they look on the outward appearance, but the Lord looks on the heart."

—1 SAM 16:7

Anyone can wear the mask. You can wear the mask. If you didn't know that before, I hope you do now. 'Cuz I'm Spider-Man.

— MILES MORALES, *SPIDER-MAN: INTO THE SPIDER-VERSE*

AT THE END OF *Spider-Man: No Way Home*, Peter Parker steps into his dingy New York apartment. Peter has no girlfriend, no job, and not much more to his name than the hand-stitched Spider-Man costume on his back.

To anyone who's read a Spider-Man comic, this is the wall-crawler's status quo. Since his first appearance in *Amazing Fantasy* #15 from 1962, Spider-Man has been the everyman hero, the guy whose attempts to balance super-powers, work life, and personal responsibilities are constantly knee-capped by "the ol' Parker luck."[1]

1. Lee, "Spider-Man!"

But that hasn't really been the case for the MCU version of Spider-Man. Played by Tom Holland, this Spidey began his career in *Captain America: Civil War* as one of Iron Man's recruits against Captain America and his team. Since then, the MCU Spider-Man has been largely the charge of Tony Stark, benefiting from privileges of having a technological genius/millionaire at your back. This Spider-Man has never been broke, wears hi-tech suits made of nanobots, and has never suffered a significant familial loss.

That is, until *No Way Home*. In that film, Peter accidentally disrupts a spell from Doctor Strange (Benedict Cumberbatch), resulting in supervillains from other universes being pulled into his reality. These villains include Doctor Octopus (Alfred Molina), the Green Goblin (William Dafoe), and the Sandman (Thomas Hayden Church), all of whom battled Tobey Maguire's Spider-Man in the three films directed by Sam Raimi. Along with them comes the Lizard (Rhys Ifans) and Electro (Jaime Foxx), antagonists in the two Marc Webb Spider-Man movies starring Andrew Garfield.

In those previous movies, the villains died fighting Spider-Man, which means that returning them to their home dimensions is to abandon them to death. Peter cannot do that, so he instead concocts a plan to cure each of the villains, restoring them to their best selves and giving them a chance to live.

Of course, it goes sideways. Peter manages to cure Doc Ock, but the Green Goblin gets away, causing an explosion that mortally wounds Peter's Aunt May (Marisa Tomei). As she dies, Peter curses himself for trying to save the villains instead of just sending them back to their own universes, where they can be someone else's problem.

"It's not my responsibility, May," spits a disgruntled Peter.

But May will have none of it. Lying in the ruins of a luxury condo, the scraps of Stark machinery behind her, May says the words that signal the close of Peter's life as a happy-go-lucky kid with a billionaire benefactor.

"You have a gift. You have a power," she declares, using up the last bits of her strength. "And with great power, there must also come great responsibility."

As May dies, she leaves with Peter the lesson every Spider-Man must learn, no matter which universe they come from.

AN AMAZING FANTASY

Spider-Man's consistently bad luck is a key part of his appeal. As we've already seen, Superman and Batman inspired many copycat heroes throughout the golden age of comic books. Hundreds of characters who followed

were either godlike creatures with amazing powers or human beings who worked hard to achieve physical or technological excellence.

But with Spider-Man, Marvel Comics introduced a new paradigm for superheroes, one about a regular person in over their head. Peter Parker has no millionaire inheritance, no fortress of solitude with otherworldly gizmos. He simply has his powers, his smarts, and his indefatigable sense of responsibility, all of which make more problems than they fix.

That approach has made Spider-Man the single most popular superhero of all time, a point proven in part by *Spider-Man: No Way Home*, which (at the time of this writing) is the sixth-highest grossing movie ever, despite being released during the COVID-19 pandemic.[2]

But he didn't start out that way. When he first swung into action in 1962, no one had much hope for his success. As with many of the early comic book heroes, several people can credibly argue that they invented Spider-Man. The artists Jack Kirby and Steve Ditko have the strongest claims, with the former pushing to Marvel to commission a bug-themed hero and the latter designing the costume and giving the comic book series its distinctive look. Over the years, Stan Lee offered several different explanations for the character's origin, but most of them begin with Marvel publisher Martin Goodman urging Lee to come up with more superheroes after the success of the Fantastic Four and the Incredible Hulk.

With those earlier books, Lee and Kirby had already given the world superheroes who didn't like being superheroes, whether it be the orange rock monster the Thing of the Fantastic Four or the Doctor Jekyll and Mister Hyde hero the Hulk. Peter Parker continued in that vein, a put-upon nerd whose superpowers make his life more difficult. He can't balance a job, school, and his superhero responsibilities, and the one time he decided to use his powers to earn money, he inadvertently allowed his Uncle Ben to be murdered. He's the subject of scrutiny by media mogul J. Jonah Jamison and police officers, all of whom consider him a menace. And even sweet Aunt May thinks Spidey does more harm than good, not aware that she's talking about her beloved nephew.

And yet, despite it all, Spider-Man keeps doing the right thing, holding to his responsibility, no matter the cost. Thanks to that formula, Spider-Man got immediately got his own comic book with *Amazing Spider-Man* #1 in 1962, a book that has continued to be released in one form or another up until this day.[3] In fact, Marvel regularly publishes anywhere from four to six

2. Boxofficemojo.com.

3. Lee, *Amazing Spider-Man* #1 (1963).

Spider-Man comic books each month, to say nothing of the regular guest appearances he makes in other comics.

With such a strong fan base, it's no surprise that Spider-Man has appeared in so many other media. Like most Marvel characters before the 2000s, Spider-Man's most consistent non-comic book appearances happened in cartoons, first in the cheaply made animated series in the 1960s and 1980s, and finally well-received animated series that have continued to run non-stop since 1994.

Initially, Spider-Man had far less success in live action. A silent version of the wall-crawler played by dancer Danny Seagren starred in "Spidey Super Stories," comedic shorts aired on the educational children's program *The Electric Company* (1971 to 1977). The character scored marginal success with the live-action series *The Amazing Spider-Man*, which ran on CBS from 1977 to 1979. Starring Nicholas Hammond as Peter Parker, the series suffered from restrictive budgets, which produced unconvincing effects. Only thirteen episodes made it to air, with several episodes being repackaged as feature films to be shown overseas.

Despite these shortcomings and a few disastrous near-misses, including a potential R-rated movie from mega-director James Cameron (*Avatar*, *Titanic*), Spider-Man eventually made it to the big screen in 2002. Since then, eight more Spider-Man solo films have premiered, along with the web-head making appearances in other MCU entries.

As this run-down demonstrates, Spider-Man is the ultimate underdog hero. Whether he's Peter Parker or Miles Morales, whether he's portrayed by Tom Holland or Tobey Maguire, Spider-Man is always an under-estimated little guy, the guy who doesn't have a perfect life and doesn't always make the best decisions. And yet, in every incarnation, Spider-Man remains focused on doing good. He always tries to live up to Uncle Ben's lesson, "With great power comes great responsibility."

NOTICING THE UNNOTICED

With their stories about the overlooked and rejected doing great things, *Spider-Man* films perhaps best embody the Bible's love for the powerless and humble.

The most famous example of such a character is David, the shepherd boy turned king. As recorded in 1 Samuel, David rose from Jesse's forgettable son to the slayer of the Philistine champion Goliath to the one who deposed King Saul, a handsome man who "stood head and shoulders above everyone else" (1 Sam 9:2). By raising a shepherd to king, God demonstrated a refusal

to look "on the outward appearance" valued by earthly systems of power (1 Sam 16:7). When David rejected that ethos and embraced his kingly power, he committed his most heinous sin by raping Bathsheba and murdering Uriah (2 Sam 11–12).

David is hardly the Bible's only such character. Hebrew Scriptures make heroes out of the sex worker Rahab (Josh 2) and the servant girl Esther. God chooses an elderly childless couple to be the founders of the Hebrews, gives a duplicitous cheat the name Israel, and repeatedly tasks everyday people with speaking the truth to kings. God even allows the abused handmaiden Hagar call God "El Ro'I" or "God of Seeing" (Gen 16:13), thus holding the distinction of "the only person in the canon to give God a name."[4]

God's preference for the rejected is illustrated in the incarnation, in which God took human form as a poor Hebrew, "a people acquainted with persecution and suffering,"[5] living in Palestine occupied by the mighty Roman Empire. By his very presence as the incarnate God, Jesus revealed God's kingdom where "the last will be first, and the first will be last," where the poor and the meek and the persecuted are "blessed" by God (Matt 20:16; see also Matt 5).

God's vision of power runs contrary to not to just the Roman Empire, but all human forms of power. From Babylon to the United States, humans associate power with the ability to defeat others, to best them in every conceivable competition, whether that be the accumulation of wealth or raw physical prowess. But God favors those who care for all of creation, no matter their social class.

Kat Armas sees this fact at work in the actions of the midwives described in Exod 1, who resist the Pharaoh's commands to kill all Hebrew children. "Ironically, while Pharaoh thinks men pose a threat to his power, he overlooks the real threat: God is using the women to set the scene of liberation," she writes.[6] Indeed, the very fact of their status gives them the ability to do their work, right under the Pharaoh's haughty nose. Says Armas, "I've found that God often works this way: shaming power by using those least expected, those whom the world might deem weak or insignificant."[7]

By the nature of their narrative structure, superhero stories always run the risk of praising power, tying goodness to the person with the most muscles and abilities. Spider-Man complicates this narrative. While Spider-Man certainly has great powers, they make his life more complicated.

4. Gafney, *Womanist Midrash*, 43.

5. Thurman, *Jesus and the Disinherited*, 12.

6. Armas, *Abuelita Faith*, 59.

7. Armas, *Abuelita Faith*, 60.

Although he can do anything a spider can, Spider-Man rarely over-powers his enemies In fact, it's his powers that keep him trapped in obligations, as Christopher Robichaud's utilitarian reading of *Spider-Man 2* finds. Peter Parker is "obligated to remain our friendly neighbor-hood superhero, even though "[d]oing so may cause him great personal pain," because his "pain is outweighed by the overall good that his superheroic activities bring to the world."[8]

This quality cannot be separated from Spider-Man's humble origins. He is a poor, awkward kid, and that experience builds in him empathy for other losers, empathy that he retains even after getting amazing abilities.

More than Superman and Batman, Spider-Man is the archetypical superhero who can help us think about God's idea of power, the power in which the "stone that the builders rejected" can become "the chief corner-stone" (Ps 118:22).

GREAT POWERS IN A WORLD OF SUPERPOWERS

Spider-Man needs information, and he needs it now. The Vulture (Michael Keaton) and his men plan to sell high-tech weapons, and Spidey needs to stop them. His only lead is petty criminal Aaron Davis (Donald Glover).

As soon as Davis is alone in a parking garage, Spidey leaps into action. He drops from the ceiling and hurls a web at Davis's hand, pinning him to the car.

"I need information and you're going to give it to me now," Spider-Man booms as he struts toward the captured Davis, his voice distorted into a threatening baritone.

But as much Spidey wants to be scary, Davis remains unimpressed. "You ain't never done this before, huh?" Davis asks, prompting Spider-Man to drop the act and simply beg for information, no more intimidation required.

This moment from director Jon Watts's *Spider-Man: Homecoming* perfectly captures the MCU Spider-Man. In a world populated by towering paragons like Thor and the Hulk, teen Peter Parker seems downright scrawny. He doesn't have the heart to intimidate anyone, despite his fantastic powers.

But it's this very quality that makes Holland's Spider-Man so fun to watch. In *Homecoming*, bad guys get away not because they beat up Spider-Man, but because he can't figure out how to use the high-tech suit he got from Tony Stark. Instead of diving from the shadows to frighten the bad guys, Spider-Man falls flat on his face and accidentally pulls down a gas

8. Robichaud, "With Great Power Comes Great Responsibility." 181.

station sign. The sequel *Spider-Man: Far From Home* finds Spidey nearly calling in a drone strike on a romantic rival. In *Spider-Man: No Way Home*, Peter's attempts to help his pals get into MIT nearly tears apart reality.

And yet, Spider-Man overcomes the bad guy at the end. Not because he's the best or the most adept, but because he remains committed to helping others. The power he receives, whether it's his spider-abilities or the various technological wonders given to him by Tony Stark, only teach him that he needs to help more people.

To underscore this point, the first two MCU films pit Spider-Man against those who crave power, formerly little people who use what influence they get for revenge against a world that aggrieved them. Adrian Toomes, aka the Vulture, was just a blue-collar guy who scored a big contract to clean up the mess left by the Chitauri invasion of New York shown in *The Avengers*.[9] When government agencies revoked the contract, Toomes became the Vulture to recover the losses for him and his employees. The villain of *Far From Home* is Mysterio aka Quentin Beck (Jake Gyllenhaal), a genius developer standing in the shadow of Tony Stark, who took his designs and used them to his own ends. Enlisting the help of other disregarded Stark employees, Beck creates Mysterio as a superhero who looks out for the little guy.

Both Vulture and Mysterio just want a little more power to accomplish their goals, and they don't care how many people they must hurt to get it. And in both cases, the villains defeat themselves more than they lose to Spider-Man. Instead of escaping from a crashing plane, Vulture insists on staying onboard to grab as much loot as he can get, a decision that allows him to be captured by Spidey. Instead of running away as he distracted Spider-Man with an illusion, Mysterio not only gets shot by drones that he controls, but also uses his last bit of strength to attempt to kill Spidey with an illusion that fails.

In their love of power, Vulture and Mysterio echo some of the Bible's most prominent villains. The pharaoh responds to God's demand that he liberate the Israelites by asking "Who is the LORD, that I should heed him and let Israel go?" (Exod 5:2). The prophet Isaiah conflates the Babylonian Empire with Satan, who said in his heart "I will ascend to heaven; / I will raise my throne / above the stars of God" (Isa 14:13). Pontius Pilate asks Jesus, "Do you not know that I have power to release you, and power to crucify you?" Jesus responds by putting the power of Rome below that of heaven: "You would have no power over me unless it had been given you

9. Whedon, *Avengers*.

from above; therefore the one who handed me over to you is guilty of a greater sin" (John 19:10–12).

Jesus's rejoinder to Pilate echoes the Christian approach to power. Unlike the "rulers of the Gentiles [who] lord [power] over them," creating "great ones [who] are tyrants over them," leaders in God's kingdom must be different. There, "whoever wishes to be great among you must be your servant" (Matt 20:25–28).

Thus, when Christ outlined his kingdom in the Sermon on the Mount, he preached to the dejected and the outcast. Only those who had no investment with the earthly kings and warriors would understand that the freedom of slaves and healing of the sick was indeed good news. James H. Cone gets at that idea when he contends, "Indeed, it can be said that to know Jesus is to know him revealed in the struggle of the oppressed for freedom."[10]

In their best moments, the MCU Spider-Man films illustrate this truth of God's opposition to dehumanizing, worldly powers. At the climax of *Homecoming*, Spider-Man spends little time in a contest of strength with Vulture. Instead of proving that he's stronger, Spider-Man focuses on steering the invisible plane away from innocents. Consumed by his own greed, Vulture lets himself get trapped in the plane. *Far From Home*'s climactic battle with Mysterio finds Peter swinging through a web of drones, disabling the weapons before they can kill civilians. Mysterio dies when he tries to attack Peter one last time, injuring himself instead.

In that moment, Spider-Man realizes that he doesn't have to be an intimidating tough guy to do good works, in part because those who, like Mysterio or the Vulture, want such power end up abusing it. Instead, Spider-Man refuses these powers and saves not only his friends, but also himself, avoiding the selfishness that consumes the bad guys.

GREAT RESPONSIBILITY

The final scene of 2002's *Spider-Man* serves no plot purpose. It does not advance the story, it does not tell us anything new about the character. Set to Danny Elfman's rousing heroic theme, it simply spends thirty more seconds letting Spider-Man swing through New York city before perching on a flagpole, the sun burnishing everything with gold.

It's nothing more than a victory lap. And it is absolutely perfect.

Helmed by bombastic genre director Sam Raimi and deeply indebted to the melodramatic seventies comics by Gerry Conway and John Romita, *Spider-Man* is all sentimental spectacle. Played with aching earnestness by

10. Cone, *God of the Oppressed*, 34.

Toby Maguire, Peter Parker seems perpetually on the verge of tears, at turns leaping between skyscrapers like a sugar-addled child and brooding like a Victorian novel love interest.

The main cast of the three Raimi films follow suit. In the role of Mary Jane Watson, actress-in-training and love of Peter's life, Kirsten Dunst breathes comic energy into a one-dimensional character. Even though she does little more in the plot than inspire Peter, Dunst's sincerity makes every action feel earned. James Franco chews scenery as Harry Osborne, Peter's best friend who blames Spider-Man for the death of his father Norman (Dafoe), aka the Green Goblin. As Aunt May, Rosemary Harris brings a surprising amount of grit and gravitas, without ever betraying the character's matronly roots.

In fact, every part of *Spider-Man*, and its two sequels from 2004 and 2007, creates a world as arch and immediate as the comics that inspired it. Women respond to oncoming supervillains by screaming directly into the camera. Doctor Octopus robs banks by carrying away giant sacks of gold. Peter's voice-over states the movies' themes, as plainly as if they were written in comic panel captions.

The most striking of these voice-overs occurs at the end of the first film. Visitors shuffle away from Norman Osborne's funeral, all but Peter un-, aware that he died by his own hand as the Green Goblin. Ignorant of his best friend's alter ego, Harry swears vengeance toward Spider-Man before storming off. Mary Jane stays behind to confess her love to Peter. But instead of responding in kind, Peter holds back his emotions, convinced that romance and web-slinging can never co-exist.

Leaving Mary Jane crying in the background, Peter's voice-over explains his rationale: "Whatever life holds in store for me, I will never forget these words: with great power comes great responsibility. This is my gift, my curse."

Those words, given to him as one last piece of advice from his beloved Uncle Ben (Cliff Robertson), are among the most powerful in all of superhero fiction. They perfectly encapsulate the ethos of nearly all superheroes, giving fans a reason to cheer for muscle-bound crusaders in flashy costumes. We don't love Superman, Batman, and Spider-Man because of their cool powers or because we want to worship their amazing feats. We love them because those powers make them responsible for others.

Just to be clear: it's a lot of fun to have those great powers. That's why Raimi chooses to end his movie with Spidey's victory lap through New York instead of Peter's glum note. Each of the three films feature exhilarating set-pieces of Spider-Man doing everything a spider can, contorting his body

to dodge plummeting debris from a collapsing building, doing a backflip around a speeding car, and using his webs to rip guns from bad guys' hands.

But the movies combine these amazing sequences with acts of responsibility. When Spider-Man hurls himself through the window of an apartment inferno, flames licking his feet, he does so while carrying a little baby to return to the worried mother below. When he swings through traffic on a crowded New York City street, he does so to whisk away a child, seconds away from being crushed by a car.

The Maguire Spider-Man movies emphasize that the great power given to the hero must be used to help others, to mitigate the threats that most people cannot handle themselves. That principle drives the main plots of each of the three films, as only Spider-Man can stop supervillains Green Goblin, Doctor Octopus, the Sandman (Thomas Haden Church), and Venom (Topher Grace). For as much fun as these final battle sequences may be, in which Raimi pulls out all the stops to choreograph fights as kinetic displays of acrobatic prowess, they all serve to demonstrate Peter's fulfillment of his uncle's dictum.

But as Peter said in his closing monologue, great power isn't just a gift, it's also a curse. Throughout the trilogy, Spider-Man constantly drives wedges between Peter and those he loves. Not only do villains constantly kidnap Mary Jane and Aunt May, but superheroing costs Peter his best friend Harry and gives his cantankerous boss J. Jonah Jameson (J. K. Simmons) a scapegoat for his editorial rants. At the start of *Spider-Man 2*, Peter loses his job, gets reprimanded by his professor, and dismissed by Mary Jane, all because he can't keep up with the demands of being Spider-Man.

Midway through the film, Peter discovers that he's lost his powers. What follows is an upbeat and silly montage, set to Burt Bacharach's "Raindrops Keep Falling on My Head," in which Peter gets a chance to enjoy his life. It's not perfect; he's still a nerdy kid in a crappy apartment. But when police cars race by in the middle of lunch, Peter can dive into action by taking a giant bite of his hot dog and moving on. The look of relief on Peter's face reminds us that the joy of great power and the honor of great responsibility threatens to become a great bummer.

It's not hard to find analogues in the Christian world. As we read in the previous chapter, many understand Christ's teaching that his followers "deny themselves and take up their cross daily" as an embrace of suffering (Luke 9:23). They focus on the abnegation of self described by St. John of the Cross. They live their lives according to Søren Kierkegaard's Christian existentialism, insisting that following Christ requires a rejection of others. For them, faithfulness toward God necessarily involves a solitary life, refusing all pleasures to advance suffering.

To be sure, there are plenty of examples in the Bible to support this type of thinking. Moses climbed Mount Sinai by himself. Elijah followed his defeat of the prophets of Baal by lying in the desert and begging God to let him die. Numerous prophets, from Jeremiah to Jonah, were despised by society for the message God gave them. Throughout the Gospels, we see Jesus escape from crowds to spend time by himself. In the most striking instance, he leaves his disciples in the garden of Gethsemane to wrestle with God.

But as powerful as these examples may be, they must be examined in context. For nearly every example of Bible figures being alone, we can find two examples of them being with others. After finishing his prayers, Moses returned to his people, and kept close council with his siblings Mariam and Aaron. Elijah did not die when he predicted famine to undermine King Ahab, but was cared for by the widow of Zarephath (1 Kgs 17). Daniel had his compatriots Shadrach, Meshach, and Abednego (Dan 3). After periods of solitude, Jesus always returned to his disciples.

These figures felt like buckling under the great responsibility placed on them because of the great powers they had to contend with. But each one of them realized that the responsibility could be shared. From sharing the sorrows of Jesus's death (John 20) to rejoicing in the coming of the spirit (Acts 2), Christ's followers better bear their responsibilities if they do them together. That's why Paul writes in Gal 2:6, "Bear one another's burdens, and in this way you will fulfill the law of Christ." The biblical model of responsibility is also a communal model.

Community plays a key role in the vision of responsibility in the Raimi Spider-Man movies, as demonstrated by one of the best moments in the trilogy, a manic battle between Spider-Man and Doctor Octopus on the top of an elevated train. Unable to stop the wall-crawler, Doc Ock finally rips out the regulator and sends the train hurling toward the end of the tracks, where its innocent passengers will plummet to their deaths.

At first, it seems like the other people are a drag on Spider-Man. Instead of continuing his awesome fight against a madman with mechanical tentacles, Spidey has to stop and pay attention to the regular people, some of whom vent their frustration at him. All attempts to slow the train fail, until Spider-Man stands in front of the lead car and shoots webs at nearby buildings. Gripping the webs with all of his strength, Spidey takes the full force of inertia and sacrifices his body to stop the train.

The framing of the scene underscores the sacrificial element. His arms outstretched in a Christ pose, agony ripples across Peter's now unmasked face. The camera cuts to close-ups of his arms and chest as the strain on his muscles cause his costume to rip. The train slows to a stop, just seconds

before careening over the edge, and Spider-Man collapses. He has accepted his great responsibility, spent all he had to help others, and now is ready to die.

But that's not how the scene ends. As he falls toward the camera, down into the pit where he will die alone, two hands shoot out from off screen and catch him by the chest. A close-up shows us the hands right next to the Spider-symbol, suggesting that the people who save Spider-Man are just as heroic as the hero who saved them. An overhead shot follows Peter as the crowd lifts him up and carries him back, gently setting him at a place of safety. "Don't worry," a little boy tells him as he returns the mask. "We won't tell anyone."

The train scene demonstrates an important part about great responsibilities. They can never be shouldered alone. Yes, we might all have our own different gifts, which means the way we enact those responsibilities might look different. But none of us fights by ourselves.

GREAT COMMISSION

"The first black superhero is Spider-Man."

So declared novelist Walter Mosely in a 2016 interview with *Vulture*.[11] "He has all of this power, but every time he uses it, it turns against him. People are afraid of him; the police are after him. The only way he can get a job is by taking pictures of himself that are used against him in public," Mosely goes on to explain. "Of course, he's actually a white guy. But black people reading Spider-Man are like, Yeah, I get that. I identify with this character here."

Mosely's comments capture a truth that's always been present with Spider-Man. Superman is an all-powerful alien who passes as a white American; Batman is an old money rich white man, the recipient of generational wealth. Very few of us, even the privileged, can relate with these archetypical heroes.

But Spider-Man struggles with things we all experience. Spider-Man can't pay the bills, he fails at romance, and he constantly feels pressure from his family. Even better, Spider-Man's full-body costume and face-obscuring mask means that the superhero could be of any race or gender.

The 2018 animated film *Spider-Man: Into the Spider-Verse* brings forward this subtext by putting Peter Parker, now a thirty-something and overweight divorcee voiced by Jake Johnson, into an adventure with Spider-Gwen (Hailee Steinfeld), Japanese girl Penni Parker (Kimiko Glenn) and

11. Riesman, "Novelist Walter Mosley."

her robotic Spider-Mech, the 1940s detective Spider-Man Noir (Nicolas Cage), and the cartoon pig Spider-Ham (John Mulaney). Brought from their respective realities thanks to a dangerous machine created by Doctor Olivia Octavius aka Doc Ock (Kathryn Hahn) for the Kingpin of Crime Wilson Fisk (Liev Schreiber), the Spider-People must work together to get home and destroy the machine before it corrupts of their universes.

The most important hero of *Into the Spider-Verse* is Miles Morales (Shameik Moore), a fifteen-year-old Afro-Latino boy from Brooklyn. Even before he's bitten by a radioactive spider, Miles already knows how to live a double life. An early sequence follows him as he heads out the door and walks through his neighborhood to Visions Academy, the advanced magnet school he attends. With the same grace that he'll later need to swing through the city, Miles slips between English and Spanish, chats up his friends from the block, and tries to fit in with the rich kids at school. He looks cool doing it, but it's clear that Miles feels torn by the pressure to fit in, even though he does not belong anywhere. That feeling only grows when he's put between his morally upright police officer father (Brian Tyree Henry) and his shady but lovable Uncle Aaron (Mahershala Ali).

Spider-Man: Into the Spider-Verse is a vibrant and self-aware take on the Spider-Man mythos. The unique animation style marries the pop-art approach of early Marvel to graffiti-splattered urban expression, presenting the story as a series of comic book panels exploding to life, with all of the problems and complexities that come with it. As outrageous as the story can be (in which Spider-Ham pulls a giant mallet from his back pocket and wind follows Spider-Man Noir even down to basements), it's still grounded in real humanity and emotions.

From the very beginning, the film engages with ideas of difference. "I was bitten by a radioactive spider, and for ten years I've been the one and only Spider-Man. I'm pretty sure you know the rest," declares a happy and successful Spider-Man (Chris Pine) in the first scene. What follows is a litany of references pulled from the Raimi trilogy, from the 1967 cartoon series, and even from our world (comics published by Marvel, novelty ice cream). The sequence plays on the audience's collective knowledge of Spider-Man to proclaim, "There's only one Spider-Man. And you're looking at him."

This Peter is the one we know, right down to his belief that great responsibility is a lonely endeavor. But *Into the Spider-Verse* directly combats this type of thinking. When Miles encounters the Spider-Man of his universe, the directors illustrate their connection with a shot-reverse-shot. Peter looks directly at the camera as squiggles emanate from his head and the background flutters with yellow backgrounds. The reverse shot shows Miles

with the exact same effect. "You're like me," says Peter with wonder, but that's not entirely true. While the effect looks similar, there are key differences.

After that Spider-Man is killed by the Kingpin, Miles does his best to live up to the prior hero's legacy. But he doesn't even have a uniform and spends the first two-thirds of the movie in a cheap-looking, ill-fitting Spider-Man Halloween costume he bought off the street (from Stan Lee, of course, in his final cameo). The poor-fitting costume serves as a clear indication that Miles cannot be the same type of Spider-Man that Peter Parker was. Even when the older, more cynical Peter Parker from an alternate reality begins to train him, Miles cannot merely mimic the previous Spider-Man.

Nothing illustrates this better than a painful scene in which Peter and the other Spider-people try to train Miles. The team has assembled to infiltrate the Kingpin's lair, use the super-collider to send everyone back to their respective dimensions, and then destroy the machine before it can further upset the multiverse. Miles volunteers to stay behind, but the others aren't certain that he can do it. Partially to test him, and partially to prove their point, the other Spider-People attack him.

"Kingpin's gonna send a lot of mugs after ya, I'm talking hard boys, real biscuit boxers. Can you fight them all off at once?" asks Spider-Man Noir, before shouting "surprise attack" and knocking Miles over.

"Can you rewire a mainframe while being shot at?" asks Penni.

"Can you swing and flip with the grace of a trained dancer?" asks Gwen.

"Can you float through the air when you smell a delicious pie?" asks Spider-Ham.

As the questions come harder and faster, the editing becomes more frantic, cutting between the characters interrogating Miles, until they all appear on-screen at once in a series of panels. The music grows more frenzied and the animation more manic, colors and images growing distorted to capture Mile's overwhelmed feeling.

It's an intense scene, but it's easy to see why the Spider-People acted in this manner. He has an incredible task before him, and they all want him to do well. But as their idiosyncratic questions suggest, the Spider-People confuse "doing well" with "doing it like them."

That type of thinking is hardly limited to Spider-People from across the multiverse. Too often churches build themselves around communities of similarities, in which the majority of members share the same ethnicity, nationality, social class, etc. There are a number of reasons for this tendency, but they often stem from the thinking described in the previous two sections. As Christians, we've been given a great power that runs contrary to those of the world, and we have a great responsibility to advance Christ's

kingdom. For some, that mission can't be derailed by earthly concerns such as politics and economics.

God's creation is inherently filled with difference. We see this in the story of the Tower of Babel, in which humans centralize (Gen 11:1–9). Because "human beings have stopped spreading and diversifying, preferring to congregate in one place and unify around something other than God," they are disrupted with the gift of different languages.[12]

We see this in the story's echo in the first Pentecost, in which the coming of the Holy Spirit brings also the ability to speak multiple languages— "Parthians, Medes and Elamites; residents of Mesopotamia, Judea and Cappadocia, Pontus and Asia, Phrygia and Pamphylia, Egypt and the parts of Libya near Cyrene; visitors from Rome (both Jews and converts to Judaism); Cretans and Arabs" (Acts 2:9–11).

As these passages demonstrate, "God's mission is to reach the whole world," and "God works in and through racial, gender, linguistic, and generational diversity."[13] In fact, it's only through such diversity that we can live out the great commission to go and "make disciples of all nations, baptizing them in the name of the Father and of the Son and of the Holy Spirit, and teaching them to obey everything that I have commanded you" (Matt 28:19–20). Diversity brings into the church people as God created them to be, not as more reproductions of those already in place.

Into the Spider-Verse illustrates this idea with the follow-up to the ill-fated training scene. Instead of trying to copy the methods of other Spider-People, Miles decides to embrace his own abilities. Set to the rousing hip-hop song "What's Up Danger" from Blackaway and Black Caviar, the montage cuts between Miles ascending a New York skyscraper and spray painting his Spider-Man costume, embracing the penchant for graffiti he's shown throughout the film.

As he works, he recalls the words of those who inspired him. He recalls his father acknowledging the "spark" inside of him, his mother (Luna Lauren Valez) reminding him that their family "doesn't run away from things," his Uncle Aaron seeing in Miles the best parts of him and his dad, and Peter admitting that one never knows when they've finally become Spider-Man.

The sequence crescendos with Miles in his own black costume, taking a leap of faith in which he dives off a skyscraper. With the soundtrack pumping, Miles bounces through the city. Not only does he go to meet the other Spider-People, where he'll stop the Kingpin and save the multiverse

12. Reyes, *Becoming All Things*, 11.

13. Kim and Hill, *Healing Our Broken Humanity*, 25.

with his unique invisibility and "venom-touch" powers; he'll also embrace the full joy of being himself.

The pure joy, the pure ecstasy of Miles's leap reminds us of the joy and healing that comes when people are allowed to be the person who God created them to be. That's how we can use great power to embody our great responsibility to fulfill Christ's great commission for us all, that we make disciples and embody his teachings.

GREAT UNDERSTANDING

Spider-Man: No Way Home doesn't just bring into the MCU bad guys from previous Spider-Man movies. It also brings in previous Spider-Men, allowing Tobey Maguire and Andrew Garfield to play Peter Parker one last time.

The duo arrives in the movie just after the death of Aunt May, when Peter's friends MJ (Zendaya) and Ned (Jacob Batalon) use a magic ring to find him. Instead of locating their Peter, they find these two alternate reality versions. After a moment of playful recognition, the two older Peter Parkers realize that they need to help the troubled younger version of themselves.

They find Peter sitting alone on the rooftop of his school, still wearing the blood and cuts from his clash with the Green Goblin. Filled with rage and anger, Peter rejects the responsibility he took and curses the fact that he tried to help the villains who would cause the death of his aunt. Now, he just wants revenge.

Before our Peter can give into his anger, the two older Peters arrive to dispense their own advice.

"No," the younger Peter snaps at them, cutting them off before they can speak. "Please don't tell me that you know what I'm going through."

But of course, they do know. Both Peters carry the shame of having contributed to the death of a loved one—Uncle Ben for Maguire's Peter and Gwen Stacy for Garfield's. Both Peters know the all-consuming cost of revenge. Maguire's Peter recounts his story of chasing down the man who killed Uncle Ben and watching him die. "I wanted him dead. I got what I wanted," that Peter says with simple, direct statements. "It didn't make it better."

No Way Home perversely suggests that the only people who know what it's like to be Peter Parker are other Peter Parkers. However, we know that's not the case. Almost everyone knows what it's like to lose, to have things go wrong, to carry guilt. We all know what it's like to be knocked down.

Because we all know what it feels like to lose, we can take joy and inspiration from watching Spider-Man get back up. We can watch him swing

away with excitement and remember that great power can come from everywhere, and with it, the great responsibility to care for one another.

CREDITS

Spider-Man (2002)
Director: Sam Raimi
Screenwriter: David Koepp

Spider-Man 2 (2004)
Director: Sam Raimi
Screenwriter: Alvin Sargent

Spider-Man 3 (2007)
Director: Sam Raimi
Screenwriters: Sam Raimi and Ivan Raimi and Alvin Sargent

Spider-Man: Homecoming (2017)
Director: Jon Watts
Screenwriters: Jonathan Goldstein and John Francis Daley and Jon Watts
and Christopher Ford and Chris McKenna and Erik Sommers

Spider-Man: Into the Spider-Verse (2018)
Directors: Bob Persichetti, Peter Ramsey, Rodney Rothman
Screenwriters: Phil Lord and Rodney Rothman

Spider-Man: Far From Home (2019)
Director: Jon Watts
Screenwriters: Chris McKenna and Erik Sommers

Spider-Man: No Way Home (2021)
Director: Jon Watts
Screenwriters: Chris McKenna and Erik Sommers

POST-CREDITS:

Theme: The Power of the Powerless

Key Biblical Passage: Matt 28:16–20

Questions:

1. Like Superman and Batman, Spider-Man's origin involves suffering. But unlike those characters, Spider-Man's suffering makes him more relatable. How do the struggles in Spider-Man's story relate to those in your own life?

2. In Spider-Man movies, Peter Parker's failures and shortcomings allow him to better serve others. We see similar examples throughout Scripture. With that in mind, how should the church respond to its members' shortcomings and failures?

3. The great power Spider-Man receives involves everything a spider can do. But Christ has imbued his church with its own great powers. What are those abilities we're given? How do the powers of the church differ from those of the powers of the world?

4. Peter Parker is driven by the "great responsibility" put upon him. What is the great responsibility we have as Christians? How do we enact that responsibility in our everyday actions?

5. *Spider-Man: Into the Spider-Verse* shows us that everyone has a part to play in accepting great responsibility. How has the church failed in the past to aid everyone in their great responsibility? How can the church better support everyone by lending great power?

PART II

THE TRUE GOD
AND THE NEW GODS

5

IRON MAN

The Hero Type

Jesus looked around and said to his disciples, "How hard it is for
the rich to enter the kingdom of God!"

—MARK 10:24

I'm not the hero type . . . clearly.

—TONY STARK, *IRON MAN*

AS THE FIRST ENTRY in the Marvel Cinematic Universe, *Iron Man* has a
ton of memorable moments. The best occurs at the end of the film, when
Tony Stark (Robert Downey Jr.) prepares to give a press conference about
his relationship to the armored superhero.

Tony takes the stage with his usual swagger, a return to the brash and
charming character reporters knew before his capture by the terrorist group
the Ten Rings. The first press conference after his capture found Tony shak-
en, stuttering, remarkably vulnerable. Now, he seems confident, in control.

At least at first. As Tony attempts to read from his notes, notes that
had been prepared for him by the intelligence agency known as SHIELD
(Strategic Homeland Intervention, Enforcement, and Logistics Division),
he begins to stammer and stumble.

"I'm just not the hero type. . . clearly," he sputters with exasperation. But after a few seconds of hemming and hawing, Tony regains his nerve. He knows who he is. He knows what he needs to do.

"The truth is," he starts, looking right into the camera. "I am Iron Man." Cut to credits.

That's a fantastic way to end the first movie in the MCU, promising something we've never before seen in superhero movies. But as exciting as his declaration is, we can't quite forget the other truth Tony told, before revealing his identity.

Tony's not wrong to say that he has a "laundry list of character defects," defects which are present throughout his nine film appearances. And yet, do those take away from his heroism? Or, more importantly, is his heroism enough to diminish those flaws?

In Tony's story, we see a man looking for grace, atonement for his past misdeeds. Few people have a harder time accepting that grace than a rich man, especially one who made his fortune selling weapons, and sees a weaponized suit of armor as his path to redemption.

By examining Iron Man's story, we can see the difficulty of imagining grace. In his desire to make right what he once did wrong, and in his ultimate sacrifice, Tony Stark confirms Jesus's teaching about the difficulty of a rich man entering the kingdom of heaven. All in all, the Iron Man movies point to a different type of heroism, one that finds its ultimate form in sacrifice.

A TALE OF SUSPENSE

Today, it's impossible to separate Tony Stark from the MCU. He launched the universe and remained at its center all the way to his death in *Avengers: Endgame*.

But back in 2008, it was hard to think of a more unlikely cornerstone for a massive film franchise. To be sure, Iron Man had been a mainstay of Marvel Comics since he first appeared in a 1963 issue of the anthology series *Tales of Suspense* #39.[1] The hero struck an immediate chord with readers and became the lead character in *Tales of Suspense*. When Stan Lee and Jack Kirby assembled Marvel's greatest heroes in *Avengers* #1, Iron Man was chosen as the leader.[2] Since then, he's been a near constant on the team, even leading spin-offs like *Avengers West Coast*.

1. Lieber, "Iron Man Is Born."
2. Lee, *Avengers* #1.

And almost as quickly, Iron Man was shifted down to B-tier status. After Captain America entered the Marvel Universe with *Avengers* #4, he became a co-lead in *Tales of Suspense* and eventually pushed Iron Man off the book completely.[3] The displacement lasted only a couple of months, as *Iron Man* #1 hit shelves in May 1968, but Captain America has been the leader of the Avengers ever since, with Iron Man demoted to supporting roles.[4]

That middling status is reflected in Iron Man's appearances outside of comics. Like most early Marvel characters, Iron Man episodes were included in the 1960s *Marvel Super Heroes* cartoons, and he did have his own solo animated series in 1994. However, none of those had the impact of the many cartoons starring Spider-Man or the X-Men.

In fact, it was almost a fluke that Iron Man was chosen as the launching point of the MCU, one that involved intellectual property rights and action figure market testing.[5] But once the key ingredients came together, Tony Stark rocketed into hearts of audiences around the world. Thanks to the loose direction of Jon Favreau, and the undeniable chemistry of Robert Downey Jr. and Gwyneth Paltrow (as his equally quick-witted partner Pepper Potts), a second-string, arrogant arms dealer became the most popular superhero in the world.

CHEAP GRACE FOR A RICH MAN

The Gospels of Matthew, Mark, and Luke all retell a story about a young rich man who questions Jesus. He asks Jesus, "Good Teacher, what must I do to inherit eternal life?"

Jesus answers by pointing to basic moral actions found in the ten commandments, to which the rich man insists, "I have kept all these since my youth."

"There is still one thing lacking," Jesus observes. "Sell all that you own and distribute the money to the poor, and you will have treasure in heaven; then come, follow me."

The answer discourages the young man. He leaves distraught, disappointed by the good teacher's answer. Why does the young man leave? Luke's account puts it bluntly: "he was very rich." Jesus looks at the man and declares, "How hard it is for those who have wealth to enter the kingdom of

3. Lee, *Avengers* #4.

4. Goodwin, *Iron Man* #1.

5. See Fritz, *Big Picture*.

God! Indeed, it is easier for a camel to go through the eye of a needle than for someone who is rich to enter the kingdom of God" (Luke 18:18–25).

The story of the rich young man illustrates the distinction German theologian Dietrich Bonhoeffer makes between cheap grace and costly grace. Cheap grace is what the young man wanted from Jesus, what he thought he had earned by keeping the commandments. Cheap grace is "grace as a doctrine, a principle, a system. It means forgiveness of sins proclaimed as a general truth, the love of God taught as the Christian 'conception' of God." The young man had the idea that he could be saved and that he wanted to be saved, but he couldn't do the last thing Jesus demanded. As Bonhoeffer writes, cheap grace "amounts to a denial of the living Word of God, in fact, a denial of the Incarnation of the Word of God."[6]

This word "Incarnation" is important. It refers to God becoming human as Jesus, intersecting into history as a person. More importantly, it means doing. It's not an "intellectual assent" to grace as an idea "held to be itself sufficient to secure remission of sins." Rather, incarnation demands action.[7]

Action is at the heart of costly grace. Bonhoeffer writes, costly grace "is the gospel which must be *sought* again and again, the gift which must be *asked* for, the door at which a man must *knock*." This description emphasizes action, but not because the grace must be earned, thus denying Paul's insistence that grace is "not the result of works" (Eph 2:9). Rather, action is grace made real, a living change in the redeemed person. This grace is "*costly* because it calls us to follow, and it is *grace* because it calls us to follow *Jesus Christ*. . . . Costly grace is the Incarnation of God."[8]

In many ways, Tony Stark is like the rich young man. He sees the limitations of his life, and it scares him. He wants a change, he wants to know how he can be saved. But he faces the same challenge as the young man for the exact same reason: he is very rich. His story across the MCU can be seen as an attempt to understand the demands of grace and to fully repent.

TONY STARK, MASTER OF WAR

The redemption of Tony Stark is a subject in every one of the character's nine main movie appearances, but nowhere is it more focused than in *Iron Man*. That film traces Tony's state of selfishness to one of repentance.

6. Bonhoeffer, *Cost of Discipleship*, 43.

7. Bonhoeffer, *Cost of Discipleship*, 43.

8. Bonhoeffer, *Cost of Discipleship*, 45. Italics original.

More accurately, *Iron Man* follows Tony's first steps toward repentance, as barely fifteen of the movie's 128 minutes show Tony in a "fallen" state. Interestingly, these minutes show plenty of undesirable behavior on Tony's part. He drinks too much, he's irresponsible, and his sexual exploits demean his partners (especially with a horribly retrograde moment in which a *Vanity Fair* reporter sleeps with Tony to gain access, only to dismissed as "trash" by Pepper).

But the most (literally) damning example of Tony's bad behavior is the one we see at the end of the opening scene. As the envoy escorting him from a weapons demonstration in Afghanistan is attacked by the terrorist group the Ten Rings, the soldiers protecting Tony die in the battle. Tony escapes behind a rock and tries to call for help on a fancy cell phone. A missile lands next to Stark and, with a snap zoom, the movie makes sure that we all know the cause of Tony's demise. "Stark Industries," reads the label on the bomb. Seconds later, an explosion fills Tony's chest with shrapnel.

The sequence points to a scene later in the film, set during the weapons presentation and before the attack. Tony delivers a speech full of self-aggrandizement, making big proclamations about the nature of power. "They say that the best weapon is the one that you never have to fire. I respectfully disagree," he brags to the assembled military men. "I prefer the weapon you only have to fire once." To demonstrate, Stark detonates a missile behind him. The military men stumble back in awe, but the camera stays trained on Tony, his arms outstretched, unaffected as the blast sends wind and rubble hurling behind him. Tony Stark is a master of war, pleased with the power in his hands.

For religious viewers, the name of the missile might raise eyebrows. Presumably, Stark Industries christened their weapon the "Jericho" missile because of its ability to destroy walls, leaving even heavily protected enemies vulnerable. But while Stark's branding consultants may have been aware of the battle recorded in Josh 6, they didn't read close enough to get much more than the plot.

The Israelites defeated the far more powerful armies of Jericho not by engaging in the methods of the day, but in a display of powerless-ness. Instead of the chariots and swords one usually uses, the Israelites asserted God's power through songs of praise and following the Ark of the Covenant. When they do take action, it's an extension of their understanding of God's power: "Shout! For the Lord has given you the city" (Josh 6:16).

More than a mere military victory, the battle of Jericho proved to all the nations that God supersedes any earthly technology of war. Those who stood against God were sure to fall, no matter how strong their weaponry may have seemed.

Stark's Jericho missile serves the exact opposite effect. Like the city for which it is named, the missile reinforces existing systems of power, whether they be the cackling generals who enjoy drinks after the demonstration, the duplicitous Obadiah Stane (Jeff Bridges) who calls in to check on the presentation's success, or arrogant Tony Stark himself. These men all believe they have achieved power thanks to Jericho.

By getting attacked by the missile he created, Tony has the opportunity to see firsthand the consequences of his sins. Like the countless people murdered by Stark Technology, Tony has been harmed, maimed by systems of power.

This event shows Tony that he has, as he puts it, "more to offer this world than just making things that blow up." In other words, Tony sees the error in his ways and begins making moves to repent. Too often we think of repentance in only spiritual terms, suggesting that it simply involves a change of heart. Once we start feeling differently, then we have changed our ways.

But as Bonhoeffer argues, relegating repentance to mere ideas is an act of cheap grace. It lessens the radical example Christ gave us in his faithfulness to God, "obedient to the point of death—even death on a cross" (Phil 2:8), to a series of nice feelings.

By immediately shutting down his company's weapons manufacturing, Tony demonstrates that he's willing to do the work of rejecting the evil things of the world, even if they made him rich. And by creating the Iron Man armor, he shows that he's willing to put himself on the line, making moves that will destroy the weapons he put into the world.

As the film progresses and leaves the realities of war in the Middle East, it takes on the language of superhero fiction and grows more symbolic. Obadiah Stane transforms from an unethical businessman to the full-on supervillain Iron Monger, complete with his own variation of the Iron Man armor.

On a plot level, the battle with Iron Monger is the weakest part of *Iron Man*, a CG slugfest that even the otherwise-bland *Iron Man 2* will outdo. But in the tradition of the Marvel Comics that spawned it, the fight carries representative weight. By defeating Iron Monger, Tony reaches the first point of repentance away from his old self. He has resisted the temptation to continue making weapons for profit, acting like the attractive face of an industry of murder, and searching for a better way of being in the world, doing good instead of harm.

THE COST OF SAFETY

Obadiah Stane may have been a madman, but he was right about one thing. "Trying to rid the world of weapons, you gave it its best one ever," he bellowed from the Iron Monger. The Iron Man armor is undeniably a weapon, and Tony uses it to do good through violence.

Iron Man 2 gestures toward dealing with the fact that Iron Man is a weapon but is too thematically inconsistent to be effective. The final movie in the *Iron Man* trilogy handles these issues much better. Directed by Shane Black, *Iron Man 3* finds Tony reeling from PTSD after nearly dying at the climax of *The Avengers*. In midst of panic attacks, Tony must face the Mandarin (Ben Kingsley), the shadowy leader of the Ten Rings.

Iron Man 3 satirizes the relationship between the American military and the arms industry, focusing on the role propaganda plays in getting us to accept it. We see signs of propaganda early in the film, in the video the Mandarin releases after the first bombing attributed to him. Over grainy footage of cheering Muslim soldiers executing prisoners and burning the US president in effigy, the Mandarin monologues about the lessons he's trying to teach the country. With the righteous drawl of a Southern Baptist preacher, the Mandarin relates his attack on a US base in Kuwait to the real-life Sand Creek Massacre.

It's a slickly produced video, intercut with images of white children dressed as cowboys and closeups of Native leaders. It comes packaged with eerie music and Ten Rings logos, with hard blasts of static between cuts. And it's totally false.

In one of the MCU's best twists, Tony and his partner James "Rhodey" Rhodes aka the Iron Patriot (Don Cheadle) storm the Mandarin's compound to find elaborate sets and props. When they finally confront the man called the Mandarin, they meet Trevor Slattery, an English actor, drug addict, and utter buffoon.

The Mandarin, we come to learn, is a distraction cultivated by the film's true villain, Aldrich Killian (Guy Pearce) and his company Advanced Idea Mechanics (AIM). With the help of his fellow scientist Maya Hansen (Rebecca Hall), Killian has been developing the Extremis procedure. Although Extremis allows users to, as he puts it, "unlock the full potential of their minds," even so far as to heal lost limbs, it's also highly unstable. More often than not, users become human bombs, exploding when overheated.

Because reports of these explosions could jeopardize AIM contracts with the government, Killian manufacturers the Mandarin. Based on market research, the Mandarin is a hodgepodge of everything that scares us,

from his Osama Bin Laden-style dress, to his undefinably ethnic appearance, to his shifting accent that signals only "otherness."

It's easy to see how the Mandarin worked for Killian. The United States has built its empire, in part, by positioning itself as a force of order and safety against chaos. Killian's actions remind us of the cost of that so-called safety. In pursuit of the better, more secure life, Killian is willing to sacrifice others. The movie slows down to remind us of sacrifice during its second act, in which Tony escapes from his destroyed home in Malibu and retreats to Rose Hill, Tennessee.

In the center of Rose Hill, Tony visits the site where an Extremis soldier exploded. Tony's companion, young inventor Harley Keener (Ty Simpkins) tells him the official story, that the soldier killed himself, taking several other citizens with him. The scene is haunting, not just for Black's presentation, but also for the way it recalls real-world atrocities. The notes and photographs pinned around the site mirror real forms of grieving for those killed in acts of war. The shadows on the wall remind us of the citizens of Hiroshima and Nagasaki killed by America's atomic blasts.

Like the scene of Tony's conversion from the original *Iron Man*, the blast puts Tony face to face with his legacy as an arms dealer. Even if he wasn't personally responsible for Extremis, he is culpable in building weapons of war.

Iron Man 3 gives us Tony Stark as both perpetuator and victim of war. The frequent panic attacks that occur throughout the film stem from a constant need for safety, which he pursues by building more and more suits. A monomania sets in, driving him away from relationships and toward the need to create suit after suit, in hopes that he can finally build a weapon strong enough to keep the baddies at bay.

The desire to be safe is certainly understandable, even among believers. It's good to take care of yourself, to know boundaries, and prioritize your health. But safety is never the ultimate good, at least for Christians. According to Mark Charles and Soong-Chan Rah, persecution "serves as a crucial aspect of [Jesus's] teaching." Because Jesus preaches a kingdom in opposition to worldly powers, the discipleship of his followers "is not to be gauged by their wealth, their power, or their prosperity here on earth. They will know they are following Jesus correctly when they are rejected, insulted, and even persecuted—just like Jesus and the prophets who were before them."[9]

John's Gospel locates a key distinction as the source of the persecution. "If you belonged to the world, the world would love you as its own," Jesus

9. Charles and Rah, *Unsettling Truths*, 48.

states. "Because you do not belong to the world, but I have chosen you out of the world—therefore the world hates you" (John 15:19). In other words, by rejecting the worldly logic of power and domination, Christ followers become enemies to those powers. To put defense first is to buy into that logic and become part of the world.

Bluntly put, buying into the logic of defense is cheap grace, especially when it causes the suffering of others. That grace is on display when Killian or his benefactor Vice President Rodriguez (Miguel Ferrer) justify their use of Extremis by pointing to their own personal sufferings, whether it be the bullying done to Killian or the missing limb on the Vice President's granddaughter.

Costly is the grace that Tony receives when he admits his participation in all the problems he caused. During his investigations into the bombings, Tony meets with Mrs. Davis (Dale Dickey), the mother of the soldier who had been labelled a suicide bomber. Mrs. Davis provides Tony with key information about Extremis, which leads directly to his discovery of the Mandarin and Killian's plan.

But the more important part of the exchange occurs after the intel swap. Looking at the hurt, grieving woman before him, Tony affirms a truth that she always knew. "Mrs. Davis, your son didn't kill himself. I guarantee you, he didn't kill anyone. Someone used him. As a weapon." The look of relief on Mrs. Davis's face, the gratitude breaking through her hard exterior, confirms that Tony's statement is more heroic than even the battle with one of Killian's minions that immediately follows. He told her the truth, he saw the suffering and lying and acknowledged that her son's suffering mattered.

Tony's statement to Mrs. Davis was an act of costly grace because it required him to acknowledge his own creation of weapons, his own becoming a weapon. He had to recognize his sins to repent, and that repentance led him to do good works for Mrs. Davis.

The film ends with an even more heroic act, one that sees the end of the repentance to which he had been working throughout the film. After defeating Killian, Tony orders Jarvis to destroy all of the suits. The camera cuts between Pepper and Tony holding one another as the suits explode above them, popping joyously like fireworks.

From close-ups of he and Pepper grasping each other, their faces registering more peace and contentment than they've shown in any other part of the movie, Tony's closing voice-over starts over a black screen. "And so, as Christmas morning began, my journey had reached its end," he declares.

The Christmas setting of *Iron Man 3* is a trait of director Shane Black, who often sets his films in the holiday season.[10] But the setting makes a particularly potent point at the end of a story about a man learning the insufficiency of peace through war. In the prophecy about Christ's birth recorded in Isa 9, we read that not only is a son coming, but that "authority rests upon his shoulders." Unlike the figures of authority who preceded him, this son is not named "the Great" or "the Conqueror." No, he is called "Wonderful Counselor, Mighty God, Everlasting Father, Prince of Peace" (Isa 9:6).

As *Iron Man 3* closes on Christmas morning, we see Tony coming into the realization of that promise. No, there's no conversion, in which Iron Man becomes a born-again Christian. But he does recognize the failure of worldly authority, he gets a sense of the peace that Christ came to inaugurate. A peace that comes not through the cheap grace of building more weapons and fighting harder, but the peace of costly grace, of leaving the battles and seeking forgiveness for the scars that they caused.

PAID IN FULL

In many ways, *Iron Man 3* completed Tony's arc. He went from manufacturing weapons to repenting of his weaponry, thanks to an interaction with the destruction that he caused.

It's disconcerting for some, then, to see *Iron Man 3* followed by five more movies, all of which not only find Tony flying around in his suit again, but also trying even more desperately to achieve security. But the throughline of these remaining films sets up a fascinating arc, one that gives us a chance to consider the relationship between safety and sacrifice.

After seeing a vision of the Avengers defeated and the Earth conquered in *Avengers: Age of Ultron*, Tony dreams of a "suit of armor around the world." But instead of bringing "peace in our time," Tony's plans bring about the robot Ultron, who sees genocide as the only reasonable plan for peace.

In *Captain America: Civil War*, Tony's single-minded insistence that the Sokovia Accords will prevent needless suffering not only pits him against many of his friends, but also ends with Rhodey getting handicapped in the process. In *Spider-Man: Homecoming*, Tony's fear that mistakes by Peter Parker will get the boy hurt leaves Spider-Man underprepared to stop the Vulture.

10. *Lethal Weapon, The Last Boy Scout, The Long Kiss Goodnight, Kiss Kiss Bang Bang*, and *The Nice Guys* all take place at Christmas. "'Christmas represents a little stutter in the march of days, a hush in which we have a chance to assess and retrospect our lives,' Black explained" (Collis, "*Nice Guys* Director Shane Black Explains").

It's not until *Avengers: Endgame*, that Tony finally gives it up. After being stranded in space in *Avengers: Infinity War*, Tony returns to Earth emaciated and defeated. He attacks Captain America with an angry outburst, certain that he had been correct when he demanded a suit around the world. But his argument ends when he falls over and passes out. At that moment, we see the outcome of Tony's commitment to defense: a tired, defeated, and sickly man, making one last bitter attack at his friends.

So it's something of a relief when we visit Tony again in the second act, five years after his return to Earth. Gone is the bitter and worried Tony who we've known so well. In his place is a contented Tony, who has completely left behind his weapons-making to become a devoted husband to Pepper and father to their daughter Morgan (Lexi Rabe). "I got my second chance right here," Tony tells Captain America, when the latter tries to get him to concoct a time travel device and undo the damage done by Thanos.

Of course, Tony agrees to rejoin the Avengers and accompany them on a time travel adventure, which not only pits him in a battle against Thanos, but also allows him to meet his father on the eve of his birth in 1970.

But where his previous calls to action were based on a desire to fix things, a selfish desire to take things into his own hands, this time he takes action based on a discussion with his wife Pepper. Directors Joe and Anthony Russo shoot the decision-making scene with warmth and connection instead of the frustration and desperation that we've seen in previous scenes of Tony entering into action. Both Tony and Pepper stay in frame in the scene, looking at each other. They both confirm the risk that's at stake—the life of peace and happiness they've found—and they acknowledge that they must try for the sake of all others.

The Tony on display here is a far cry from the braggart riding in a Humvee through Afghanistan, and even from the cocky hero who insisted in *Iron Man 2* that he alone could be trusted to beat all the bad guys. This Tony recognizes the importance of sacrifice.

Apropos of a religion based on the life of Jesus, sacrifice is a key part of Christianity. Sacrifice means many things, all part of the radical transformation and acts of service embodied by Jesus. They are most pronounced in the sacrifice of one's life, as indicated by Jesus's declaration recorded in Mark 8:35–37: "For those who want to save their life will lose it, and those who lose their life for my sake, and for the sake of the gospel, will save it."

To be sure, this verse does not teach morbidity, the notion that true Christians live in a death cult that valorizes suicide. On the contrary, it teaches to embrace the abundance of life offered by God's design. However, because following God often puts one in opposition to the powers and principalities of the world, Christians may very well find themselves called to

sacrifice. And rather than support those powers for the sake of saving one's own life, thus repeating the pain inflicted on others, Jesus is clear: it's better to sacrifice.

Tony Stark's death helps us think about this distinction. As Tony has made clear throughout *Endgame*, he does not want to die. He's finally reached a happiness with Pepper and Morgan that he doesn't want to give up. He doesn't put on the armor and fight Thanos because he wants to show off or achieve suicide by supervillain.

But when he sees Doctor Strange, the magician who has watched 14,000,605 variations of their battle with Thanos, lift his index finger to remind him that they stop the Mad Titan in only one, Tony understands. Tony Stark, the consummate selfish man, the futurist who had gone mad for safety, is willing to do what it takes to help others. He's willing to do the one thing that no one else can do.

And so he takes the Infinity Stones, snaps his fingers, and declares one last time, "I am Iron Man."

Jesus closes his teaching in Mark 8 by asking, "For what will it profit them to gain the whole world and forfeit their life? Indeed, what can they give in return for their life?" For most of his life, Tony Stark had profit, and saw nothing more important than profit. He put his faith in the Jericho bomb to defend that profit. He put trust in his suit to defend himself.

But in the end, he put faith in others and sacrificed his life. He saved his soul at the highest price. This is, of course, costly grace, fully embodied in final repentance.

CREDITS:

Iron Man (2008)
Director: Jon Favreau
Screenwriters: Mark Fergus and Hawk Ostby and Art Marcum and Matt Halloway

Avengers (2012)
Director: Joss Whedon
Screenwriter: Joss Whedon

Iron Man 3 (2013)
Director: Shane Black
Screenwriters: Shane Black and Drew Pearce

Avengers: Infinity War (2018)

Directors: Joe and Anthony Russo

Screenwriters: Christopher Markus and Stephen McFeely

Avengers: Endgame (2019)

Directors: Joe and Anthony Russo

Screenwriters: Christopher Markus and Stephen McFeely

POST-CREDITS:

Themes: Grace and Repentance

Key Biblical Phrase: Mark 10:17–30

Questions:

1. So much of the Iron Man story involves Tony Stark trying to be a good man. What "good" things does he do in the movies? How do those good things relate to Jesus's teachings about goodness?

2. As much as the Iron Man movies want to convince the viewer that Tony Stark has stopped selling weapons, it cannot be ignored that the Iron Man armor functions like a weapon, complete with lasers and rockets. Why can't these movies avoid the use of weapons? What would complete rejection of weaponry look like?

3. Early in *Iron Man 3*, Tony's voice-over states "We make our own demons." The movie then goes on to show how making monsters based on our fears can force us to miss opportunities to care for one another. How can Christ's message drive out those demons we make and help us care for one another?

4. I've argued in this chapter that Tony's acts of repentance happen symbolically, that fighting off bad guys helps us think about rejecting our selfish and un-Christlike ways. How do you and others repent from past ideas about yourself? What does it look like when real people set their minds on Christ?

5. Tony's story ends with a spectacular act of sacrifice. We know that Christ calls us to follow his actions and be faithful even unto death but focusing too much on death can profane the joy of the life we've have been given. What are practical, real ways we can sacrifice in our lives to become more Christlike?

6

CAPTAIN AMERICA

Citizen of God's Kingdom

Jesus answered, "My kingdom is not from this world. If my king-
dom were from this world, my followers would be fighting to keep
me from being handed over to the Jews. But as it is, my kingdom
is not from here."

—JOHN 18:36

"What makes you so special?"
"Nothing. I'm just a kid from Brooklyn."
—RED SKULL AND CAPTAIN AMERICA, *CAPTAIN AMERICA: THE FIRST
AVENGER*

FOR ITS FIRST HALF, *Avengers: Infinity War* is great fun. Every time a new
member of the MCU makes their entrance, excitement shocks the audience,
thrilled that one more piece of the shared universe has come together.

So when Steve Rogers aka Captain America (Chris Evans) emerges
from the shadows to take on two menacing minions of Thanos, viewers in-
stinctively cheer. But clear-eyed watchers might notice something different
about the first Avenger.

It's not just that the formerly clean-cut Cap now sports long hair and
a beard. It's that the reds, whites, and blues of his costume have diminished

to a dingy gray. It's that the star that once adorned his chest has been ripped away, leaving an empty space on his uniform.

Even viewers who don't know the comic books well enough to recognize a nod to the Nomad uniform that Rogers wore when he gave up his Captain America identity can tell that Steve feels differently about his country.[1] After bringing down the Hydra-infected SHIELD in *Captain America: The Winter Soldier* and after becoming a fugitive from the law in *Captain America: Civil* War, Rogers has become a man without a country.[2] The nation he once represented has turned against him.

To be sure, there's tragedy in this turn of events. But it's hard not to see that Steve Rogers would eventually outgrow his superheroic identity. The appeal of the *Captain America* movies, and their spin-off series *The Falcon and the Winter Soldier*, is in the difficulty a good man feels representing a country that so often does wrong.

That's a tension that's appealing to Christians. As human beings, we are involved in the world, and that involvement includes governments like those of the United States. And while we certainly owe allegiances to those governments, to a certain degree, our ultimate identity is with the Kingdom of Heaven, as inaugurated by Jesus Christ.

In the struggle of Captain America to do justice, first as Steve Rogers and later as Sam Wilson (Anthony Mackie), Christians can see our own call to love the Lord our God and to love our neighbors as ourselves.

MEET CAPTAIN AMERICA, SENTINEL OF LIBERTY

Before taking over as writer of Captain America comics in 2018, author Ta-Nehisi Coates published an essay in *The Atlantic* entitled, "Why I Am Writing Captain America."[3] Although his comic fandom was well-known, the author of incisive critiques of the racism in the United States seemed like an unlikely pick to tell the latest adventures of a white guy decked out in red, white, and blue. But Coates saw this as a worthwhile intellectual opportunity. Citing a speech from *Daredevil* #233, in which Cap shuts down a general by stating "I'm loyal to nothing . . . except the dream!" Coates asks, "Why would anyone believe in the Dream?"[4]

1. Disillusioned with the US Government, Steve Rogers gives up the Captain America title and becomes Nomad in *Captain America* #180 (1974). Written by Steve Englehart, penciled by Sal Buscema, inked by Vince Colletta, colored by Linda Lessmanm, and lettered by Tom Orzechowski.

2. Russo and Russo, *Captain America: The Winter Soldier*.

3. Coates, "Why I'm Writing *Captain America*."

4. Miller, *Daredevil* #233.

Coates's question and writing project gets at the primary appeal of Captain America, something that MCU movies get surprisingly right about the character. There's an inherent contradiction to Captain America, a good man who endeavors to embody democracy and decency but is often tripped up by the country that claims to support those ideals.

He didn't start out that way. Created by writer Joe Simon and artist Jack Kirby, Captain America made his debut in 1941's *Captain America Comics* #1.[5] To the modern reader, there's little to distinguish Cap's early adventures from those of any other Golden Age hero. They followed the exploits of Steve Rogers, an ordinary GI who is transformed through experimental methods into a super-soldier. In every issue, Captain America and his teen sidekick Bucky (not a man of Rogers's age, but a kid in a Robin-like domino mask) solved various crimes around military bases.

Despite his genre constraints, Captain America was a big hit among comic books' most rabid fanbase, American soldiers. The patriotic trappings and fantasies of socking Hitler in the jaw, as portrayed on the cover of *Captain America Comics* #1, resonated with soldiers and made Cap a sensation. But that same nationalist fervor brought the character down after the war.

Sales of superhero comics started to plummet after GIs returned home and put aside such childish things. Atlas Comics, the precursor to Marvel Comics, tried to keep Cap and Bucky relevant by rebranding the hero as a "commie-buster," who sought out fifth columnists undermining the American way. The new direction failed to draw readers, and by 1954, Captain America had disappeared from shelves across the country.

It wasn't long before comics called Cap back to duty. "Captain America Lives Again!" declares the cover to *Avengers* #4, complete with a typically kinetic Kirby drawing of Cap leaping in front of the titular team. Written by Stan Lee, the story finds the Avengers reviving Cap, who has been frozen in ice since the end of World War II, when he and Bucky sacrificed themselves to stop a drone attack by the evil Baron Zemo. Where Bucky perished in the attack (Lee always hated teen sidekicks), Cap remained in suspended animation, completely unaged from the day he hit the water.[6]

The story not only connected the upstarts of the Marvel Age to the golden age of comics, but it also gave Captain America a new status quo. No longer the upright Sentinel of Liberty from his World War II days, Cap was now a conflicted man out of time.

5. Simon and Kirby, *Captain America Comics* #1.

6. The "commie-smasher" Caps from the 1950s will later be revealed to be imposters, one of whom will become the evil Ku Klux Klan-inspired Grand Director.

Initially, writers portrayed that disillusionment by making Captain America a bit of a square and a relic compared to the hip mods of the 1960s. But over the years, Cap's outsider status became more aligned with the values of the American Dream than with any particular time period. As Captain America, Rogers fought for the dignity and rights of all, of democratic government by the people and for the people, which often put him against the administrations he worked for.

This attempt to embody values that so rarely exist that make Captain America such a compelling character. Various attempts to bring Captain America to film and television have failed, in large part because they forget this tension, and portray him as a single-minded patriotic sap.[7] Although Cap's entries in the 1966 *Marvel Super Heroes* cartoon directly adapted his origin and Avengers appearances, two 1979 TV movies starring Reb Brown emphasized the character's military bravado. A 1990 direct-to-video release from Canon Pictures starred Matt Salinger in the title role, who wakes up from the ice to discover that his old enemy the Red Skull is masquerading as an anti-environmentalist Italian criminal.

Despite their limitations in budget and effects, all these releases failed to grasp the thing that makes Captain America interesting. It isn't just that he's a patriotic superhero who wakes up in modern times. It's a steadfast belief in decency and justice, ideals that put him at odds with the country he's supposed to represent.

CAPTAIN AMERICA AND THE CROSS OF CHRIST

"If any want to become my followers, let them deny themselves and take up their cross and follow me." This well-known declaration of Jesus, recorded in Matt 16:24, has often been interpreted by modern Christians as a call for individual morality. However, while that's certainly part of the teaching, the interpretation treats the cross as an idea instead of a real and existent threat for Jesus's original audience.

In *The Day the Revolution Began*, New Testament scholar N. T. Wright explains the significance of the cross. Before it became a piece of jewelry or a signifier of a religion, the cross was a form of Roman capital punishment. More specifically, it was the spectacular way that the Romans punished those who dared to question their authority. It was a way to show everyone

7. The notable exception here is a 1944 serial produced by Republic Pictures. Directed by Elmer Clifton and John English, *Captain America* bore only the slightest resemblance to its comic book counterpart. Dick Purcell starred as District Attorney Grant Gardner, who doubles as the masked crime fighter Captain America, and Lionel Atwill played Dr. Cyrus Maldor, secret identity of the villainous Scarab.

what happens to those who talk about an empire other than Rome, a god other than Caesar.

In other words, Jesus's original audience to whom he spoke in the passage in Matthew wouldn't have had the luxury to think in metaphorical terms. They were following a person talking revolution and revolt. The cross was imminently political.

But where the distinction between Christ and empire was clear to the first-century church, those lines blurred when Roman emperor Constantine adopted Christianity as his religion. No longer standing in contradiction to imperial power, Christianity became the subject of it, a model that continued in the European nations that rose after the fall of Rome, all the way through their colonial remnants, including the United States.

Today, that conflation of power and morality still exists, especially in the US. The country has put forward what Greg Boyd has called "the myth of a Christian nation," one that insists that the US is uniquely blessed by God, given the right and responsibility of leading "Christian" values of freedom and individualism.[8]

While there certainly can be some overlap between American rhetoric and the teachings of Christ, it's hard to see where the US follows either the greatest commandment or its similar second: "You shall love the Lord your God with all your heart, and with all your soul, and with all your mind . . . You shall love your neighbor as yourself" (Matt 22:37–39).

Instead, the American history of indigenous genocide, enslavement of Africans, patriarchic institutions, rampant capitalism, and faith in military strength shows love for neither God nor the neighbor. In fact, the treatment of prophets who decry America's sins, whether they be Martin Luther King Jr. or Cesar Chavez or Harvey Milk, demonstrates that America likes to exercise its power just as much as Rome and other empires.

That fact can be depressing, especially for people like me, who have always lived in American privilege. But Christ gives us an example of loving God while living in a godless empire. We see it laid out in his inquisition with Pilate, a governor representing the power of the Roman Empire.

After he has been sentenced and flogged in John 19, Jesus refuses to answer further questions from Pilate. "Do you refuse to speak to me," he asks before attempting to assert dominance over Jesus. "Do you not know that I have power to release you, and power to crucify you?" But Jesus puts Pilates's threats into cosmic perspective: "You would have no power over me unless it had been given you from above; therefore the one who handed me over to you is guilty of a greater sin" (John 19:10–11).

8. Boyd, *Myth of a Christian Nation.*

Indeed, Pilate has forgotten the lesson Jesus gave him earlier, during the first round of questioning. "My kingdom is not from this world," Jesus told Pilate. He draws a distinction between the type of power exercised by Rome and the power of the God who sent him. "If my kingdom were from this world, my followers would be fighting to keep me from being handed over to the Jews," explains Jesus. "But as it is, my kingdom is not from here" (John 18:36).

This conversation reveals what Jesus means by taking up one's cross and following him. As a "particular form of execution reserved by the Roman Empire for insurrectionists and rebels . . . a public spectacle accompanied by torture and shame," the cross is intrinsically an instrument of earthly power. But by dying on the cross and then overcoming death, Christ transforms that symbol. James H. Cone puts it best when he writes, "The cross is a paradoxical religious symbol because it inverts the world's value system with the news that hope comes by way of defeat, that suffering and death do not have the last word, that the last shall be first and the first last."[9] In light of this fact, taking up one's cross means standing against the ways of the world and living as a citizen of the kingdom of heaven.

It is not mere good thinking and moral behavior, but a radical devotion to follow the teachings of the sermon on the mount. It's loving God and your neighbor as yourself in the manner demonstrated by Jesus. These actions bring us into conflict with earthly forms of power. "Central to Christianity is sacrificial love and the laying down of one's life," write Mark Charles and Soong-Chan Rah. "Empires are concerned with self-preservation, conquest, and expansion."[10] Thus, while our embodiment of Christ's teachings happens within the context of powerful empires, they are not determined by it. Our kingdom is not from here, our citizenry is in heaven.

Because of that tension of being in the world but not of the world, the movie version of Captain America has resonance with Christians. In the struggles of Steve Rogers and Sam Wilson to have compassion and to treat others with dignity, sometimes for and often against the country they represent, we can see our own work of taking up our cross and following Jesus.

TO THE LITTLE GUYS

If you asked Colonel Phillips (Tommy Lee Jones), the United States military has found its man. As the leader of a project to find the perfect test subject for an upcoming experiment to create a super soldier, Phillips sees

9. Cone, *Cross and the Lynching Tree*, 1–2.
10. Charles and Rah, *Unsettling Truths*, 58.

everything he needs in recruit Gilmore Hodge (Lex Shrapnel). A tough soldier who knows how to take orders, Hodge will only get better once he's injected with a serum that will make him even bigger, faster, and stronger.

The lead scientist on the project, Abraham Erskine (Stanley Tucci) isn't convinced. "He's a bully," Erskine warns.

To a military man like Phillips, Erskine's complaint makes no sense. They're trying to take on Adolph Hitler and the Nazis. To beat a bully like that, you need an even bigger bully. "You don't win wars with niceness, Doctor," he sneers. "You win wars with guts."

Phillips proves his point by tossing a dummy grenade in front of the practicing men, shouting at them to take cover. All the soldiers, including big and strong Hodge, run away. All except for one.

Steve Rogers, the skinny asthmatic who had been denied for service five times before being cleared by Erskine, dives onto the grenade, wrapping his frail body around the explosive and telling others to save themselves.

"He's still skinny," Phillips quips as he walks away.

In the latter half of *Captain America: The First Avenger*, Steve Rogers shows lots of guts. Having been augmented by the super-soldier serum created by Erskine and equipped with an indestructible vibranium shield designed by Howard Stark (Dominic Cooper), Steve is nearly unstoppable as Captain America.

Director Joe Johnston, who got his start making special effects for *Star Wars* and *Raiders of the Lost Ark*, taps into the nostalgic heroism of those movies with his action montages.[11] Immersed in sepia tones and accompanied by a soaring score from Alan Silvestri, *The First Avenger* shows us Cap driving his motorcycle through the high-tech forces of Nazi splinter group Hydra, reflecting their otherworldly weapons with his shield, and rescuing prisoners of war.

But it's not guts that Erskine saw that day when Rogers jumped on the grenade. It was selflessness, a desire to help people with everything he has, even his own safety.

As an action movie, *The First Avenger* reframes ideas about power from those of strength and brute force to those of selflessness and compassion. Those qualities explicitly run contrary to the worldly powers of empire, represented here by the machinations of the Nazi Party and their fictional science division, Hydra. By imaging selflessness and compassion as powers greater than the arrogance of Hydra, *The First Avenger* reminds Christians of the power we've been given to resist earthly kingdoms and follow Christ.

11. Johnston famously designed Boba Fett's costume for *The Empire Strikes Back*. He also designed the titular creature from the 1999 animated film *The Iron Giant*.

That tension is demonstrated in the broad portrayal of Hydra leader Red Skull (Hugo Weaving), a man so convinced of his own exceptionalism that he has surpassed even the Nazis. "He believes he walks with the gods," the captured Hydra scientist Armin Zola (Toby Jones) tells Colonel Phillips of the Red Skull, a fact fully embodied by Weaving's performance. The Skull strides through every scene, declaring his greatness and demeaning all he finds beneath him. He interrupts a montage of Cap's exploits by staring directly at the screen and screaming, "You are failing!" as if his disappointment extended all the way to the audience.

The first recipient of Erskine's super-soldier serum, Red Skull sees his frightening visage, a side-effect of the chemical's earlier version, as proof of his evolution. Ripping away the mask of human skin he wore over his true face, Red Skull mocks his fellow super-soldier Rogers. "You pretend to be a simple soldier, but in reality, you are just afraid to admit that we have left humanity behind," he declares with glee.

As a manifestation of Nazi exceptionalism and the destructive ends of the arms race, the Red Skull is a mistake that Erskine does not want to repeat. He sees in Rogers the opposite of the Red Skull's pretenses to power. Where the Red Skull demanded the serum to take his place among the gods, Rogers just wants to do his part to stop bullies.

That's what Erskine saw when Rogers covered a grenade with his body. Not guts, but selflessness. He's not interested in fighting or proving his power, but in helping others with whatever he has, even if it costs his life.

That principle drives the movie's best scene, set the night before the procedure which transforms Rogers into Captain America. A German himself, Erskine describes the country's descent into fascism as a response to their loss in World War I. Where the loss made them feel "weak" and "small," Hitler's parades and flags made them feel strong.

That's particularly true of the Hydra scientist Johann Schmidt, who forces Erskine to give him the serum. "The serum amplifies everything inside," Erskine explains. "So good becomes great, bad becomes worse." That distinction is why Erskine chose the little weakling Rogers to become the next recipient of his serum: "Because the strong man who has known power all his life may lose respect for that power, but a weak man knows the value of strength."

Erskine's search for the little guy, looking beyond "qualities of the physical," bring to mind Samuel examining the sons of Jesse for the next king of Israel. Where Samuel is impressed with the strength and height of Jesse's oldest sons, God instructs the prophet, "Do not look on his appearance or on the height of his stature, because I have rejected him; for the Lord

does not see as mortals see; they look on the outward appearance, but the Lord looks on the heart" (1 Sam 16:7).

More specifically, those who know the power of the world, in the form of physical strength or appearance or influence, are reluctant to give up on that strength. But God's work in history is one of liberation. The kingdom preached by Christ runs contrary to those of the world. The gospel cannot be good news to those who have succeeded in the earthly kingdoms, who have known power and want to keep it, regardless of how many it hurts. But to the poor in spirit, the peacemakers, and the mourners, Christ's good news involves power to those who love others and sacrifice.

More than his military garb and mighty shield, this is what Captain America represents: the little guy with the guts to hold to kindness and compassion against the power-hungry ways of the world.

BUILDING A BETTER WORLD

As in the comics, Cap's sacrifice during World War II leaves him not dead, but frozen. He awakens in the modern day and tries to find comfort, first by joining the Avengers and then by working for the global defense organization SHIELD. But by the opening of *Captain America: The Winter Soldier*, Cap is already troubled by his boss's aims.

When confronted by Cap's hesitations, director of SHIELD Nick Fury (Samuel L. Jackson) gets defensive. "Greatest generation," he mocks. "You guys did some nasty stuff."

Cap doesn't disagree, admitting, "Yeah, we compromised."

That's a surprise to viewers of *The First Avenger*. That movie dissolved all shades of grey in a sepia glow, pitting the undeniably good Captain America against the simplistic evil of Red Skull and Hydra. If Rogers and his cohorts compromised, it wasn't on screen.

Still, away from the nostalgic bombast of the first film and back into the real world, it's easy to accept Fury's charges. No matter how evil the Nazis certainly were, fascism is hardly contained to early twentieth century Germany. Many developed nations have participated in acts of genocide and terror, as demonstrated by American evils such as the attempted eradication of Indigenous peoples, the enslavement Africans and continued oppression of their ancestors, internment camps for Asian Americans, aggressive harassment of Latinos, and more. In pursuit of safety, the United States has been bent on destroying even those who may look like enemies.

To that end, *The Winter Soldier* is a far more realistic film. Sure, it involves sky-bound super-carriers, immortal cyborg assassins, and

super-soldier Captain America. But the motivations of the nations portrayed better mirror those of real-world powers. As its name suggests, SHIELD sees itself as the necessary protection against a world of chaos and disorder. It protects people through force, it brings safety through restriction.

It's that logic that drives Fury to launch Project Insight, an initiative to send a fleet of heavily-armed carriers into the sky. These carriers allow SHIELD to eliminate threats almost immediately, sacrificing due process and justice in the name of safety. Secretary Alexander Pierce (Robert Redford), a high-ranking SHIELD official, puts it like this: "despite all the diplomacy and the handshaking and the rhetoric, to build a really better world sometimes means having to tear the old one down."

Even if Fury and Pierce can't see it, that type of antagonism isn't that far off from the logic of the Nazis, who sought to build a better world by eliminating those they found lesser. But it's a point the movie makes with the revelation that SHIELD has been infiltrated by Hydra long ago.

The revelation comes in the form of a sci-fi premise, in which a digitized Armin Zola delivers his evil plan in a ridiculous accent, complete with imagery of chaos all presented on 1970s computer screens. In between his mad monologue about world domination and secret societies, Zola displays footage of uprisings, stock market crashes, and terrorist attacks. These are not the fantastic creations of the MCU, but real things from the real world, events that scare us.

Zola describes he and his Hydra accomplices as "a beautiful parasite inside SHIELD," but the truth is that the two groups always had the same perspective. Order through violence, safety at the cost of humanity.

Against the focus on safety and control, *The Winter Soldier* repeatedly reminds us of the cost of this violence. Rogers performs missions alongside fellow Avenger Black Widow (Scarlett Johansson), an experienced spy who worries that her work has eroded her conscience. New partner Sam Wilson holds support meetings for veterans to talk about the trauma they still carry after leaving the service. Wilson himself recounts how the death of a fellow soldier disillusioned him and prompted him to leave the Air Force.

But the most striking example comes in the form of the titular Winter Soldier. A perfect killing machine with a mechanical arm, we learn about the Winter Soldier as a legend long before he appears on screen.

In his first attack on Nick Fury, directors Joe and Anthony Russo emphasize the Winter Soldier's otherworldly efficiency. He first appears as blurry object standing in the middle of the road. The soundtrack cuts to silence, save for a single high-pitched note that intensifies as the Soldier comes into focus. He remains unbothered as Fury's demolished car flies by him. He marches mechanically toward the wreck to kill his prey.

Those inhuman attributes grow all the more chilling when, in the middle of a fight with Rogers, his mask falls to reveal that the Winter Soldier is in fact Bucky Barnes (Sebastian Stan), Steve's old friend from World War II.

Bucky is a complete casualty of war, a study in how war robs all participants of their humanity. Bucky seemed to die in *The First Avenger*, when he fell from a train during a raid on Hydra. But he was kept alive, turned into a cybernetic assassin for Hydra. Not only has the experience stripped Bucky of any of his previous personality, but it has also removed memories of the people he loved. They've left him only with the attributes he gained from the US military back in World War II: deftness with a knife and with a sniper rifle.

In Bucky's empty eyes, we see a reminder of the cost of war, as described in Scripture. There's a reason that Jesus mourns the calls for violence in Jerusalem (Luke 13:34) and warns Peter that "all who take the sword will perish by the sword" (Matt 26:52). Walter Wink reminds us of the shortcomings in English translations of the Greek word *antistēnai* in Matt 5:39, which make the text claim "Do not resist an evildoer," despite all of the resistance in Jesus's own ministry. Rather, Wink contends, the word better translates to "Do not retaliate violence with violence," precisely because doing so brings one to the same profanity of God's creation.[12]

It's this point that represents the clearest division between Rogers and the US government. Alongside Black Widow and Sam, who has become the winged hero Falcon, Rogers suits up to thwart Hydra's appropriation of the Project Insight helicarriers and to expose SHIELD to the world. But more importantly, he makes the reclamation of Bucky his primary mission.

There may be fisticuffs between the two, as Bucky tries to prevent Steve from shutting down the helicarriers. But after that larger threat has been stopped, so also does the battle between them. Instead, Steve stops the Winter Soldier by acknowledging his humanity. "You've known me your whole life," he tells him. "Your name is James Buchanan Barnes." The Soldier responds with anger, attacking the very reminder of the life he lost, but Rogers drops his shield and refuses to fight back. This isn't an enemy he wants to destroy. This is a friend he wants to love.

Bucky gets Rogers into a lot of trouble, in this film and in the future. At the end of the movie, Rogers has abandoned the Captain America mantle to go look for Bucky. It's that same allegiance that makes him a fugitive of the law and an enemy to many of his fellow Avengers in *Captain America: Civil War*, as he refuses to turn the framed Bucky over to authorities.

12. Wink, *Jesus and Nonviolence*, 11.

But in that devotion to a person against the demands of the government, we see a distinction between the kingdom of God and the earthly kingdoms represented by the United States. In God's kingdom, every life matters, every person matters, and that takes precedence over safety.

SYMBOLS AND PEOPLE

In the MCU, the story of Steve Rogers ends with *Avengers: Endgame*. After using the Infinity Stones to defeat Thanos and bring back the billions snapped out of existence, Rogers goes back in time to return the Stones to their proper place. But instead of going back to the future, Rogers decides to retire and spend his life with his one great love Peggy Carter (Haley Atwell). When Bucky and Sam Wilson see Rogers again, he's an old man who has had a good life, ready to pass on the mantle.

In the first episode of the Disney+ series *The Falcon and the Winter Soldier*, not only is Sam still using his Falcon persona, but he has decided to pass up the opportunity. Standing on the stage in a windowed room in the Smithsonian Museum, a giant banner bearing the image of Steve Rogers towering like a sentinel above him, Sam officially donates the shield to the vaunted museum. Cutting to an extreme close-up, director Kari Skogland captures the indecision wracked on Wilson's face. "We need new heroes," Wilson declares.

"Symbols are nothing without the men and women who give them meaning," he explains, before deciding that no one can better embody the symbol than Steve Rogers. Each of the series' six episodes, directed by Skogland and guided by showrunner Malcolm Spellman, explore that tension between symbols and real people. For Sam, Steve Rogers fought for the ideal that every person mattered, often against the nation that claimed to be democratic. As a Black American, Sam not only feels like he can't take up that fight but also that he isn't sure that he wants to. As the television critic Sophie Gilbert so accurately puts it, *The Falcon and the Winter Soldier* doesn't ask if Sam is worthy of the shield, but rather the show wonders if the shield is worthy of him.[13]

Ultimately, the show argues that it is, and ends with Sam becoming the next Captain America. But it makes this argument through a series of contrasts. These contrasts certainly include Bucky the Winter Soldier, the traumatized former assassin who learns to take on the hard work of making amends for past sins, but most importantly, they involve a new Captain America chosen in Sam's place.

13. Gilbert, "Power of a Skeptical Captain America."

At first glance, Army captain John Walker seems like a fine successor to Steve Rogers. A one-time football star turned decorated soldier, Walker says all the right things in his introductory interview. Played with affable charm by Wyatt Russell, Walker has nothing but respect for Rogers and does his best to work with Sam and Bucky, in their investigations into an insurgent group called the Flag Smashers.

But very quickly, Walker shows himself as someone who puts symbols over people. When a sympathizer with the Flag Smashers refuses to cooperate with his investigations, Walker bellows, "Do you know who I am?" Walker refers not to who he actually is, a soldier sent by his superiors to undergo a military mission to advance the interests of the United States, but rather the symbol he's taken on, that of Captain America. And to Walker, Captain America symbolizes power.

It's this obsession with Captain America's power that leads to the downfall of Walker. Convinced that Captain America must be as unstoppable as the country he serves, Walker feels deeply insecure whenever he's challenged. That insecurity only increases when Walker discovers that several of the Flag Smashers have been augmented with the super soldier serum, giving them strength that he lacks.

But as Erskine warned Rogers decades earlier, the serum increases what is inside its user. Walker grows mad with power, especially after a Flag Smasher kills his partner Lamar Hoskins (Clé Bennett). Angry over the death of his friend and humiliated that he could not stop it, even with superpowers, Walker goes mad with rage. After chasing down the perpetrator, Walker stands over the defeated man and ignores his pleas, slamming the star-spangled shield onto his enemy.

Beating his adversary to a pulp, Walker straps the shield back onto his wrist. The camera takes a worms-eye view, looking up at Walker as he stands triumphant, finally manifesting in the Captain America he was meant to be: victorious over all enemies, burning with self-righteous anger, blood splattered on the red, white, and blue of his shield.

Although he will become a very different type of Captain America, Sam first has to wrestle with the fact that Walker better represents the country as it has been and as it is. Not only does Sam not want to the country, but he isn't sure that the country wants him, a Black man.

For a Disney+ continuation of a MCU mainstay, *The Falcon and the Winter Soldier* is surprisingly frank in its depiction of American racism. Throughout the series, we see glimpses of the micro-aggressions directed at Sam and other Black Americans, from denied bank loans to harassment from police.

But the most striking reminder of America's racist power comes in the form of Isaiah Bradley (Carl Lumbly), a Black super-soldier who served in the Korean War. In a story that recalls real-world incidents such as the Tuskegee Experiment, we learn that Bradley and other Black GIs were made unwilling test subjects when the US wanted to recreate the serum that made Rogers into Captain America.[14] Most of the subjects died in the process, but Bradley gained powers.

Although the government never made Bradley an official Captain America, they did send him into the field. On one of the missions, Bradley was captured by Hydra agents, who performed experiments on him. When he broke free and returned to the US, American doctors performed their own experiments on him. Finally, after several years in prison, Isaiah was released, his work and identity never acknowledged by the government.

Bradley represents not just a threat of what might happen to Sam if he becomes Captain America. He also represents the reasons that Sam shouldn't take on the title. Bradley puts it directly when he says, "They will never let a Black man be Captain America. And even if they did, no self-respecting Black man would ever want to be." Time and time again, the country has shown how it treats Black people as less than human. Why would Sam want to represent that country?

The answer that Sam eventually gives is that he wishes to follow in the footsteps of Steve Rogers. Like his predecessor, Sam doesn't fight for the country as it is, but he fights to make the country into what it claims to be: a government for the people by the people. He too is loyal to nothing but the dream.

But more importantly, Sam couches his heroics in an emphasis on the dignity of all people. Throughout the story, we see Sam approach problems not by fighting, but through listening and empathy. His first face-to-face encounter with Flag-Smasher leader Karli Morgentheau (Erin Kellyman) isn't a knockdown battle, but a conversation, in which Sam acknowledges her pain and her humanity. His big moment in the last episode, when he finally dons the Captain America costume, isn't a battle to the death, but a speech in which he chastises leaders of the world to better care for the displaced in their midsts.

In other words, Sam still believes that symbols mean nothing without the people who give them meaning. And he embodies the symbol of Captain America by treating people as people.

14. The story comes directly from the 2003 Marvel Comics miniseries *Truth: Red, White, and Black*, written by Robert Morales, drawn by Kyle Baker, and lettered by Wes Abbott.

That's a position that runs directly contrary to the power sought by Johann Schmitt, John Walker, and earthly leaders all throughout history. The kingdoms of the world find all sorts of ways to justify their power, painting themselves as paragons of virtue or inheritors to superior rights. But the kingdom of heaven is the one that Jesus described in the Sermon on the Mount, a kingdom where God preferences the peacemakers and the meek and the poor in spirit.

Whether featuring Steve Rogers or Sam Wilson, the Captain America movies illustrate this tension, a tension between the world's power and the power that Christ embodies, power that comes from the least of these.

CREDITS:

Captain America: The First Avenger (2011)
Director: Joe Johnston
Writers: Christopher Markus and Stephen McFeely

Captain America: The Winter Soldier (2014)
Directors: Joe Russo and Anthony Russo
Writers: Christopher Markus and Stephen McFeely

Avengers: Infinity War (2018)
Directors: Joe Russo and Anthony Russo
Writers: Christopher Markus and Stephen McFeely

The Falcon and the Winter Soldier (2021)
Director: Kari Skogland
Showrunner: Malcolm Spellman

POST-CREDITS

Theme: God's Kingdom

Key Biblical Passage: John 18:36

Questions:

1. Why is patriotism so compelling for Christians? Why do we so easily put love of country over love of people?

2. Captain America stories suggest that the pursuit of power leads to corruption. How does the birth, life, and death of Christ illustrate God's perspective on power? Why does that perspective so often run contrary to the perspectives of the world?

3. In *The Winter Soldier*, Steve Rogers becomes a fugitive because of his care for his friend Bucky. What have you given up in defense of other people? How does that sacrifice mirror the love God has for us?

4. In *The Falcon and the Winter Soldier*, we get some of the only depictions of superheroes talking through problems with supervillains. Why are these depictions so rare? How do these depictions reflect the teachings of Christ?

5. In your perspective, do "the little guys" have power in the world? Why is that the case? How does this fact relate to God's promises about power and discipleship?

7

ORIGINS, NAMES, AND FAITH

Captain Marvel—Aquaman—Shang-Chi—Shazam

Now faith is the assurance of things hoped for,
the conviction of things not seen.

—HEB 11:1

You can't outrun who you really are.

—WENWU, *SHANG-CHI AND THE LEGEND OF THE TEN RINGS*

A LITTLE GIRL RACING down a go-kart track.

An Air Force recruit scaling ropes during basic training.

Two women singing rock songs in a bar.

No one would expect to find these images in the mind of the cosmic warrior Vers (Brie Larson), who serves in the far reaches of space in the army of the galactic Kree Empire. Vers may not remember anything from her past, but that doesn't seem to trouble her. Under the fierce tutelage of her friend and commander Yon-Rogg (Jude Law), Vers has become a formidable member of an elite force. Whatever came before is irrelevant. Vers knows who she is.

But then again, there's something intruiging about those images, especially during an interrogation session conducted by the shapeshifting Skrulls—a race of aliens who have captured Vers in an attempt to resist the Kree army. With their help, Vers discovers that she isn't just a space warrior,

but a human who has been kidnapped by the Kree and used as a weapon of their empire.

Directed by Anna Boden and Ryan Fleck, *Captain Marvel* is the perfect example of an origin story. The movie shows us how the human Air Force pilot Carol Danvers became Vers, a soldier for the oppressive Kree Empire, and eventually the superhero Captain Marvel.[1]

But more importantly, it's an example of how faith plays into origin stories. As this scene illustrates, *Captain Marvel* shows how Danvers's belief in her identity and values push back against the reality that her Kree captors created for her. The world appeared to be one way, but Danvers believed it was something different, and acted accordingly.

By looking at acts of faith in superhero origin stories, Christians can imagine the relationship between our beliefs and the vocation set before us.

THE ORIGIN OF ORIGIN STORIES

In the early days of comic books, very little attention was given to origin stories. *Action Comics* #1 spends only half a page on Superman's beginnings, barely sketching out his escape from a dying planet and the development of his powers before moving along to an adventure tale. Batman gets six full stories before we learn the barest details of his origin in *Detective Comics* #33.[2] The creation of Captain America takes a whole story, but it's only one of four of the hero's tales in *Captain America Comics* #1.

As these examples show, the first comic book readers weren't interested in how a hero came to be. They just wanted to watch them in action, thrilling on the daring do and unbothered by the human side.

But by the time DC characters were revitalized in the late 1950s, and especially with the advent of Marvel comics in the early 1960s, origin stories were a necessary part of introducing a new hero.

When 1956's *Showcase Comics* #4 brought in a new Flash, several pages showed the perpetually late Barry Allen getting struck by lightning and discovering super-speed before he put on his familiar red suit.[3] Two years later, the first story in *Showcase Comics* #22 doesn't put new Green Lantern

1. Carol Danvers has one of comics' most convoluted storylines, even before she took the name Captain Marvel. Since her first appearance in 1963's *Marvel Super-Heroes* #13, Danvers has taken on many names, including Binary, Ms. Marvel, and Warbird. The name Captain Marvel has belonged to many different characters within the Marvel Universe and did not become the code name of Danvers until 2012's *Avenging Spider-Man* #9.

2. Finger and Kane, "Legend: The Batman."

3. Kanigher and Infantino, "Mystery of the Human Thunderbolt."

Hal Jordan into his green and black uniform until the very last panel.[4] In these comics, the iconic figures of old were reimagined into regular human beings who were given amazing abilities.

That feet of clay approach became a calling card when Marvel Comics launched with 1961's *Fantastic Four* #1. The issue begins en media res, with the members using their powers to thwart a monster from the deep. But it then quickly flashes back to show our heroes being bombarded with cosmic rays, their bodies changing. While the flashback ends with the heroes taking on superhero code names, the Four don't wear uniforms at all in the issue.

Over time, origin stories have become the norm. Every few years, comic book writers retell or reimagine a hero's origin, updating it for modern times (as in the 2005 to 2006 "Extremis" storyline from *The Invincible Iron Man*, which gave Tony Stark nanobots instead of a clunky iron suit), or giving it a more complex and mature spin (as in the great *Batman: Year One* from 1987).[5] Even the X-Men character Wolverine, who for decades had a past shrouded in mystery, eventually starred in *Wolverine: The Origin*, which laid bare his secret past.[6]

For the most part, all superhero movies tell origin stories. 1991's *The Rocketeer* shows us how down-on-his-luck stunt pilot Cliff Secord (Billy Campbell) found an experimental jet pack to become the Nazi-busting Rocketeer. In the 1982 Wes Craven movie *Swamp Thing*, we watch scientist Alec Holland (Ray Wise) get attacked by the goons of Dr. Anton Arkane (Louis Jordon) to become the monstrous hero Swamp Thing.

Sure, some exceptions—*The Shadow* (1994), *Tank Girl* (1995), and *Daredevil* (2003)—only give us occasional glimpses of the hero's creation. But for the most part, origins are so important that even when we all know that, say, Superman comes from the doomed planet Krypton or that Spider-Man was bitten by a radioactive spider, those plot beats need to be part of *The Amazing Spider-Man* and *Man of Steel*. They've become the de facto starting point for any basic superhero story.

FAITH AND FORMATION

It's no surprise that origin stories would be so compelling. They help us make sense of our heroes, allowing us to see them as human beings. In an origin story, we see how a character develops from a regular person to someone with amazing powers, someone who would put on an outlandish

4. Broome and Kane, "S.O.S. Green Lantern."
5. Ellis and Granov, "Extremis." and Miller, "Batman: Year One."
6. Jenkins and Kubert, *Wolverine: The Origin*.

costume and go fight crime. Most importantly, they help us see ourselves in a hero's cape and boots.

Unsurprisingly, given its wide range of genres, origin stories are common in Scripture. Genesis starts as an origin story for humanity, explaining how God created humans and how humans fell into sin. The genealogies in Matthew and the Christmas story in Luke provide an origin story for Christ, explaining how a carpenter from Galilee came to shock the Roman Empire.

According to author Rachel Held Evans, Scripture's origin stories "remind us we belong to a very large and very old family that has been walking with God from the beginning." Thanks to this reminder, we understand that "God is in it for the long haul," that we "will not be abandoned," even "when we falter and fall."[7]

In other words, origin stories are stories of faith. In them, a person finds their life radically changed, and with it, their understanding of the world and how they will respond to it. When he decided to take up the identity of Batman, Bruce Wayne had an outlet to right the wrongs that haunted him. When he was bitten by a radioactive spider, Peter Parker realized that he had a responsibility greater than he had previously known.

These origin stories feature heroes who change their perspectives and their missions. They understand the world in a radically different way. They take faith.

In the series of lectures collected in *Dogmatics in Outline*, German theologian Karl Barth describes the transformative nature of faith. Against those who would describe faith as "not irrational, not anti-rational, not supra-rational," Barth insists that faith is "rational in the proper sense . . . Faith means knowledge."[8] By this, Barth means that the Christian faith requires trust and confession in the promises of God against all other things that would make claims to the nature of reality, such as economic or political systems.

Because faith comes from looking at the world through the logos (logic) of God, a believer "can no longer ask, What is the meaning of my life?" because "by believing he actually lives the meaning of his life . . . He recognizes the task assigned to him in this whole, and the hope vouchsafed to him in and with this task, because of the grace by which he may live and the praise of the glory promised him, by which he is even here and now secretly surrounded in all lowliness."[9]

7. Evans, *Inspired*, 21.

8. Barth, *Dogmatics in Outline*, 23.

9. Barth, *Dogmatics in Outline*, 26.

Barth's countryman Paul Tillich gets at a similar idea when he describes faith as "the state of being ultimately concerned," the guiding principle of understanding.[10] For Tillich, all humans put their faith in something, because they are all ultimately concerned with that thing. The content of that faith—whether it be God or nations or financial success, etc.—drives their actions and their outlook. For that reason, faith belongs wholly to neither one's "rational functions" nor is it "an act of the unconscious," but rather, "an action which the rational and the nonrational elements of [the faithful person's] being are transcended."[11]

The "dynamics of faith," as Tillich puts it, involve the relationship between a person's faith and the reality they make. For Tillich, this fact makes it paramount that the content of faith be the God of Israel, the God embodied in Christ. "Idolatrous faith," faith in anything other than God, necessarily leads "to a loss of the center and to a disruption of the personality," which cannot be sustained even by the "ecstatic" feelings one has through an act of faith.[12]

Both of these ideas can be traced to the simple definition put forward by the writer of Heb 11, which begins with this declaration:

> Now faith is the assurance of things hoped for, the conviction of things not seen. Indeed, by faith our ancestors received approval. By faith we understand that the worlds were prepared by the word of God, so that what is seen was made from things that are not visible. (Heb 11:1–2).

No matter what the world may seem to look like—a world in which pursuit of wealth and power is the highest good, in which the evil prosper and the good suffer—faith means understanding that God's logic supersedes all of these forces, and living accordingly.

But as the writer of Hebrews makes abundantly clear, faith cannot be merely private and ineffective. Indeed, the Scripture goes on to describe people whose faith moved them to action, from Noah who "built an ark to save his household" (Heb 11:7) to Abraham who "obeyed when he was called to set out for a place . . . not knowing where he was going" (Heb 11:8) to Moses who "refused to be called a son of Pharaoh's daughter" (Heb 11:24). In each of these cases, faith lead to public and often political action.

It's that belief in the realness of God and in God's promises that makes faith so dangerous. Indeed, we see the way faith shapes the world most

10. Tillich, *Dynamics of Faith*, 1.

11. Tillich, *Dynamics of Faith*, 7.

12. Tillich, *Dynamics of Faith*, 14.

clearly among oppressed Christians, such as believers of color in the US, believers resisting Hitler in 1930s Germany, believers seeking peace in war torn East Asia, and more.

Writing during apartheid, South African theologian Bonganjalo Goba gets at that idea when he insists that "To have faith in Jesus is to oppose apartheid . . . to participate in struggles for justice and peace wherever they are pursued."[13] As opposed to the private faith of white South Africans, who enjoy the privilege afforded by the racist system, Black faith must be practical and embodied. In the face of "a white, racist, and capitalist society," the Christian faith of Black South Africans opens up "new possibility for theological creativity within our communities."[14]

Origin stories powerfully illustrate this aspect of faith. In each case, the character begins wracked with doubt, certain that they are not equal to the journey to which they are called. But as the story unfolds, the character embodies heroics by accepting their calling, by becoming one with it.

AQUAMAN AND THE QUEST FOR A NAME

As the triumphal strains of Rupert Gregson's score soar in the final moments of *Aquaman*, we transition from disparate locations. The first is atop of a strange, oblong warship in the center of the ocean, where Arthur Curry (Jason Mamoa) has defeated his power-mad half-brother Orm the Ocean Master (Patrick Wilson) and thwarted his attempts to conquer land and sea. As undersea denizens chant "Hail Arthur, King of Atlantis!" the film shifts to a sun-drenched dock at a lighthouse. There, Arthur's father Thomas (Temuera Morrison) walks the beach alone, only to find his long-lost love Atlanna (Nicole Kidman) waiting for him. As the two embrace, Arthur's voice-over matches the intensity of the score.

"My father was a lighthouse keeper, my mother was a queen," he intones with utter sincerity. "They were never meant to meet, but their love saved the world." We watch as the two kiss in front of an aggressively artificial, but nonetheless brilliant, sunrise.

For the last shot, the camera dives back into the ocean, where florescent pink and purple sea-life punctuate the unbelievably blue water. "They made me what I am—a son of the land, a king of the seas," Arthur continues as he launches upward, cresting the surface. With his golden armor shimmering, he declares. "I am the protector of the deep. I am . . . Aquaman!"

13. Goba, "What Is Faith?," 21.
14. Goba, "What Is Faith?," 24.

With its mixture of unapologetic goofiness and open-hearted sincerity, the closing minutes of *Aquaman* perfectly capture the tone set by director James Wan. An old-school adventure film that fully embraces the cartoon capabilities provided by modern CGI, *Aquaman* never backs away from its comic book roots.

On a narrative level, however, the closing proclamation is somewhat surprising. Throughout much of the film, Arthur has resisted the idea that he's a hero. When he and his father overhear a television news show reporting on Arthur's rescue of a Russian Navy ship from the undersea pirate Black Manta (Yahya Abdul-Mateen II), Arthur blanches at being called "Aquaman." He scoffs at the title, insisting, "That's not me."

He continues that position even later that night when Mera (Amber Heard) arrives to bring him to Atlantis. With Orm on the warpath, willing to slaughter billions on land and on sea in pursuit of power, Mera and the wiseman Vulko (Willem Dafoe) believe that Arthur's status as the oldest son of Queen Atlanna gives him a better claim to the throne.

Arthur disagrees, explicitly on grounds of identity. "I'm the bastard son of the queen your people executed," he says with a mocking smile. "I'm no king."

Even after Orm's tidal wave nearly kills Thomas, sending Arthur on a mission to first defeat his half-brother and then to retrieve a magical trident, he remains skeptical of his identity. Despite the urging from Mera and Vulko, Arthur has no faith that he can be what the Atlanteans need. All Arthur believes are the insults hurled by Orm and his collaborators, charges of being a half-breed, a child of an illicit alliance. The product of Atlanna's forced political marriage to King Orvax, Orm is full Atlantean, and he has faith in his bloodline, faith that allows him the right of power.

This faith is demonstrated in Arthur's first battle with Orm, during a rite known as the Challenge of Kings. On a platform ringed with lava, Orm and Arthur do battle. "You have our mother's trident," Orm observes on the outset of their clash. "Powerful, but flawed, like her." The camera pushes on Orm's angry visage as he counters, "I wield my father's, and it has never known defeat!"

With that, Orm launches at his brother, setting the two to slicing at each other, a flurry of bubbles following the trajectory of their weapons. The brothers slam one another against the rocks and toward the lava, delighting the masses with their displays of power. But despite his valiant efforts, Arthur falls short. With a flurry of strikes, Orm's trident splits Arthur's in two, leaving him forlorn, staring slackjawed what seemed like a mighty weapon. Only Mera's intervention saves the dispirited Arthur from the killing strike that would cement Orm as the one, true king.

To some, Arthur's downfall here is a byproduct of his lack of faith. If he simply shared the certainty of Orm, the confidence in his own abilities and identity, then he would somehow have the strength to overcome his brother and set things right.

Tillich insists that doubt is not only not the opposite of faith, but one of its key components. Because faith is an act of finite beings trying to grasp and understand the infinite, it will always be lacking. For this reason, the "element of uncertainty in faith cannot be removed, it must be accepted," and to accept this "is courage," writes Tillich.[15]

We see that courage in one of the most famous acts of faith in the Gospels, when the disciple Simon identifies Jesus as the Christ. In Matthew's telling of the event, the confession comes only after the disciples acknowledge other names for Jesus: "Some say John the Baptist, but others Elijah, and still others Jeremiah or one of the prophets" (Matt 16:14). By putting these points first, the text makes clear that it is by no means certain to the disciples that Jesus is the Christ. The competing ideas introduce a level of doubt.

But Simon acknowledges and accepts that doubt when he makes his claim, declaring "You are the Messiah, the Son of the living God" (Matt 16:16). Because of the doubt, and the courage Simon marshaled, the declaration was itself an act of faith. And Jesus rewards this faith by pushing it further, giving him "the keys of the kingdom of heaven," and telling him, "whatever you bind on earth will be bound in heaven, and whatever you loose on earth will be loosed in heaven" (Matt 16:19).

Crucially, name-giving figures heavily into the exchange, with Simon calling Jesus "Christ" or "the Messiah," and Jesus christening him "Peter," the rock on which Christ will build his kingdom (Matt 16:18). More than just a simple name change, Jesus gives Peter "a whole new identity as the foundation of the community."[16] And that too is an act of faith, because it requires Peter to overcome the doubt he and others might feel to become the person that God, through Jesus, has called him to be.

It's these connections between faith and doubt and identity that make the end of *Aquaman* so powerful. For much of the movie's two-hour-and-twenty-three minute runtime, we've watched Arthur take courage and wrestle with the doubt infecting his identity.

It all comes together, but not in his final battle with Orm, in which he continues the Challenge of Kings to become the new monarch of the seas. Rather, it involves one last example of doubt, when Arthur finds the

15. Tillich, *Dynamics of Faith*, 21, 23.

16. Hartke, *Transforming*, 77.

Trident of Atlan protected by a giant monster known as the Karathen. The Karathen knocks Arthur about, but the most painful thing is the way the creature (voiced by Julie Andrews) makes accusations that play on Arthur's insecurities "You dare come here with your tainted mongrel blood to grasp Atlantis's greatest treasure," it growls before pushing him aside with a dismissive, "half-breed."

In his struggle with the Karathen, the film visualizes Arthur's courage as he melds faith and doubt to take action. Arthur is overcome, thrown through the murky grey waters until he finally lifts his hand and speaks one command: "Stop."

Even though Arthur goes on to admit his unworthiness, to explain that he only seeks the trident because someone needs to stop Orm, the Karathen relents. Not because of his words, but because of his speech. The very fact that Arthur can hear the Karathen proves that he is a worthy heir to King Atlan.

The next time we see Arthur, he's emerging from a waterfall to rejoin Mera and his long-lost mother Atlanna, dressed in gold and green armor. Arthur pushes through the water, as if he were arising from a baptism, to take on his new identity and his new name, Aquaman. He could not accept the name when it was foisted upon him by uninvolved news reporters. But through the act of courage captured in the film's narrative, he's finally embodied his faith, finally become the person everyone believed he could be.

SHANG-CHI AND THE SINS OF THE FATHER

Katy is worried. The young American-born Chinese woman, played by Akwafina, was just trying to ride the bus through her hometown San Francisco when a group of imposing thugs started harassing her best friend Shaun (Simu Liu). They lift Shaun up by his jacket and demand that he relinquishes some secret medallion.

"You've got the wrong guy," she shouts at them. Ever since she's known Shaun, he's been a bit of a goof. With no family around, Shaun faces none of the pressures that Katy's relatives heap upon her, the expectation that she speak Mandarin or find a husband. He's content just working as a valet and spending his weekends at the karaoke bar. That's a lot of fun, but it's poor preparation for battles against ninjas.

"Does he look like he can fight?" demands Katy, in one last attempt to save her friend.

As the very words leave Katy's mouth, Shaun unleashes a punch that sends an assailant soaring backwards. Time stops, and we watch the villain

fly through air in slow motion, a bass drop on the soundtrack accompanying his journey.

What follows is a dazzling fight sequence, in which Shaun flips and slides through the bus, using everything from his jacket to the bus poles to dispatch the attackers without taking a single hit. After the last man goes down, Shaun leaps to his feet and adjusts his jacket with a tug before turning to see the amazed and terrified look on Katy's face.

"Who are you?" she gasps.

He is obviously not Shaun, the underachieving San Francisco valet. He is Shang-Chi, the Master of Kung Fu. And he has a very good reason for changing his name: to escape his father, a centuries-old warlord.

Shang-Chi and the Legend of the Ten Rings taps into the title character's core struggle, dating back to his debut in 1975's *Special Marvel Edition* #15.[17] Shang-Chi has always railed against the machinations of his warlord father, who was in the comics Dr. Fu Manchu, a strikingly racist caricature who debuted in the 1912 pulp novel *The Mystery of Dr. Fu Manchu*, by white British author Sax Rhomer. Director Destin Daniel Cretton and his collaborators add depth and humanity to the character, reimagining the Shang-Chi's father as a tragic figure named Wenwu.

Played by Hong Kong cinema legend Tony Leung, Wenwu is a warrior of unimaginable strength and deep love for his family. We meet Wenwu in ancient China, where he begins his bloody conquest, thanks to his possession of the magical ten rings, glowing bracelets on his arms. These rings grant Wenwu eternal life and untold power, which he uses to enact his bloody rule for centuries, crushing anyone who would oppose him.

But his reign came to an end when in 1996 he marched upon the hidden city of Ta Lo. There, Wenwu encountered the city's protector Ying Li (Fala Chen), and promptly fell in love. Love drove Wenwu to put away his violent ways and to raise two children, Shang-Chi (played as a child by Jayden Zhang and Arnold Sun) and his sister Xialing (played as a child by Elodie Fong and Harmonie He, and as an adult by Meng'er Zhang).

The peace was short-lived. When warriors bent on revenge come to Wenwu's house and find him missing, Ying Li dies to protect their children. The loss devastates Wenwu, and he begins shaping Shang-Chi (but, crucially, not his sister Xialing) into an object of vengeance, a master of kung fu. Wenwu dispatches his fourteen-year-old son to assassinate the leader of the rival Iron Gang, but Shang-Chi refuses and escapes to San Francisco.

By becoming Shaun, the unmotivated American valet, Shang-Chi is trying to reject his origin story. He wants nothing to do with the narrative

17. Englehart and Starlin, "Shang-Chi, the Master of Kung Fu!"

that his father set out for him, the narrative that has been his since birth. He has no faith that the life his father set out for him will come to any good end.

The significance of the name change is not lost on Wenwu. After re-uniting with Xialing, Shang-Chi and Katy sit at Wenwu's table for a family meal. When the discussion turns to Katy's Chinese name ("Ruiwen"), Wenwu reminds his family of the importance of names. "Names are sacred, Ruiwen," he explains, with a warmth that belies his bloody past; "They connect us not only to ourselves, but to everyone who came before."

Wenwu recounts some of the names that have been given to him, including "The Warrior King" and "The Most Dangerous Man on Earth," and relates the insult he felt when an American terrorist appropriated the legend of his organization the Ten Rings and constructed a figurehead after him, but called this leader "The Mandarin" (as seen in *Iron Man* and *Iron Man 3*). "For years, I thought that was all I was meant to be," relates Wenwu, pausing to reflect on his foolishness, the sadness creasing his forehead contrasting to the glint of relief in his eyes. Sitting back in his chair, taking in the memory, Wenwu recalls how his wife Li changed the world for him, opened him to so much more than the pursuit of power and destruction.

"My real name is Wenwu," he announces with pride, steadying himself as he says it. "She was the only one who called me that."

As the regret and satisfaction in Leung's performance makes clear, Li's pronunciation of Wenwu's name was a gift. She called him away from the life that he had lived, the only life he thought possible, and toward something richer and more abundant.

Scripture is full of those name changes, but few are important as that of Jacob, son of Isaac and grandson of Abraham. From birth, Jacob seemed destined for war and deception. In a message to his mother Rachel, God announced that Jacob and his twin brother Esau would be "two nations" at conflict with each other, until "the older will serve the younger" (Gen 25:23).

Immediately, Jacob begins to enact that destiny, first by following his brother out of the womb "with his hand grasping Esau's heel" (Gen 25:26). In fact, his name means "he who deceives." In the chapters that follow, Jacob lives up to that name, tricking Esau and Isaac into giving him the birthright intended for the elder son, and later fooling his duplicitous uncle Laban. Years of deception separated Jacob from his brother and parents, forcing him to live in the wilderness with his wives and children.

That is, until one night when Jacob encountered a man in the desert. The two fought to a standstill, until the stranger asked to be released. Jacob refused, saying, "I will not let you go, unless you bless me." The blessing comes in the form of a name change, as the stranger tells him, "You shall no

longer be called Jacob, but Israel, for you have striven with God and with humans, and have prevailed" (Gen 32:26, 28).

By wrestling with God, Jacob changed his origin story. He refused to be what he had been before, what scholar Wilda Gafney described in her epitaph for Jacob's mother Rachel as *"Ya'aqov the Heel-Grabbing-Sneak."*[18] His faith drove him to grapple with God, to refuse to loose God until he received a blessing that freed him from the past. He redeemed his past and set a new path for his future.

Shang-Chi has no wrestling, but it does have many dazzling fight sequences. Pulling from the wuxia tradition of Chinese cinema, in which martial arts sequences operate as storytelling moments like dances in a musical, *Shang-Chi* has some of the best action in any superhero movie. Stunt choreographer Brad Allen and editors Nat Sanders, Elísabet Ronaldsdóttir, and Harry Yoon make the film's outstanding fight scenes into moments that reveal and advance the character.

That's most obvious in the final battle between Wenwu and Shang-Chi. Convinced that his dead wife Li is calling from a mountain in Ta Lo, Wenwu marshals his armies to attack the city and set her free. But thanks to the help of Ta Lo's current protector, Li's sister Ying Nan (Michelle Yeoh), Shang-Chi knows that the voices are a deception of the evil Dweller-in-the-Darkness, who wants to be freed to wreak havoc on the Earth.

As the forces of Ta Lo fight against the Army of the Ten Rings, Shang-Chi escapes to stop his father. Refusing to believe that the voice he hears is anything other than his beloved wife, Wenwu leaps into action, firing his rings at Shang-Chi. Together, the two launch into battle. Shang-Chi, desperate to keep his father away from folly, drives him away from the mountain. Wenwu, mad with grief over the one woman who saw good in him, pummels forward, knocking aside his son in the process.

Just when Wenwu prepares to dispatch his son for good, something changes. He shoots five rings toward Shang-Chi, but instead of striking him, they simply stop and float in the air. Cretton cuts to a series of flashbacks, in which Shang-Chi remembers the body movements he learned from his mother as a child, the white warmth of their home contrasting sharply with the grey nightmare in which he now stands. With each cut back to the present, Shang-Chi replicates the moves of his mother. And the rings, changing in hue from blue to orange, cycle around his arm.

Now in control of five rings, Shang-Chi strikes back against Wenwu, the orange glow signifying that he carries the memory of Li, and with it, the memory of who Wenwu could be. Rather than see his son for who he is,

18. Gafney, *Womanist Midrash*, 57. Italics original.

Wenwu continues the attack, flying around his son and firing his angry blue bands at Shang-Chi.

But it's not enough. Carrying the memory of his mother, of the name she bestowed upon Wenwu and the faith that she had in him, Shang-Chi continues to hold his father back. Finally, the remaining five rings slide off Wenwu's arms and circle around Shang-Chi again. Pulling his arms back in a fighting stance, he gathers the rings together into a ball, bristling with the orange energy that signifies Li's love. Shang-Chi releases his hands, but not to attack. Rather, his movements let the rings drop to the ground, stripped of their power.

Shang-Chi has negated the power his father sought. He's helped Wenwu come to his senses, to become the person Li always knew he could be.

But it's too late. Bursting from the mountain comes Dweller-in-the-Dark, who takes the form of a hideous dragon and saps the lifeforce out of Wenwu. In his last moments, Wenwu uses the dregs of his energy to send the rings over to Shang-Chi.

As they wrap around his arms, the ten rings burst in blue and orange lights, mingled together, indicating the combined memory of Li and Wenwu, of both the good and evil that he's done. He stands ready to face the Dweller-in-the-Dark, no longer Shaun the Valet, but Shang-Chi, the Master of Kung Fu. He's embraced the name his parents have given him and walks in faith in the person they believed him to be, carrying the memory of both of them in each of the rings.

In his victory, Shang-Chi enacts his faith. He carries not only the actions of his mother, but also her faith in her husband Wenwu. It's that faith that allows him to take on a new name, to embody a different set of beliefs and make the world anew. That's the same call put to us Christians, to carry the faith of those who came before us to make real the Kingdom of Heaven.

UNTO US, A CHILD IS GIVEN

With muscles barely contained by his bright red suit, the lightning emblem on his chest crackling with electricity, and his cape majestically billowing in the wind, the superhero Shazam (Zachary Levi) looks every bit like the next in a line of great champions. At his disposal are the best characteristics of heroes of old: the Wisdom of Solomon, the Strength of Hercules, the Stamina of Atlas, the Power of Zeus, the Courage of Achilles, and the Speed of Mercury.

And yet, he's getting his butt kicked. Standing over Shazam is a growling grey demon, the personification of the Deadly Sin of Wrath, pouring its anger and rage down on the good guy.

With the attributes of seven mythological heroes at his disposal, Shazam could surely summon greater power to best the beast. So what does he do?

"Shazam!" he shouts, speaking the magic word and calling a crack of lightning from the sky. With a puff of smoke, Shazam disappears and in his place is young Billy Batson (Asher Angel), small enough to run between the legs of Wrath and plan a new strategy.

That type of inventiveness has been the defining aspect of Shazam, ever since he debuted in *Whiz Comics* #2 in 1940.[19] At that time, the character went by the name Captain Marvel, a moniker he kept even long after the copyright on the title expired, leaving room for Marvel Comics to snatch it up and manufacture their own superhero called Captain Marvel. Created by writer Bill Parker and artist C. C. Beck, Captain Marvel quickly became the world's most popular superhero, whose sales outpaced even those of his forerunner Superman.[20]

The secret to the character's success was the boundless imagination Beck, Parker, and especially subsequent writer Otto Binder brought, mixing super heroics with whimsy. Captain Marvel's first adversaries included the archetypical mad scientist Doctor Sivana and Mister Mind, a telepathic earthworm from Venus. The creators gave their hero a full supporting team called the Captain Marvel Family, which included everyone from Billy's sister Mary and best friend Freddy Freeman (who became Mary Marvel and Captain Marvel Jr., respectively, when they spoke their magic words) to the urbane tiger Tawky Tawny to Hoppy, the Marvel Bunny.

Thanks to his popularity, Captain Marvel made the jump outside of comics, first in *The Adventures of Captain Marvel*, a 1941 serial from Republic Pictures—the first time a superhero graced the silver screen—and then the live-action CBS TV series *Shazam!* (1974 to 1977) and the animated show *The Kid Super Power Hour with Shazam!* (1981 to 1982). Even though

19. Parker and Beck, "Introducing Captain Marvel!" *Whiz Comics* #2 (1940). Written and colored by Bill Parker, penciled and inked by C. C. Beck.

20. The popularity of Captain Marvel quickly became a threat to National Comics, who owned the copyright to Superman. In 1948, National launched a series of lawsuits contending that Fawcett Comics, who published Captain Marvel, had infringed on their copyright. Although judges ultimately found no infringement, the protracted legal battle sent Fawcett into bankruptcy. They stopped publishing in 1954, only to later lease Captain Marvel to National (now called DC Comics) in 1972. By 1991, DC had purchased Captain Marvel outright, bringing him into their mainline continuity, often alongside Superman.

these various pieces of media had very different tones, they all shared the same central premise, that of young Billy Batson becoming the heroic Captain Marvel.

That's particularly true of the 2019 blockbuster film *Shazam!*, directed by David F. Sandburg. Although the movie only winks at the sillier aspects of the comic book source material—Mister Mind makes a cameo in one scene, and Billy's fondness for tigers draws to mind Tawky Tawny—it lets its childlike goodness stand out in a world that is often cruel, if not outright horrifying.

That tension is apparent in *Shazam!*'s take on the old origin story standard, in which the new hero discovers their superpowers. Upon realizing that he's an adult as Shazam, Billy and his best friend Freddy (Jack Dylan Grazer) go to a convenience store to purchase beer. But their adolescent misadventure is interrupted when two masked burglars enter the store, demanding the clerk empty the register. Instinctively, Billy hides behind Freddy, who quickly reminds him that he is literally a superhero. As Shazam, Billy strides toward the robbers and says, in a voice dripping with pomposity, "Gentlemen, why use guns when we can settle this like real men?"

Shazam's super-speed lets him grab one gun, but the other goes off before he can stop it, hitting him squarely in the chest. Shazam doubles over with the impact, Freddy screams in terror, and Sandberg cuts between individual shots of everyone present, looking on in horror. But then, a single bullet drops to the ground. Shazam's amazed and delighted face stares directly at the camera and then to an equally enthralled Freddy.

"Bullet immunity! You have bullet immunity!" shouts Freddy, prompting a giddy Billy to return the guns to the assailants so they can shoot him some more. What follows is seconds of Shazam being blasted by gun fire—in the chest, the arms, and even the face—as he and Freddy giggle with glee.

When the guns stop, Shazam lets out one last laugh before turning to the burglars with a serious scowl and saying, "You're dead." Cut to two bad guys flying through the convenience store window.

The goofy way Shazam approaches his power provides a strong contrast to the rest of the movie. For a film featuring a superhero in bright red tights, *Shazam!* is surprisingly bleak, with numerous acts of cruelty. Billy becomes an orphan when his mother, a scared seventeen-year-old, abandons him at a fair. Social workers treat Billy with disdain, as do the bullies who nearly murder Freddy with their truck.

This despairing worldview is fully embodied in the movie's primary villain, Dr. Thaddeus Sivana (Mark Strong). Powered by demons who represent the seven deadly sins, Sivana is Shazam's equal in strength and abilities. He uses those gifts to wreak havoc on others, most memorably in a shockingly violent scene in which he slaughters a boardroom full of executives.

For Sivana, power means the right to dominate others, to assert your will on others, and to protect yourself. The film takes pains to trace that cruelty back to childhood, where Sivana was bullied by his father (John Glover) and older brother Sid (played at different ages by Wayne Ward and Landon Doak). The father and son seem to take special joy at young Sivana's weakness, implicitly teaching him that those without power deserve to be hurt.

"Thad! You can't go crying to other people all the time," his father barks. "A man needs to know when to stand up for himself." When Sivana becomes a man, a man haunted by the cruelty of his family and rejection from the Wizard Shazam (Djimon Hounsou), who initially considered giving Sivana superpowers before eventually choosing Billy instead, he takes standing up for himself to be his prime vocation.

As this plot point indicates, *Shazam!* is deeply interested in the way childhood innocence can be corrupted by the cruelty of the world, creating adults who perpetuate the abuse. While we viewers may blanche at the harsh words from Sivana's father, it's hard to say he's wrong. Most of the characters in the film treat each other cruelly, as do people in the real world. Lust for power, domination of weaker people, is simply the way of the world.

For that reason, Jesus chose children to illustrate the contrast between the ways of the world and the ways of his kingdom. The Synoptic Gospels all tell a story in which parents bring to Jesus their children, so he can touch and bless him. Although the disciples try to shoo the parents and kids away, Jesus was, in Mark's telling, "indignant." Not only does Jesus accept the children, but he tells the disciples to follow his example. "Truly I tell you, whoever does not receive the kingdom of God as a little child will never enter it," he insists (Mark 10:15).

As Austin Hartke rightly explains, Jesus uses this teachable moment to show that "it's not the adult males who are the keepers of the kingdom," but rather, "the children, the ones with no social power at all." According to Hartke, the scene points to "the upside-down world of the kingdom, [where] giving up riches and power, humbling yourself, and taking a seat at the foot of the table is just good sense."[21]

The Kingdom of Heaven stands in opposition to the kingdoms of the earth, in which people establish and keep their power by establishing dominance, by destroying those who oppose them. In these kingdoms, might makes right.

But that cannot be so among the people of God's kingdom, a point God makes by inaugurating the kingdom by coming not as a conqueror, but as a child. "For a child has been born for us, / a son given to us"; declares the

21. Hartke, *Transforming*, 108.

prophet, a child with power, because "authority rests upon his shoulders" (Isa 9:6).

With its image of a child with literal powers, *Shazam!* helps us imagine the role of the church in relations to earthly powers. Like most superhero movies, the film builds to a climactic battle between two equally powerful titans, Shazam and Sivana. But instead of completing his journey from dejected orphan to respected hero, Shazam overcomes the evils of the world through a communal act.

For much of the film, the sole refuge from the world's cruelties are Victor and Rosa Vasquez, played with palpable warmth and kindness by Cooper Andrews and Marta Milans. Aware of the pressures facing orphan children by their own experience in the foster system, Victor and Rosa have become foster parents themselves. Undeterred by his troubled past and determined to accept him without judgment, Victor and Rosa welcome Billy into their diverse and raucous home. In addition to Freddy, Victor and Rosa's foster family consists of the brilliant senior Mary (Grace Fulton), the taciturn body builder Pedro (Joven Armand), the tech-obsessed Eugene (Ian Chen), and the openly affectionate Darla (Faithe Herman).

While the life lessons Billy's received teach him to look out for himself—a perspective that continues even in his first adventures as Shazam, which largely involve his posing for selfies and scaring bullies—the foster family refuses to give up on him. Their welcome and goodness brings out the best in Billy, redirecting him from the fate of Sivana.

That redirection is made clear in the final battle, in which Sivana attempts to destroy Billy and to take all the power for himself. Recalling how the Wizard Shazam grew weaker without his brothers and sisters, Billy calls for his foster siblings to put their hands between them and say his name. Together, they shout "Shazam!" and a bolt of lightning comes from the sky. When the smoke clears, all of the foster children have changed into adults with their own brightly colored costumes and superpowers.

With his family at his side, Shazam asks Sivana a question that the villain cannot answer: "What good is power if you have no one to share it with?"

In this moment, we see a picture of the childlike wisdom Jesus praises when he sat with kids on his lap. A child who knows that sharing is always better than hoarding, who can hold onto the ability to love, who hasn't yet been ground down by the brutal lust for power and the cruelties of others—that's the type of person who sees the necessity of God's kingdom. When Billy recalls that faith and shares it with his family, he finally becomes the type of hero his world needs.

Like most origin stories, *Shazam!* is the story of a weak person coming into power. It is not power for one, but power for many, power spread

and shared to stand against the selfishness and weakness that perpetuates generations of cruelty.

THE FAITH OF CAPTAIN MARVEL

Danvers comes into full realization of who she is in a battle against the Supreme Intelligence, the leader of the Kree Empire, who has taken the form of Danvers's mentor on Earth (Annette Benning). "Remember, without us, you're weak, you're small, you're flawed," gloats the Supreme Intelligence, as images of Danvers's failures display in front of her. A wavey golden screen floats in front of Danvers, showing clips of her crashing a go-cart, striking out in baseball, falling from a military ropes course.

"Without us, you're only human," the Supreme Intelligence scoffs as Danvers drops to the floor in front of her.

But Danvers is undeterred by what she saw. She knows who she is. She believes that her identity encompasses far more than the moments of weakness displayed before her.

"You're right," she agrees. "I'm only human." A series of flashbacks fill the screen, returning to images of Danvers's failure throughout her life. But here, we see what happens right after she fails. Each time, Danvers stands back up.

In these images, we're reminded of a core fact of Christ's calling. God knows who we are, even when the world wants to deny us our place, wants to dismiss us as failures or, worse, objects fit for oppression. But when we act in the faith that each and every person is a child of God, then we owe no allegiance to any oppression, no fealty to any past failure. Our future is as secure as our origin, allowing us to stand back up and walk on.

CREDITS:

Aquaman (2018)

Director: James Wan

Screenwriters: David Leslie Johnson-McGoldrick and Will Beall

Captain Marvel (2019)

Directors: Anna Boden and Ryan Fleck

Screenwriters: Anna Boden and Ryan Fleck and Geneva Robertson-Dworet

Shazam! (2019)

Director: David F. Sandberg

Screenwriter: Henry Gayden

Shang-Chi and the Legend of the Ten Rings (2021)

Director: Destin Daniel Cretton

Screenwriters: Dave Callaham and Destin Daniel Cretton and Andrew Lanham

POST-CREDITS:

Theme: Faith

Key Biblical Passage: Heb 11:1

Questions:

1. Origin stories work well in movies, even movies about fantastic things like superheroes, because they are so relatable. What is your origin story? Which key elements of your past make you who you are today?

2. Throughout *Aquaman*, Arthur must wrestle with his perception of himself as an outsider, as not good enough or worthy of the mission he must undergo. When have you felt unworthy? How did you use your faith to respond to those feelings?

3. *Shang-Chi and the Legend of the Ten Rings* is about a person whose faith in his identity brings him into conflict with his father's wishes. Has your faith ever contributed to a disagreement with someone you loved? How does Christ's teachings help you grapple with that?

4. In *Shazam!*, the hero only wins by putting his faith in his foster family. How does personal faith relate to our communities? How do our communities help us enact our individual beliefs?

5. Fundamentally, all of the origin stories discussed in this chapter are about people who have faith in goodness that overcomes the evils of the world. What evils do you see in the world? What concrete steps does your faith drive you to take in response to those evils?

8

THE POWER OF THE PEACEMAKERS

WandaVision—Doctor Strange—Thor—Wonder Woman

Blessed are the peacemakers,

for they will be called children of God.

—Matt 5:9

It's not about deserve! . . . It's about what you believe.

—Steve Trevor, *Wonder Woman*

A bomb and a television. After seven episodes, that was the true reveal of the 2021 Disney+ series *WandaVision*.

For the first six episodes, we watched as Wanda Maximoff (Elizabeth Olsen) lived a happy suburban life with her family, including android husband Vision (Paul Bettany). Even more odd than the fact that Vision died in *Avengers: Endgame* is the fact that reality appeared to change with every episode. In the first episode, Wanda and Vision seemed to live in a 1950s milieu reminiscent of the sitcom *The Dick Van Dyke Show*, complete with black and white coloring and a laugh track. By episode 7, Wanda and Vision spoke directly to a handheld camera, à la *Modern Family* or *The Office*.

In episode 8, "Previously On," the witch Agatha Harkness (Kathryn Hahn) reveals that the traumatized Wanda has kidnapped a town and used her powers to shape their reality into something she finds safe: the sitcoms she enjoyed as a child. Agatha forces Wanda to watch a flashback that traces

the source of Wanda's trauma, to her childhood in the fictional war-torn eastern European country Sakovia. Wanda and her twin brother Pietro (played as children by Michaela Russell and Gabriel Gurevich, respectively) gather with their parents to watch *The Dick Van Dyke Show* together but are interrupted by explosions. The collapsing rubble kills the Maximoffs' parents, but Wanda and Pietro take shelter under a bed. From there, they see two things: a bomb with a blinking light, threatening to explode at any second, and the television, still playing the sitcom.

A bomb and a television. With those two images, *WandaVision* director Matt Shakman captures a tension at the root of superhero movies. They are escapist works of fantasy, fun and family-friendly like the classic sitcoms. But they are inherently violent, stories about people who solve their problems with their fists.

If superhero movies valorize war and fighting over peace and love, how can they be an acceptable form of entertainment for Christians?

A HISTORY OF VIOLENCE

Superhero comics are a product of war. The genre's first fans were not only young children, but also GIs who brought Superman and Batman with them into the battlefields of World War II. Accordingly, it was not uncommon for publishers to cater to their wartime readership with covers that portrayed Superman, Batman, and Robin triumphantly straddling a tank or Captain America and Namor the Sub-Mariner attacking Axis powers.

The superhero boom waned in the salad days following the Great War, but nuclear anxiety brought the genre back to the fore. DC Comics found great success reimagining the Flash, Green Lantern, and Hawkman from characters based in magic to those based in science fiction. These stories often directly addressed issues such as the arms race, as demonstrated by the introduction of the new Green Lantern Hal Jordan, doing battle with a rocket on the cover of 1959's *Showcase* #22. The first wave of Marvel Comics heroes took this even further, as the Fantastic Four, Spider-Man, and the Hulk all received their powers from radiation exposure. By co-creating these radiated superheroes, Stan Lee "stole back the annihilating radiation of the Bomb, and for children like me—raised in its icy shadow—he peopled the glowing darkness with extraordinary heroes," recalls acclaimed comic book writer Grant Morrison.[1]

Even when not dealing directly with war, violence is inseparable from superheroes. This fact may be partially attributed to the development of

1. Morrison, *Supergods*, 97.

the Comics Code Authority in 1954, formed by publishers in response to the moral panic firebrand psychologist Frederic Wertham stoked that same year. The CCA may have prohibited scenes of excessive violence, but it also ruled that "In every instance good shall triumph over evil and the criminal punished for his misdeeds." That punishment invariably took the form of the hero beating up the villain, thus reframing Wonder Woman's clashes with Cheetah and Spider-Man's fights with the Scorpion as virtuous duels to make plain God's will.

Superheroes may have changed along with trends and tastes, but the might makes right approach remained constant. The relevance movement inaugurated by writer Dennis O'Neill and artist Neal Adams in 1970's *Green Lantern/Green Arrow* #76 may have brought up issues such as racism and the exploitations of capitalism, but they were often solved by Green Arrow firing a boxing-glove arrow at some fat cat landlord.[2] When gritty crime movies like *Death Wish* and *The French Connection* dominated box offices of the 1970s, and triumphalist action films starring Arnold Schwarzenegger and Sylvester Stallone conquered the eighties, superheroes followed suit. The PTSD-stricken Vietnam war vet Frank Castle, aka the Punisher, became one of Marvel's biggest stars, preceded by feral X-Man Wolverine.

To be sure, some creators have tried to critique or address the genre's devotion to violence. Psychedelic characters such as Jim Starlin's Adam Warlock often engaged in philosophical debates instead of fistfights with his nemesis Thanos and Wonder Woman's William Moulton Marston imagined his heroine as an emissary for peaceful submission.[3] But visually, the portrayals of these conflict bared little difference from your standard beat-em-up.

Likewise, satirical comics such as the long-running *2000 AD* feature Judge Dredd or Howard Chaykin's *American Flagg* made superheroes into fascist grotesques, but the violence was too spectacular and engaging to be a proper critique. By the time Scottish writer Mark Millar applied 2000s War on Terror politics to superheroes with his series *The Ultimates*, it was hard to tell if readers were to cheer or cower when Captain America bullied invading aliens by bellowing, "Surrender? Surrender? You think this letter on my head stands for France?"[4]

Superhero movies have had even less success thinking critically about the genre's dependence on violence. Where the Batman of the comics adheres to a strict "no killing" principle, his film counterparts have no problem

2. O'Neil and Adams, *Green Lantern / Green Arrow* #76.
3. See Lepore, *Secret History of Wonder Woman*.
4. Millar and Hitch, *Ultimates* #12.

taking lives, whether it be blowing up Ace Chemicals in *Batman*, setting off a bomb in Ra's al Ghul's palace in *Batman Begins*, or firing a machine gun in *Justice League*. *Man of Steel* builds to a climax in which Superman and General Zod destroy Metropolis in their fistfight. Even as Captain America warns his teammates to protect civilians in *The Avengers: Age of Ultron*, they can still only stop killer robot Ultron by pounding him into oblivion.

Worse still are the adaptations of works designed as critiques of violence. Neither the campy Stallone vehicle *Judge Dredd* nor the gritty update *Dredd* retain the comic's repulsion toward police activity. Zach Snyder's take on *Watchmen* transforms the traumatized humans of Alan Moore and David Gibbons's groundbreaking comic book series into power-tripping madmen, whose punches shatter concrete. Movies such as *Bloodshot* and *The Punisher* uncritically invoke tropes about the honor of soldiers and violence against women.

POWER POLITICS AND THE PRINCE OF PEACE

The love of violence is easily the greatest stumbling block for Christians interested in superhero movies. To be sure, the Bible is full of violence, from the wars chronicled in the Hebrew Scriptures to Christ's promise that he comes to bring "not peace, but a sword" (Matt 10:34). Thus, if we go to Scripture looking for justification to carry weapons or destroy our enemies, we can find them in the genocides chronicled in Joshua and when Jesus orders his followers to buy swords (Luke 22:36–38).

But if we go looking for a vision of peace, of images of a God who opposes the proud and rebukes the warlike ways of earthly empires, we'll find that as well. Biblical ambiguity certainly shows that "God is the God of peace, who does not will the destruction of even one little child, but God is also the God of war, who orders war throughout the whole history of the Old Testament and even in the last book of the New."[5] But fundamentally, Christians serve a God who became a man who allowed himself to be crucified and did not kill the Romans in self-defense. Scripture sometimes presents Jesus in violent terms, appearing in Revelation riding a white horse, with eyes "like a flame of fire" and "a robe dipped in blood" and a sword in his mouth, leading "the armies of heaven" (Rev 19:11–15). However, Revelation more often describes Jesus as "the lamb" and ties his victory to his sacrifice on the cross.

Moreover, even those who strongly support Christian nonviolence acknowledge its contextual nature. For most modern Christians, the

5. Winn, *Ain't Gonna Study War No More*, 5.

paradigmatic example is that of Dietrich Bonhoeffer, who joined a plot to assassinate Hitler despite his convictions toward nonviolence, and trusted that God's grace would be extended to him. James H. Cone identifies a similar tension in *God of the Oppressed*, when he acknowledges that just because the "ethic of liberation arises out of love, for ourselves and for humanity," this "radical rejection of hatred and violence does not mean that [Black Christians] accept white people's analysis of violence and nonviolence."[6] Until one looks at liberation movements in relation to various forms of oppression and systemic violence directed at oppressed people, one cannot speak clearly about Christian nonviolence.

Given the complexities of real-world violence, it's important to remember that superhero movies are fundamentally imaginary, a way of thinking about larger-than-life conflict instead of a prescription for daily behavior. By their very nature, superheroes and supervillains transcend the sphere of reality, becoming icons of worldviews and philosophies instead of three-dimensional individuals. Even when superhero movies take on real-world issues, such as the government surveillance in *Captain America: Winter Soldier* or the Hurricane Katrina-like disaster briefly seen in *Batman v Superman: Dawn of Justice*, the depictions are so outlandish, so over-the-top, that they cannot be considered suggestions for real behavior. They can only be ways of imagining the clash of worldviews.

For that reason, it's all the more powerful when a superhero movie imagines something other than pure force as the way to overcome a threat. Such instances are rare, and always imperfect. No superhero movie is without at least one fight. But they can be useful reminders for Christians to remember that no matter what power or principality seems to be running the world, we know that we can have peace because we serve a God who has "conquered the world" (John 16:33).

LEARNING AND UNLEARNING
THE WAYS OF THE WORLD

Doctor Stephen Strange thought that he knew what to expect when he came to the far eastern village of Kamar-Taj. The world's foremost neurosurgeon until a car accident destroyed his hands, Strange has become so desperate that he has come to the village to consult a secretive healer known only as the Ancient One. But his confidence started to crumble upon learning that the Ancient One is a spritely Celtic woman (Tilda Swinton), whose talk of

6. Cone, *God of the Oppressed*, 217.

teaching the soul to heal the body strikes Strange as the nonsense found on gift shop knickknacks.

Strange expresses his frustration with a series of condescending insults, flowing freely until the Ancient One strikes his chest, punching his soul out of his body. The Ancient One sends Strange's spirit on an astral journey, visualized through psychedelic images of fingers growing from fingers and the planet melting into a mélange of shapes and colors.

His soul returns to the body, which drops to floor with a thud. "Teach me," he begs the woman he once mocked.

With this sequence, director Scott Derrickson taps into the mind-bending visuals that have defined Doctor Strange since artist Steve Ditko and writer Stan Lee debuted the character in 1963's *Strange Tales* #110.[7] A beatnik hero who wrestled reality-altering threats from his sanctum hidden in New York's (then) bohemian Greenwich Village, Doctor Strange stories demand absurd images, which kept the character out of live-action contention, save for a bland 1978 TV movie.

The climax of a Doctor Strange story requires not fistfights or martial arts sequences (although Derrickson does employ some of those in his film, even casting modern-day action master Scott Adkins as a minor villain), but rather two contrasting viewpoints. More often than not, Strange turns away magical invaders not by matching powers, but by providing a different perspective.

So it is for the climax of the MCU film, in which Strange, alongside Masters Mordo (Chewitel Ejiofor) and Wong (Benedict Wong), find themselves outclassed by the sorcerer Kaecilius (Mads Mikkelsen) and his acolytes. Obsessed with conquering death, Kaecilius has called forth the entity Dormammu (a CG creation voiced by Cumberbatch), who will grant him eternal life in exchange for the Earth itself.

After being thoroughly trounced by Kaecilius, Mordo urges his partners to continue using the same strategy. "Strange! Get up! Fight!" he shouts, assuming his battle stance once again. In response, Strange flies away, seemingly embracing defeating.

What appears to be surrender is in fact a new perspective. Engaging the glowing green time stone that he keeps in an amulet around his neck, Strange address the beast and declares, "Dormammu, I've come to bargain." Unimpressed, Dormammu quickly kills Strange, obliterating him with an energy blast. Seconds later, Strange appears again, making the same declaration, "Dormammu, I've come to bargain." The encounter ends the same, as do the third, fourth, fifth, and so on. Using the time stone, Strange has

7. Lee and Ditko, "Doctor Strange, Master of Black Magic!"

contained Dormammu in a loop, so that every time he dies, he returns to face the creature once again.

"This is how things are now," Strange tells Dormammu. "You and me trapped in this moment, for all eternity."

Rather than use violence to stop violence, power to overcome power, Strange tries a different perspective. He forces Dormammu to relive the violence over and over again, stripping it of all its spectacular strength. What seemed like unstoppable domination becomes, in fact, an empty play, accomplishing nothing.

For Christians, the climax of *Doctor Strange* illustrates a lesson found when reading the Bible through a christological lens. Throughout the Old Testament and all the way through to the Roman Empire symbolized in Revelation, we see a cycle of violence, in which earthly forces use war and destruction to establish themselves. They preach safety and redemption, but always do so through exploitation.

But when God incarnates in the person of Jesus, a Palestinian Jew living in Roman occupation, God reveals the unsatisfying nature of their violent ways, the way they achieve nothing from repeating a cycle of domination and control. Christ breaks that cycle, providing a map for God's kingdom, one in which the meek inherit the Earth and the poor are blessed.

UNWORTHY WAR

Thor (Chris Hemsworth) knew that he had a fight ahead of him. The Norse God of Thunder had been captured by the Grandmaster (Jeff Goldblum), warlord of the planet Sakaar, and his only hope of escape is by defeating the Grandmaster's champion in gladiatorial combat—a feat no one else has ever accomplished. Thor enters the ring with a desperate confidence, despite the shouts of onlookers, which grow only more pronounced with the rhythm of the champion's thundering footsteps. With a crash and an explosion, the champion explodes from the gate, revealing himself to be none other than the Incredible Hulk!

"Yes!" Thor shouts with glee. "I know him," he informs the confused crowd. "He's a friend from work." Whatever fealty his human alter ego Bruce Banner (Mark Ruffalo) may have toward Thor, it's not shared by the Hulk, who unleashes a flurry of attacks on his Avengers teammate.

"Banner, I don't want to fight you," Thor assures the monster. In response, Hulk grabs Thor by the legs and slams him to the ground.

This standout moment from the 2017 film *Thor: Ragnarok* gives us a very different take on the title character, not just because it adheres to

the goofy sensibilities of its director, New Zealander Taika Waititi. Rather, *Ragnarok* features a version of Thor who is surprisingly slow to fight. That's a vastly different take on the character than the one seen at the start of his film debut, 2011's *Thor*, directed by Kenneth Branagh.

Branagh's film follows the outline of the character's origin, as presented by Jack Kirby and writer Larry Lieber in Thor's first appearance in *Journey Into Mystery* #83 from 1962.[8] Both stories find the God of Thunder expelled by his father King Odin (played in the film by Anthony Hopkins) from the Norse world of Asgard to Earth, where he eventually becomes a superhero. But where Kirby's version made Thor an arrogant brute who learned humility by being bonded to the disabled physician Dr. Donald Blake, Branagh's film hinges upon Thor's love of war.

Early in the movie, Thor and his brother Loki (Tom Hiddleston) lead Lady Sif (Jamie Alexander) and the Warriors Three—Volstagg (Ray Stevenson), Hogun (Todanobu Asano), and Fandral (Josh Dallas)—in an attack on Jotunheim, home world of their sworn enemies the Frost Giants. While Thor considers the attack a justified response to an invasion into Asgard by a small band of Frost Giants, the filmmaking underscores the disastrous nature of Thor's decision. Rather than render triumphant shots of Thor smashing Frost Giants with his magical hammer Mjolnir, cinematographer Haris Zamabarloukos bathes the scene in murky blues, blacks, and grays while Patrick Doyle's score fills the scene with foreboding instead of joy.

The attack ends only with the arrival of Odin, who comes not to aid his sons in their onslaught, but to beg forgiveness from the Frost Giant King Laufey (Colm Feore). "These are the actions of a boy," he beseeches Laufey. "Treat them as such."

The Frost Giant refuses, promising to give Thor exactly what he came for: "war and death."

Because his love of battle has shattered the peace Odin had once brokered with Laufey, Thor is stripped of his powers and sent to Earth. In a desert New Mexico town, Thor forms a friendship with humans, namely the astrophysicist Jane Foster (Natalie Portman) and her mentor Dr. Erik Selvig (Stellan Skarsård). By the time the film reaches its climax, Thor has learned to love people more than battle. When Loki betrays his brother by sending the Destroyer, a suit of Asgardian armor animated by magical fire, to attack New Mexico, Thor chooses to sacrifice himself rather than bring more destruction to the humans. The sacrifice proves to be enough, restoring power to Thor now that he knows the value of peace.

8. Lee et al., "Thor the Mighty!"

Despite its wackier tone, *Thor: Ragnarok* finds Thor continuing the journey. The movie's silliest moments take place on Sakaar, where Thor convinces the Hulk to help him escape to Asgard. Joining him is the gentle rock monster Korg (voiced by Waititi), the knife-wielding bug creature Miek, and Valkyrie (Tessa Thompson), a one-time member of Asgard's elite fighting force. The goofy jokes only enhance, rather than undermine, the movie's portrayal of war's futility. Beneath its gladiator-obsessed culture, Sakaar is a planet filled with off-beat goofballs masquerading as warriors, ruled by a self-obsessed neurotic who makes no pretensions to nobility or honor.

Waititi underscores these themes with the movie's primary plot, which features the return of Odin's first-born Hela, the Goddess of Death (Cate Blanchett). Banished by Odin for becoming too violent, Hela has been freed after her father's death at the start of the film and seeks to return Asgard to its conquering ways.

In a particularly striking scene, Hela and her executioner Skurge (Karl Urban) examine frescos in Odin's throne room. Presented in the style of medieval Christian artwork, the frescos portray Odin as a noble leader, presiding over peace treaties and garden parties, a ringed halo illuminating his head. After an attack from Hela, the fresco falls away, revealing behind it images immersed in blood red, depicting Odin and Hela as angry conquerors. Hela sneers as the camera pans across the paintings, "Odin, proud to have it, ashamed of how he got it."

Hela's return is chilling not just because it imperils Asgard. Rather, her attack serves as a warning to Thor that his turn from war is not enough. Whatever Odin did as a good king later in life, he did so on the same grounds that he conquered, trying to grow boughs of peace from bloodsoaked ground.

Thus, the only solution available to Thor is the same one he used in his battle against the Destroyer. But instead of sacrificing himself, Thor chooses to sacrifice Asgard, setting free the monster Sutur (voiced by Clancy Brown). As Thor and the surviving Asgardians fly away from Asgard, watching Sutur consume the city and Hela with it, he completes his repentance.

In their book *Unsettling Truths*, Mark Charles and Soong-Chan Rah examine the many sins of the United States, starting with the justification for conquest and genocide known as the "Doctrine of Discovery." As frank and detailed as Charles and Rah are about American sins, they never condemn or lose hope. They see all throughout Scripture reminders that God deals mercifully and justly with nations, even those who mistreat God's chosen people the Jews, if those nations repent.

The hope for the United States comes from a God who was willing to negotiate with Abraham over the fate of Sodom and Gomorrah. The hope for the United States comes from a God who pulled Rahab out of the city before he destroyed Jericho. The hope for the United States comes from a God who said to Jonah, "Should I not be concerned" when he protested that God had sent him to prophesy to the pagan city of Nineveh. The hope for America does not come from a land covenant with God—it comes from the character of God. And the character of God is not accessed by our exceptionalism but through a humility that emerges from the spiritual practice of lament.[9]

In the diagnosis provided by Charles and Rah, that repentance requires some difficult tasks for Americans living on colonized land, but those difficulties pale in the light of God's promises of forgiveness and redemption.

Such a repentance is hard to imagine, but the ending of *Thor: Ragnarok* gives us a glimpse. As the surviving Asgardians fly away from their home, a home they built in conquest of others, the sight of Sutur razing their kingdom fills them with fear. But that fear is tempered by hope and relief, expressed in the statement, "Asgard is a people, not a place."

Knowing that they still have their people, that a life of war did not cost them their lives, the Asgardians can enjoy peace—perhaps for the first time in their lives. In that image, there's also hope for Christians in lands born of war, if we're just willing to follow the Christ's difficult teaching and take seriously the promise that his "yoke is easy, and [his] burden is light" (Matt 11:30).

A BLESSING IN NO MAN'S LAND

Wonder Woman will break Maxwell Lord's neck.

Most comic book fans expected that ending for *Wonder Woman: 1984*, the 2020 movie that pitted Wonder Woman (Gal Gadot) not only against her greatest nemesis from the comics, the Cheetah (Kristen Wiig) but also the megalomaniacal businessman Maxwell Lord (Pedro Pascal). Many comic book fans remember the page from issue #219 of *Wonder Woman*, depicting a resolute Wonder Woman snapping Maxwell Lord's neck to break his mind control over a rampaging Superman.[10]

For her movie, director Patty Jenkins takes a very different approach to the climactic showdown between Wonder Woman and Lord. Having

9. Charles and Rah, *Unsettling Truths*, 186.

10. Rucka and Morales, *Wonder Woman* #219.

discovered a magical wishing stone, Lord uses satellite television technology to grant the desires of everyone on Earth, gaining more power for himself with every wish. The wishes quickly wreak havoc on the world, forcing Wonder Woman to stop him.

Rather than break Maxwell Lord's neck, or even lay a finger on him, Wonder Woman appeals to the viewers of Lord's broadcast. Using her lasso to interrupt Lord's speech to send her message to the audience, Wonder Woman makes an impassioned petition to choose the good of others over selfish desires. Jenkins and her cinematographer Matthew Jensen shoot the sequence with Gadot looking directly at the camera, as if Wonder Woman was directing her pleas toward us movie viewers, begging us to accept that the truth is enough and that our desire for more will only tear us apart.

While that climax may differ from what comic fans expected, it is in fact very much in line with the intentions of Wonder Woman's creator, the psychologist and inventor of the lie detector William Moulton Marston. A deep believer in loving submission, which he considered likely only when women were in positions of power, Marston saw the burgeoning superhero genre as a way to explain his ideas. Working alongside artist H. G. Peter, Marston brought the character to National Comics, where she eventually made her official debut in 1941's *All Star Comics* #8.[11]

Over the years, that aspect of Wonder Woman is often forgotten, especially when the character branches out into other media. Although the character's first television appearance, in a 1972 episode of the animated series *The Brady Kids*, retains Wonder Woman's emphasis on submission, nearly every other appearance portrays her as a generic superhero or a proficient warrior. Even the best-known examples of Wonder Woman outside of comic books—the late seventies live-action television series starring Lynda Carter and the early 2000s animated *Justice League* series (in which Susan Eisenburg voiced the character)—fall victim to this problem.

But from her first take on the character, it's clear that director Patty Jenkins wanted to emphasize Wonder Woman's ability to inspire peace. 2017's *Wonder Woman* takes place during World War I, a conflict unknown to the Amazons living peacefully on the female-only island of Themyscira. When American spy Steve Trevor (Chris Pine) accidentally lands on the island, bringing with him pursuing German troops, Wonder Woman is certain that the war is the work of the God of War, Ares. Because Zeus created the Amazons to stop Ares and teach peace to humanity, Wonder Woman volunteers to go with Trevor to the front.

11. Marston and Peter, "Introducing Wonder Woman."

THE POWER OF THE PEACEMAKERS

Much of *Wonder Woman*'s charm comes from the way Gadot imbues the character with principled innocence. She dismisses the gender restrictions of 1918 London, swoons at the sight of babies and the taste of ice cream, and repeatedly insists that she go directly to the front to confront Ares.

That conviction gives us the film's most powerful moment, in which she reveals her full costume on a field of battle between the English and German fronts. Utterly sickened by the cost of war she sees all around her and tired of Trevor's insistence on staying hidden and following standard battle techniques, Diana decides to let loose.

Jenkins and Jensen train the camera on Diana as she rises from the cramped trenches where she hid with Trevor. Rupert Gregson-Williams's score turns from foreboding to rousing as we watch Diana climb from the trench and onto the battlefield, catching only glimpses of her shield, her tiara, and her boots. The camera follows a bullet as it speeds from a German gun toward the fully revealed Wonder Woman, staying with the hero as she bats the bullet away with her bracelets.

Faster, Diana speeds toward the German line, knocking rockets aside and absorbing the machine gun blasts until she can finally disable the weaponry. By the end of the sequence, Wonder Woman has shrugged off a platoon of German soldiers and taken out a sniper, allowing the English to liberate captured civilians.

It's a powerful scene, one that allows us to think that we've witnessed a fantasy example of just war. The good guys won and the bad guys lost.

But the movie explicitly rejects that kind of thinking. Throughout the film, Diana's mission has been simple: she will kill Ares and free humanity from the thrall of war. But after killing the man she thought was Ares, the merciless German General Ludendorff (Danny Huston), Diana realizes that nothing has changed. When she discovers Ares's true identity, that of English nobleman Sir Patrick Morgan (David Thewlis), Diana must face a truth that she couldn't consider. Humans may have been influenced by Ares, but they were never controlled by him.

A frustrated, exasperated Steve Trevor puts it best when a disillusioned Diana suggests that, if humanity did all of this killing and bloodshed without Ares's control, then they don't deserve her help. "It's not about deserve," he snaps, before begging her to realize that "it's not about that. It's about what you believe." As much as Steve wishes he could believe in the fantasy that there's just one bad guy out there to blame, one villain she could just kill, and all would be good, he can't. All of humanity is to blame, him as much as the others.

Diana's realization and Steve's confession get at something at the heart of Christian devotion to non-violence. Walter Wink reminds us that "Jesus did not advocate non-violence merely as a technique for outwitting the enemy, but as a just means of opposing the enemy in such a way as to hold open the possibility of the enemy's becoming just as well."[12] It means believing that "all have sinned and fallen short of the glory of God," and that God's mercy in Christ extends to us all. It means that we as Christians have a mission to show Christ's love, resisting evil by doing good (Rom 3:23). "Biblical peacemaking is the cessation of hostilities between nations and individuals as a sign of God's in-breaking kingdom," writes Esau McCaulley. "Peacemaking involves assessing the claims of groups in conflict and making a judgment about who is correct and who is incorrect." McCaulley continues, "*Peacemaking, then, cannot be separated from truth telling.*"[13]

Instead of letting Diana pretend that all of the world's problems could be directed to a single bad guy, who she could then strike down and save the world, Steve tells the truth, in all of its messiness. And from that truth-telling, Diana learns how to deal with other acts of violence, as shown in her interaction with Maxwell Lord. She's able to tell the truth to him, using his humanity and her compassion as a means to pursue justice and give him space to repent.

In the heart of our own war-torn world, we need images such as these to remember true biblical peacemaking.

AFTER THESE MESSAGES . . .

In many ways, the hero of *WandaVision* is neither Wanda nor Vision, but rather Monica Rambeau (Teyonah Parris), who Wanda magically expelled from her suburb after discovering that she is an undercover agent. Upon realizing that Wanda is being pushed toward violence by her boss Director Hayward (Josh Stamberg), Monica forces herself back into the neighborhood to confront Wanda, not with violence, but with empathy.

Monica urges Wanda not to give into her fears and anger, showing her that loss need not destroy us, that we can grieve and love one another and call for justice, without spreading the hurt elsewhere. "Don't let him make you the villain," Monica pleas, begging Wanda to break the cycle of violence Hayward wants to maintain.

In that act of bravery, we see something other than the fights and violence that superhero stories so often have. We see an emblem of the Prince

12. Wink, *Jesus and Nonviolence*, 45–46.
13. McCaulley, *Reading While Black*, 68 (italics original).

of Peace, calling forth the image of God in another person, even while standing her ground.

CREDITS:

Thor (2011)
Director: Kenneth Branagh
Screenwriters: Ashley Edward Miller and Zack Stentz and Don Payne

Doctor Strange (2016)
Director: Scott Derrickson
Screenwriters: Jon Spaihts and Scott Derrickson and C. Robert Cargill

Wonder Woman (2017)
Director: Patty Jenkins
Screenwriter: Allen Heinberg

Thor: Ragnarok (2017)
Director: Taika Waititi
Screenwriters: Eric Pearson and Craig Kyle and Christopher L. Yost

Wonder Woman: 1984 (2020)
Director: Patty Jenkins
Screenwriters: Patty Jenkins and Geoff Johns and Dave Callaham

WandaVision (2021)
Director: Matt Shakman
Showrunner: Jac Schaeffer

POST-CREDITS

Theme: Peace

Key Biblical Passage: Matt 6:9

Questions:

1. All of the heroes in the movies/series discussed in this chapter have to fight to achieve peace. Why is peace such a struggle? What prevents

peace from occurring? How does one "fight" for peace in the real world?

2. In *Doctor Strange*, Steven Strange defeats Dormammu by locking the monster in a time loop in which it relives its experiences again and again. Can you think of any real-world examples in which those who reject peace find themselves trapped by the consequences of that decision? How can one break the cycle of avoiding peace?

3. In most depictions, the mythological Norse god Thor is violent and war-like. What is the effect of putting this type of character in situations that underscore the suffering caused by pursing war? What is lost when Thor becomes a hero who pursues peace?

4. In *Wonder Woman*, Wonder Woman wants to believe that all war stems from one enemy. Why is that type of fantasy so appealing? How does that fantasy differ from Christ's teaching about loving one's enemies?

5. For all of the variety in superhero movies, very few of them imagine peaceful resolutions to the conflicts they portray. Why are stories about beating up bad guys so popular? Why is it so hard to tell a story about pursuing peace? How can stories about violence still be useful to Christians?

<div align="center">

9

MONSTERS MAKE GOOD

Black Widow—Blade—Hulk—Hellboy

</div>

God chose what is foolish in the world to shame the wise; God
chose what is weak in the world to shame the strong.

—1 Cor 1:27

The humans, they will tire of you. They have already turned
against you. Leave them. Is it them, or us? Which holocaust
should be chosen? We die . . . and the world will be poorer for it.

—Prince Nauda, *Hellboy II: The Golden Army*

"Still think you're the only monster on the team?"

That might seem like an odd question for superspy Natasha Romanoff (Scarlett Johansson) aka Black Widow to pose to her Avengers teammate Dr. Bruce Banner (Mark Ruffalo). After all, Banner's alter-ego the Hulk had just decimated parts of Johannesburg, South Africa, forcing the team to retreat midway through *Avengers: Age of Ultron*.

But there's truth to her confession. Trained from childhood in a secret Russian facility known as the Red Room to be an elite assassin, Black Widow has had her humanity stripped away by her handlers. Her experiences have left her with "red" in her ledger, a constant sense of debt she's desperate to repay.

One of the most striking examples of that debt resurfaces in 2021's *Black Widow*, in the form of the villain Taskmaster. For years, Natasha believed that her attack on General Dreykov (Ray Winstone), director of the Red Room, resulted in the death of a young girl called Antonia. But in *Black Widow*, Natasha learns that not only did Dreykov live, but that the damage Antonia (Olga Kuryenko) suffered allowed the general to control her mind, reshaping her into the perfect killer, Taskmaster.

Even as *Black Widow* puts Natasha face-to-face with a casualty of her most destructive behavior, the movie never forgets the good she does with that same training that dehumanized her. Natasha could never free other women from the Red Room, let alone save the galaxy alongside the Avengers in other MCU films, if she never became the monster they made her.

IS HE MAN OR MONSTER?

To a comic book reader in 1962, *The Incredible Hulk* #1 wasn't a superhero story.[1] Superhero stories were published by DC Comics, home of stalwarts Batman, Superman, and Wonder Woman, and of recently reimagined characters Flash, Green Lantern, and Hawkman. They featured square-jawed men and gorgeous women who wore bright costumes and unequivocally stood for what was right and good.

The Incredible Hulk #1 simply felt like a continuation of the comics Marvel published under its prior names, Timely Comics and Atlas Comics. The anthology series published by those companies, with outlandish titles like *Journey into Mystery* and *Strange Tales*, regularly contained creature features, stories of strange monsters called Spragg, Glopp, and It! The Living Colossus.

The Jack Kirby-drawn cover to *The Incredible Hulk* #1 promised more of the same, with its image of a giant grey beast, whose design recalled the Universal Pictures version of Frankenstein's Monster, towering over a shrimpy, startled scientist. "Is he man or monster . . . or is he both?" teased the tantalizing cover copy. The story inside answered that question with a tale inspired by Dr. Jekyll and Mr. Hyde, in which gamma radiation curses scientist Bruce Banner with a condition that changes him into the brutish Hulk every night.

As it turned out, Hulk wasn't an outlier, but a bellwether for the Marvel superheroes. Still nervous about jumping back into the superhero genre, which had died shortly after World War II, Stan Lee and his collaborators kept their new characters close to evergreen horror and sci-fi tales. When

1. Lee and Kirby, *Incredible Hulk* #1.

a bystander catches the first glimpse of the Thing in 1961's *Fantastic Four* #1, he yelps, "Yikes! A monster!"[2] Thanks to the odd physiology artist Steve Ditko gave his characters, Spider-Man and Dr. Strange had little in common with DC's handsome heroes in the Justice League of America.

Although the monster-first approach came from a hedged bet, it turned out to be revolutionary. By integrating monsters and superheroes, Marvel created what turned out to be their defining feature: people for whom superpowers were a curse instead of a blessing. Combined with Lee's melodramatic prose, Marvel comics were just as likely to be about the X-Men running from the humans they just rescued or Hulk sulking away from the crowd as they were about stopping bad guys.

Over the years, monsters became a mainstay among superhero comics. Marvel introduced more horror-themed heroes, including the demonic motorcycle stuntman Ghost Rider, Jack Russell aka the Werewolf by Night, and the inexplicable Man-Thing.[3] DC soon got into the action with their botanical monster Swamp Thing, Etrigan the Demon, and the magician John Constantine.[4] Both companies worked public domain monsters into their stories, devoting series to Dracula and Frankenstein's Monster. Some of the most popular independent characters have monster themes, including Mike Mignola's fantasy hero Hellboy and James O'Barr's violent creature of vengeance the Crow.[5]

Given the crossover appeal of monster superheroes, it shouldn't be too much of a surprise that these characters have been most often adapted into other media. *Blade*, featuring a vampire hunter played by Wesley Snipes, launched the second wave of superhero films in 1998. *Hulk* soon followed in 2003, Nicolas Cage starred in *Ghost Rider* and *Ghost Rider: Spirit of Vengeance*, and even Man-Thing got a direct-to-video film. DC monster Swamp Thing got a 1982 movie directed by none other than horror legend Wes Craven (and a campy 1989 sequel) and Keanu Reeves starred as an American

2. Lee and Kirby, *Fantastic Four* #1.

3. Ghost Rider (first appearance *Marvel Spotlight* #5, 1972) created by Roy Thomas, Gary Friedrich, and Mike Ploog. Werewolf by Night (first appearance *Marvel Spotlight* #2, 1972) created by Roy Thomas, Jeanie Thomas, Gerry Conway, and Mike Ploog. Man-Thing (first appearance *Strange Tales* #1, 1971) created by Stan Lee, Roy Thomas, Gerry Conway, and Gray Morrow.

4. Swamp Thing (first appearance *House of Secrets* #92, 1971) created by Len Wein and Bernie Wrightson. Etrigan the Demon (first appearance *The Demon* #1, 1972) created by Jack Kirby. John Constantine (first appearance *The Saga of the Swamp Thing* #37), created by Alan Moore, Stephen Bissette, Rick Veitch, and John Totleben.

5. The Crow (first appearance *Caliber Presents* #1, 1989) created by James O'Barr. Hellboy (first appearance *San Diego Comic Con Comics* #2, 1993) created by Mike Mignola.

version of the company's premier magician in 2005's *Constantine*. Not to be left out, independent monster characters all got their own movies, with *The Crow*, *Spawn*, *Dylan Dog: Dead of Night*, *Faust: Love of the Damned*, and even the comedy films *The Mask* and its family-friendly sequel *Son of the Mask*.

It's not hard to see why these characters so thoroughly capture the public's imagination. Superhero monsters are inherently redemptive, a surprisingly hopeful take on the power fantasy central to superhero stories. In these movies, evil cannot overcome even those who seem to serve it, and goodness arrives in the most unlikely places.

FAMOUS MONSTERS OF THE FAITH

Comic books aren't the only place where there be monsters. The Bible is full of strange creatures, including the behemoth and leviathan described in Job (40:15; 41:1), the multi-winged seraphim witnessed by Isaiah (6:1–8), and a race of six-fingered giants (2 Sam 21:16; 1 Chr 20:6).

The most compelling monsters, and those who best resemble the monsters in comic books are the many outsiders, whose physical or personal qualities render them inhuman in the eyes of society. Without question, these people suffer oppression and live in threat of violence. It's those same qualities, however, that make them perfect vessels for God's work, suited to shame the world's kingdoms, the kingdoms that reject them.

One such figure is the woman with an issue of blood, whose story is told in the Gospels of Matthew, Mark, and Luke. For twelve years, the woman suffered from hemorrhages, which marked her unclean in the eyes of Jewish law, barring her from social interactions and religious ceremonies. But when she defied custom and law to touch the hem of Jesus's robe, she received not censure, but praise. "Daughter, your faith has made you well; go in peace," Jesus tells her (Luke 8:48).

Another figure is the Ethiopian eunuch met by the apostle Phillip in Acts 8. The Holy Spirit directs Philip to the eunuch, who was reading Scripture while riding in a chariot. Philip offers to interpret Scripture for the eunuch and takes the opportunity to tell him about the liberation promised by Jesus. Filled with hope, the eunuch points Philip to a nearby stream. "Look, here is water! What is to prevent me from being baptized?" (Acts 8:37).

As Austen Hartke points out, the Ethiopian eunuch here is an outsider in multiple ways. Because of exclusions listed in Deut 23:1, the eunuch cannot participate in the assembly of believers. Secondly, the eunuch was Black, of a different race than the Jews, Samaritans, Persians, and Romans who

occupied Israel and the surrounding areas. The author of Acts never identifies the eunuch as either Jew or gentile, meaning he belongs to something other than the dichotomies with which the early church considered. Finally, the eunuch was likely a former slave since freed people were rarely castrated.

Simply put, "This means that the eunuch of Acts 8, whose name we never learn, was outside the boundaries of gender, race, class, and religion—a quadruple threat."[6] And yet, it was that very threat—that very monster, in the eyes of larger society—who could testify to the redeeming power of Christ. The Holy Spirit moved Philip toward the eunuch because "God decides to move in our direction by choosing to experience suffering alongside us."[7]

With figures like the eunuch and the woman with an issue of blood, God shows the world that those whom the earthly powers reject are accepted, loved, and celebrated by God. Through their existence, God shows the limits of earthly powers and the glory of the heavenly kingdom. As Paul so succinctly puts it, "God chose what is foolish in the world to shame the wise; God chose what is weak in the world to shame the strong" (1 Cor 1:27).

When we watch monster heroes through a Christian lens, we see the rejected and the odd, the dehumanized outsider, doing good works through the strength given to them by their outsider status. They do what no one else can do because they exist where no one else will go.

IT TAKES A MONSTER TO CATCH A MONSTER

When the young man at the start of *Blade* followed the strange, alluring woman he just met to a secret rave, hidden in the bowels of a meat-packing plant, he knew he was courting danger. But he thought it would be the sexy, exciting kind of danger, not the kind of danger that involves blood spraying from sprinklers on the ceiling.

Even worse, while the man finds the blood utterly horrifying, scrambling away to keep the viscous fluid off of him, every other person at the rave seems thrilled by it, licking their lips and exposing fangs behind their smiles.

Every person, except one. A stoic man in bandoleers and black leather, wrap-around shades hiding his eyes and an ornate tattoo blending perfectly into his stylish fade. That man is Blade, the vampire hunter, who has come to destroy the bloodsuckers who have congregated for a party. And destroy

6. Hartke, *Transforming*, 115.

7. Hartke, *Transforming*, 124.

them he does with an utter lack of remorse, dispatching the creatures with an unmatched ferocity.

The foolish young man has been saved, rescued from monsters by a monster.

Few movies have so strongly declared their statement of purpose like *Blade*, directed by Stephen Norrington and written by David S. Goyer. Based on the character writer Marv Wolfman and artist Gene Colan created in 1973 for the horror series *The Tomb of Dracula*, Blade seems like an unlikely start to the second wave of superhero movies.[8] After all, how could a movie about a minor Marvel Character, one who hadn't even starred in his own series at that point, succeed when movies about Batman and Superman flopped earlier in the decade?

The answer could be partially attributed to the film's use of action tropes of the time, filling the frame with techno-infused martial arts action a full year before *The Matrix*. It can also be attributed to star Wesley Snipes, who oozes charisma even when keeping Blade stoic, pulling off stylish superhero poses without ever seeming silly.

But I suspect the answer is the same for every other monster hero. Blade is ultimately a tragic figure, a monster made from monsters who destroys monsters. Born from a woman who was attacked by a vampire while nine months pregnant, Blade has super-strength and heightened senses, but is unaffected by sunlight. Dubbed "The Daywalker," Blade has made it his life's mission to rid the world of vampires, all the while struggling with his own need to drink blood, a weakness curbed thanks to a serum created by his partner Whistler (Kris Kristofferson).

For all of their twisty plotlines and over-the-top action, *Blade* and its two sequels all have a tragic element. Blade can only defeat the monsters he battles by becoming more feral, more like them.

Perhaps unsurprisingly, the purest example of this tension occurs in *Blade II*, directed by future Academy Award-winner Guillermo del Toro. Towards the climax of the movie, a heavily injured Blade crawls atop a blood-processing machine in a vampire stronghold. Del Toro and cinematographer Gabriel Beristain lean into the gothic elements of the design, the thick reds of the blood pumping through pipes highlighted against the machine's steel exterior. The hulking vampire Reinhardt (Ron Perlman) fires his shotgun at the day-walker, knocking him off the structure and hitting him as he falls. With a splash, Blade lands in a pool of blood at the basin of the machine, seemingly dead.

8. Wolfman and Colan, *Tomb of Dracula* #10.

Considering the attack accomplished, Reinhardt strides away from the blood pool. He does not see the ascending Blade, the blood dripping off of his muscles highlighted by the flames of the machine exploding behind him.

As monstrous as the image may be, the emergence from the blood pool signals not a reversion of Blade to his most animalistic side, but his overcoming of it. The scene carries particular potency for Christian viewers, who have witnessed a miniature death and resurrection. In this movie, there's quite literally "power in the blood," a reminder of the way that the horrible machinery of death holds no dominion over Christians, allowing us to do God's good work on Earth.

Throughout Scripture, we're told that our sins do not define us. Rather, the forgiveness we experience through Christ not only frees us from the guilt associated with those sins, but also gives us the ability to show compassion for others. Paul gets at the principle when he urges the church at Ephesus to "be kind to one another, tenderhearted, forgiving one another, as God in Christ has forgiven you" (Eph 4:32). Only those who have been forgiven know how to forgive others.

For all of its garish imagery, the blood baptism scene in *Blade II* helps us imagine this principle. In the movie, Reinhardt doesn't kill Blade by shooting him into the pool of blood. Rather, he reinvigorates him, giving him the strength to continue. And when Blade emerges, he's not controlled by his beastly desires, but is controlling them, proving that they can be conquered. The thing that sought to destroy him made him more powerful. His monstrosity has enabled him to defeat more monsters.

Christians won't be fighting vampires, but we do battle our feelings of guilt and worthlessness after our sins. In the same way Blade emerges from blood to do away with his enemies, we emerge covered by the blood of Christ, empowered by the forgiveness it signifies. We walk in that forgiveness, not to destroy others struggling with the same as monster, but to love and forgive them as children of God.

HOW TO LIKE YOURSELF WHEN YOU'RE ANGRY

Things look bad for the Avengers. They've been holding their own against the invading Chitauri army, but the aliens have unleashed their greatest weapon, a giant creature called the leviathan. As the leviathan bears down on the heroes, Captain America turns neither to Thor nor to secret agents Black Widow or Hawkeye, but to the haggard scientist Bruce Banner.

"Dr. Banner," he entreats; "now might be a really good time for you to get angry."

Banner stops his march toward the oncoming leviathan only long enough to glance back at the team. "That's my secret, Cap," he says with a bit of a smile. "I'm always angry."

In a single fluid motion, Banner grows bigger and greener as he turns back toward the leviathan. In his full form as the Hulk, he smashes the creature with a single punch, wreaking havoc on the invading aliens.

This scene isn't just one of the most memorable from *The Avengers*. It's also a unique approach to the Hulk, giving us a glimpse of the monster made into a superhero, unleashed on a seemingly unstoppable enemy.

That's a relatively rare approach to the jade giant, as indicated by his other notable appearances in the MCU. Earlier in *The Avengers*, Hulk goes wild in a helicarrier, nearly killing Black Widow and pummeling Thor. Hulk destroys a swath of Johannesburg in *Avengers: Age of Ultron* and is the champion gladiator of the warlord the Grandmaster in *Thor: Ragnarok* . Even the lone Hulk solo film within the MCU, 2008's *The Incredible Hulk*, climaxes with Banner (played here by Edward Norton) transforming in downtown Harlem to battle Abomination (Tim Roth), destroying the borough in the process.

One of the first Marvel superheroes, the Hulk is also one of the most consistently popular. The Hulk has been a mainstay in the Marvel Universe, carrying his own long-running solo title and starring in team-up books such as *Avengers* and *Defenders*. Even as the Hulk has experienced multiple transformations—including the grey-skinned Vegas mobster Mr. Fixit, the super-intelligent Professor Hulk, and the futuristic dictator the Maestro— the character remains driven by a simple, irresistible concept. The Hulk is the savage id of the meek and traumatized scientist Bruce Banner made manifest when he gets angry.

That aspect of the Hulk is certainly present in the character's first big-screen movie from 2003, *Hulk*. The Hulk of this film is the same green beast that you find in everything from the MCU movies to the live action television series that ran from 1978 to 1982 to the character's many animated appearances.[9] The Hulk growls and roars, smashing everything that gets in his way.

9. The CBS television series *The Incredible Hulk*, starring Bill Bixby as Bruce Banner and Lou Ferrigno as the Hulk, aired eighty-two episodes from 1977 to 1982, including a 1977 TV movie. Three television movies followed: *The Incredible Hulk Returns* (1988), *The Trial of the Incredible Hulk* (1989), and *The Death of the Incredible Hulk* (1990). In addition to appearances in the 1966 cartoon series *The Marvel Super Heroes*, Hulk also starred in an animated series *The Incredible Hulk*, which aired thirteen episodes in 1982–1983. Twenty-one episodes of a second animated series called *The Incredible Hulk* aired between 1996–1997. The team-up cartoon series *Hulk and the Agents of S.M.A.S.H.* ran between 2013–2015, totaling fifty-two episodes. The Hulk has also

But under the direction of Academy Award-winning Ang Lee, *Hulk* shows that the monster is more than just the uncontrollable anger of scientist Bruce Banner (Eric Bana). It's also the release of all Banner's repressed emotions, a legacy he inherited from his father. Lee and writer James Schamus use the Hulk story as an exploration of the problems our forerunners pass onto us.

That theme appears on the story's literal level in the form of the mutated DNA that geneticist David Banner (Nick Nolte) carried onto his son after performing experiments on himself. On a metaphorical level, David also gave Bruce a host of emotional problems, including the trauma of seeing him murder Banner's mother Edith (Cara Buono). Bruce matures into an emotionally closed-off adult, with no memory of his biological parents and unable to connect with his supportive girlfriend Betty (Jennifer Connelly).

While exposure to gamma radiation gives Banner the ability to become the Hulk, just as it does in every other version of the story, *Hulk* makes parental relationships the catalyst for the change. The Hulk does not appear until forty minutes into the film, after David reenters Bruce's life. The first transformation sequence features close-up shots on Bruce's eyes, tinted green by the lights of his lab, as he investigates David's claims about the special nature of his DNA. Combining voice-over echoes of David's comments to Bruce with a phone message from Betty, outlining her own aborted attempt to connect with her father, Lee interposes images of atomic explosions and mutating cells, matched with flashbacks to David killing Edith.

The sequence climaxes with Banner changing into the Hulk, who promptly destroys a lab in a fit of rage. But when the Hulk confronts David, he becomes docile, vulnerable, wounded. This version isn't just a rage monster, but also a scared child, who longs to be loved. Throughout the movie, the Hulk switches immediately from destroying attacking soldiers to leaping through the desert, closing his eyes in peaceful bliss as the wind blows through his hair. A brutal battle against mutated dogs ends with Hulk tenderly lifting Betty away from the danger.

In his letter to the Ephesians, Paul urged readers to follow Christ by putting away "your former way of life, your old self, corrupt and deluded by its lusts, and to be renewed in the spirit of your minds, and to clothe yourselves with the new self, created according to the likeness of God in true righteousness and holiness" (Eph 4:21–24).

That powerful metaphor helps us remember that the world into which we are born is already entrenched in sin, in the powers that exploit and demean and wage war, that do not accept the kingdom of love and hope

appeared in numerous other Marvel cartoon series.

preached by Jesus. Even as we strive for the renewing of the mind that Paul describes above, the becoming of a new self, we sometimes lose hope, convinced that the old self will always return. Triggered by the wounds of the world, whether it be traumas inflicted by abusers or economic and political systems wedded to violence, we experience a relapse, in which that old self manifests and wreaks havoc.

In those moments, we certainly sympathize with poor Bruce Banner, who wakes up to discover his clothes shredded, surrounded by last night's debris. But the sympathetic approach Lee takes in *Hulk* reminds us to be gentle with ourselves, even in our pain. Our sins are not our own, but part of world that precedes us and follows us. Furthermore, there is grace always available to us, an unending love that cannot be separated by "death, nor life, nor angels, nor rulers, nor things present, nor things to come, nor powers, nor height, nor depth," let alone the pain we receive from our parents or pass onto our children (Rom 8:38–39).

Living in a fallen world may leave us hurt, forced to keep our constant anger a shameful secret, but that does not prevent us from receiving and enacting the unfailing love of God.

THE RIGHT HAND OF HOPE

Scattered among ancient ruins stands a glowering crimson beast. Brought from another dimension by Nazi mystics and scientists at the end of World War II, this demon is Amung un Rama, the Right Hand of Doom. Decades later, the unkillable Russian sorcerer Grigori Rasputin (Karel Roden) and his undead Nazi associates have returned to force Amung un Rama into bringing about the apocalypse.

After a series of incantations and manipulations, Rasputin coerces the demon into embracing its power. A pair of jet black horns protrude from his head, holding a flaming crown between them and causing portals to tear open the sky.

But just as the apocalypse seems inevitable, an agent for the Bureau of Paranormal Research and Defense (BPRD) tosses to the demon an item to halt its hellish transformation: a rosary, worn by the BPRD's late director, Professor Broom (John Hurt). The rosary burns the creature's skin, but it does not hurt him, even as it leaves on his hand the glowing imprint of a cross.

"Remember who you are," shouts the agent, prompting the demon to recall his first day on earth, when he was adopted by Professor Broom. Broom saw in the creature more than an agent of chaos. He saw a child

who needed a father, who deserved to be loved. And so Professor Broom raised the demon as his son, filling him with a sense of duty, a weakness for kittens, and a voracious appetite for pancakes. The demon is not Amung un Rama, the Right Hand of Doom. He is Hellboy, the blue-collar paranormal investigator with a heart of gold.

Each of Hellboy's three film appearances address this tension between the protagonist's evil destiny and his desire to be a normal, everyday guy. It's the focus of both Guillermo del Toro-directed *Hellboy* films, which star a pitch-perfect Ron Perlman in the title role, and the 2019 reboot directed by Neil Marshall and starring David Harbour.

Modelled after Mignola's own rough and tumble father, Hellboy is a gruff, no-nonsense figure who approaches his fantastic mission like an ordinary day job.[10] But behind his hard exterior, Hellboy is a big softy who just wants to be accepted, by the world he fights to save and by those closest to him. These two qualities put Hellboy into a constant state of conflict, doing his best to save humans who hate and fear him and fights monsters who simply want their place in the world.

Of the three Hellboy films, 2008's *Hellboy II: The Golden Army* best captures this tension. The movie follows Hellboy and his fellow BPRD agents working to prevent Nauda (Luke Goss), renegade Prince of the Elves, from reforming a golden army and destroying humanity.

At no point does the film endorse Nauda's violent plans, as it puts him against his father King Balor (Roy Dotrice) and his twin sister Princess Nuala (Anna Walton). The film does, however, sympathize with Nauda. He and his fellow Elves have been betrayed by the humans with whom they entered into a treaty centuries ago.

Director Guillermo del Toro captures that struggle with a striking scene that pits Hellboy against a forest elemental, unleashed upon the city by Nauda. The elemental tears up the city streets and hurls cars at the crowd, using its verdant vine tentacles to topple buildings. Hellboy does his best to control the threat while protecting a human baby, cradling the child in one hand and gripping an oversized pistol, dubbed "Big Baby," in the other. At the climax of the scene, Hellboy tosses the infant into the air so he can load massive bullets into his gun. A lullaby breaks into the soundtrack to make a humorous comparison between the human baby and Big Baby before Hellboy blows the monster away.

Instead of punctuating the victory with a sense of triumph, del Toro pauses the movie for reflection. The elemental writhes and roars as it dies,

10. The first Hellboy story, drawn by Mignola and written by John Byrne, was published in *San Diego Comic Con Comics* #2 (1993). Since then, Hellboy's adventures have been almost solely made by Mignola and published by Dark Horse Comics.

spraying green seedlings into the air and spreading flowers and bushes across the city. The creature's death brings a vibrant life, decorating the concrete landscape with foliage of a type it long ago displaced. A moment of beauty forever sacrificed in the battle between Nauda and Hellboy.

The battle underscores Hellboy's position in his stories. He will always fight for life, even if it means saving those who do not believe goodness can come from something that looks different from them. Christians have a similar charge, called to love those who others denigrate as subhuman or enemies. That command can be found all throughout the Bible, from God's protection of Abraham's discarded slave Hagar to the aforementioned Ethiopian eunuch.

One image best captures this teaching, an image that wouldn't be out of place in a Hellboy film. Acts 10 recounts a vision of the apostle Peter in which he sees a sheet lowered from heaven, filled with "four-footed creatures and reptiles and birds of the air"—animals deemed unclean by Jewish law. When a voice commands Peter to kill and eat the creatures, he refuses on the grounds of his obedience. The voice rebukes Peter, saying, "What God has made clean, you must not call profane" (Acts 10:9–16).

The passage in Acts officially marks the inclusion of gentiles into the Christian church, extending to the rest of the world the promises of redemption God gave first to the Hebrews. It reminds all who follow that no person created in the image of God can be called unclean, no matter how much we may dislike them or by what self-righteousness we want to reject them. To reject and condemn is to bring about destruction.

Despite his satanic moniker and intimidating red horns, Hellboy is no agent of the devil. He does work that God calls good, serving others and looking out for the oppressed and dejected. Moreover, through his good works, Hellboy inspires others to do the same. He achieves these goals precisely because he doesn't let others condemn him, but always remembers who he is, a memory sealed by the image of the cross.

FACE TO FACE

Natasha and Taskmaster have numerous spectacular battles throughout *Black Widow*, in which the latter mimics the fighting styles of Black Panther, Spider-Man, and other Avengers. But their final clash ends not with an epic beatdown but with an act of redemption.

The two women battle relentlessly, until they both lie broken on the ground. Taskmaster crawls toward her rival, her helmet knocked off to reveal two wild eyes glaring from a face that still bears the scars of Natasha's attack.

Natasha gathers strength to do one more flip, to land one more punch. But her fist doesn't land on Taskmaster. It lands on a vial containing an antidote to the mind-control drugs Dreykov uses on his Red Room graduates.

As red dust engulfs them, Natasha grasps Antonia's neck and pulls her close. Natasha nuzzles her one-time enemy, watching the anger and mindless rage fade from Antonia's face. The two collapse to the ground, and Natasha crawls over to Antonia to say the only thing she can possibly say: "I'm sorry."

It was a monstrous thing Natasha did when she attacked Dreykov and wounded Antonia. But it was a direct result of abuse she suffered at the hands of Dreykov and other administrators in the Red Room. And it was only Natasha's position as a monster that allowed her to do something heroic, saving the monster that she made out of Antonia.

In this scene, *Black Widow* captures one of the most potent fantasies in stories about heroic monsters: that we can help others from a place of apparent helplessness, that our weakness becomes a power to minister to others.

CREDITS:

Blade (1998)

Director: Stephen Norrington

Screenwriter: David S. Goyer

Blade II (2002)

Director: Guillermo del Toro

Screenwriter: David S. Goyer

Hulk (2003)

Director: Ang Lee

Screenwriters: James Schamus and Michael France and John Turman

Hellboy (2004)

Director: Guillermo del Toro

Screenwriters: Guillermo del Toro and Peter Briggs

Hellboy II: The Golden Army (2008)

Director: Guillermo del Toro

Screenwriter: Guillermo del Toro

Black Widow (2021)

Director: Cate Shortland

Screenwriter: Eric Pearson

POST-CREDITS:

Theme: Acceptance

Key Biblical Passage: 1 Cor 1:27

Questions:

1. We've all been rejected or pushed to the outside. When have you been treated like less than a human? When have you treated others as less than human? Which feelings were involved in each instance?

2. The *Blade* movies are about a person who becomes heroic thanks to the same things that make him a monster. Has the experience of rejection ever created an opportunity for you? How have you been able to embody the gospel from an outsider position?

3. For many people, the Hulk is one of the most relatable superheroes. What triggers do you have that drive you to become something other than yourself? Have you experienced grace after such moments? Have you extended grace to others in that situation?

4. Hellboy is a character who lives in an in-between space, doing good while afraid that he's destined to do evil. Do you worry that you'll harm others or do evil things? What do God's promises of forgiveness mean to you?

5. Stories about heroic monsters are compelling in part because they remind us that goodness can come from anywhere, even from unlikely places. How have you experienced surprising reminders of God's goodness? What did you learn from such experiences?

10

LESSONS FROM THE LESSER EVILS

Loki—Joker—Venom—Deadpool

I do not understand my own actions. For I do not do what I want,
but I do the very thing I hate.

—Rom 7:15

Well, I may be super, but I'm no hero.

—Deadpool

At the start of *The Avengers,* Loki marches into SHIELD headquarters
and makes a bold proclamation. "I am Loki, of Asgard," he announces. "And
I am burdened with glorious purpose."

It's easy to see why he feels so confident. After all, he has at his disposal
a Chitauri army provided by Thanos, the ability to control minds, and after
a quick scuffle, he even possesses the powerful weapon known as "the tes-
seract." He couldn't anticipate the trouble he's about to have with Earth's
Mightiest Heroes.

When he repeats those words in the first episode of the Disney+ series
Loki, they take on a very different tone. The Loki who speaks then doesn't
know that he would be thoroughly trounced by the Avengers, that he would
watch his mother die, that he would be strangled to death by Thanos. In fact,
he's quickly informed that he is not the real Loki, but a variant, an unneces-
sary alternate version who must be purged from the timeline.

Throughout the *Loki* series, we watch as the one-time God of Mischief is laid low, brought to realize the futility of his actions, and even forced to taste his own medicine, thanks to other alternate versions of himself.

Does that make *Loki* a redemption story? No, not exactly. But it is a story about the cost of villainy, a look at the burden of being bad.

IMMORALITY TALES

Although it is certainly unusual to give a villain like Loki his own series, it isn't unheard of. In the comics supervillains regularly get their own series, including Loki himself. In some cases, the character stays villainous even when becoming the protagonist, as in the several series starring the Joker or the team-up book *The Superior Foes of Spider-Man*.[1] In others, we see through the villain's twisted perspective in which they see themselves as heroes holding to a type of morality, as in any comic starring Doctor Doom or the excellent 2005 miniseries *Lex Luthor: Man of Steel*.[2] Finally, sometimes, the villain becomes a type of antihero, doing a type of good by clashing with an even greater evil, as in most Deadpool and Harley Quinn stories.

Although superhero movies are less likely to put a villain in the starring role, they do follow this path. In addition to Loki and the three franchises discussed in this chapter, spin-offs such as *Catwoman* and *Elektra* take an antagonist and pit them against greater evils. MCU entries *Ant-Man* and *Ant-Man and the Wasp* star Paul Rudd as thief Scott Lang, but they quickly make him an ethical thief before transforming him into a straightforward hero. Movies about antiheroes, characters who go on a heroic arc even though they have decidedly un-heroic behavior, remain very popular, as seen in *Barb Wire*, *The Punisher* and the reboot *Punisher: War Zone*, as well as *Kick-Ass* and *Kick-Ass 2*.

More common in superhero movies is to simply have the villain outshine the hero. Ever since the much more respected actors Gene Hackman and Jack Nicholson took on bad guy roles against the lesser-known Christopher Reeve and Michael Keaton in the first wave of superhero movies, filmmakers have relied on the villains to bring complexity and gravitas to the screen.

Superhero films of the second wave followed suit, with Heath Ledger's Academy Award-winning portrayal of the Joker in *The Dark Knight* and Alfred Molina's Shakespearean approach to Doctor Octopus in *Spider-Man 2*. While some have criticized the third wave of superhero films for

1. Spencer and Lieber, *Superior Foes of Spider-Man*.
2. Azzarello and Bermejo, *Lex Luthor: Man of Steel*.

downplaying villains, relying on forgettable figures such as Steppenwolf (Ciarán Hinds) from *Justice League* and Malekith (Christopher Eccleston) from *Thor: The Dark World*, this wave has featured some of the best of all time, including Michael B. Jordan's Killmonger, Tony Leung's Wenwu, and, of course, Hiddleston's Loki.

It's easy to see why villains can so easily capture our attention. There's an allure to looking at the world through such twisted eyes, to trying to see how one could make the evil choices these characters make. But even more importantly, villain stories directly challenge our morals. When we follow the bad guy's perspective, we find our own assumptions tested. We get an opportunity to rethink our ideas of good and evil, of normal and abnormal. We have opportunity to rebuild our own sense of what matters.

BAD GUYS OF THE GOOD BOOK

One of the most dangerous ideas to threaten Christianity is the assumption that the Bible is "The Good Book," a collection of morality tales and instructions for being a good person. While certainly some Bible stories are intended for clear instruction, most belong to other genres: histories, poetry, letters, and more. It would be too simple to suggest that villains or antagonists who appear in every story serve the same purpose, no matter what the genre.

Instead, it helps to look at villains as real people. As JR. Forasteros writes in his book *Empathy for the Devil*, these characters are "born into sin as we all are; they were not more evil than the rest of us."[3] With that in mind, we can see something of ourselves in even the worst biblical baddies. Forasteros suggests that Christians approach these characters with empathy, moving past the cursory readings that we usually give them in the hopes that "we might discover we're walking their path—just a few steps behind," so that we can "repent before sin blooms and we become villains in our own right."[4]

Take for example, Herod the Great, the Judean king who, according to Matt 2, orders the death of all boys in Bethlehem two years old and younger, in hopes of eradicating the Christ child. Forasteros's reading never justifies Herod's actions, but it does humanize them, helping us see why a person would do something so heinous. Forasteros imagines Herod as a man stuck in an impossible situation, with no good choices. The arrival of Magi seeking the newborn king of the Jews upsets the tenuous position granted him

3. Forasteros, *Empathy for the Devil*, 4.
4. Forasteros, *Empathy for the Devil*, 5.

by Roman Emperor Caesar Augustus. By instigating the slaughter of the innocents of Bethlehem, Forasteros writes, Herod hoped to send "a message that he was Rome's man to the end."[5]

Biblical scholar and priest Wilda C. Gafney performs a similar creative work when describing Queen Jezebel in her book *Womanist Midrash*. Combining textual close reading of passages in 1 and 2 Kings with historical research and her own sanctified imagination, Gafney looks beyond the infamous queen's reputation, which has reduced her name to "a cross between a taunt and a slur."[6]

In her reading, Gafney describes Jezebel as one who, "in hip-hop womanist parlance . . . stays true to her set, her 'hood, or her colors. Jezebel is a straight gangsta, ride-or-die Ba'al worshiper."[7] Despite her position as a foreigner who was married to Israel's King Ahab for political reasons, Jezebel refused to be limited by her status, religion, or gender. So great was her faith in Ba'al that it shamed the inconstant Israelites. "Jezebel is a model of religious fidelity," writes Gafney. "She is faithful to her gods until the moment of her death."[8]

As these interpretations demonstrate, attending to villains' stories help us recontextualize the beliefs and assumptions of good guys, the morals that we too often take as givens. These stories put pressure on our beliefs, giving us space to rethink and rebuild them.

GETTING WHAT YOU DESERVE

In the first scene of *Joker*, the camera watches professional clown and part-time comedian Arthur Fleck (Joaquin Phoenix) apply his makeup. Over the radio, we hear a news report about a garbage strike in Gotham City, which has, as the announcer puts it, "even the nicest parts of the city . . . looking like slums." As various New Yorkers call into the program, denouncing the disgusting state of their city, Fleck plunges his fingers into the corners of his mouth and yanks them upward, twisting his face into something like a smile.

Few movies have started with such a clear statement of intent. Directed by Todd Phillips, who co-wrote the screenplay with Scott Silver, *Joker* is a film that heaps ugliness and garbage upon the screen, all while forcing an unconvincing smile. Filled with visual nods to Martin Scorsese films,

5. Forasteros, *Empathy for the Devil*, 102.

6. Gafney, *Womanist Midrash*, 240.

7. Gafney, *Womanist Midrash*, 241.

8. Gafney, *Womanist Midrash*, 242.

namely *The King of Comedy* and *Taxi Driver*, *Joker* is part treatise on the worst in modern society and part origin of the famous Batman villain. The latter part comes in the form of a subplot involving Thomas Wayne (Brett Cullen) and a cameo by young Bruce Wayne (Dante Olsen) and his loyal butler Alfred (Douglas Hodge). The film even ends with the familiar scene of the Waynes' murder, complete with Martha's pearls being spilled on the ground.

The former part comes in the form of, well, everything else. Fleck suffers from multiple ailments, including (but not limited to) near-illiteracy, mental illness, a history of parental abuse, disrespect from everyone he meets, and a neurological condition that results in uncontrollable laughter.

Over its 122 minutes, *Joker* chronicles Fleck's transformation from a helpless sad sack to the titular murderous clown. The downfall can be attributed to a range of issues, from government funding cutting off his mental healthcare to derision from late night talk show host Murray Franklin (Robert De Niro) to the machinations of his co-dependent mother (Frances Conroy). In fact, there are so many issues plaguing Fleck that it's hard to say that the movie adheres to any coherent worldview. All of society is bad in the movie's estimation, and Joker is the natural outcome of it.

That position comes through in the scene leading to the climax, in which Fleck is invited on Franklin's show. Franklin has been airing footage of Fleck's deranged and hapless stand-up sets as part of his comedy bits and wants to make the act live. By the time he arrives at Franklin's studio, Fleck has resolved to take no more insults from people. His mother has died and he has brutally murdered a bully from work. He dons his white face-paint and purple suit and dyes his hair green, asking Franklin to introduce him as "Joker."

While Franklin attempts to conduct the show as usual, Fleck isn't having it. He quickly tosses aside the pretense of telling jokes and begins ranting about the cruelty of the world, how "decent" people like Franklin and Thomas Wayne have no kindness, decrying a world in which "Everybody just yells, shouts, and screams at each other."

Fleck's rant builds to his final point, which he presents in the form of a joke, "What do you get when you cross a mentally ill loner with a society that abandons him and treats him like trash?" While Franklin tries to shut up his guest, Fleck grows apoplectic with rage. "I'll tell you what you get," shouts Fleck, pulling out a gun. "You get what you f-----g deserve!" With that, Fleck shoots Franklin in the head, killing him on live television.

Ever since writer Bill Finger and artists Jerry Robinson and Bob Kane debuted the character in 1940's *Batman* #1, the Joker has represented a

type of chaos to contradict Batman's sense of order and justice.[9] Later Joker stories accentuate the relationship between Joker and the broken society that birthed him, especially the 1980s releases *Batman: The Killing Joke* and *Batman: The Dark Knight Returns*.[10] This film version takes it to an extreme, making his violence the natural endpoint of a trashed society, a nearly just response to the cruelty of the world. Murray Hamilton, the Waynes, and everybody else deserves the terror wrought by the Joker because they contribute to the horrible world in which he lives.

To some Christians, talk about deserving punishment brings to mind Hell, the place of eternal torment in the afterlife. Many people think of Hell in simplistic terms, as a place where bad people or unrighteous people go as consequence of their sinful actions.

But theologian and Trappist monk Thomas Merton has a different take. He describes Hell as a state of separation from God. Because God's love is invested in all creation, to be against God is to "love ourselves more than Him." As a result, "all things become our enemies."[11] In Merton's telling, Hell is a place of self-hatred manifested in hatred of others. In Hell, sinners are "are all thrown together in their fire and each one tries to thrust the others away from him with a huge, impotent hatred . . . not so much that they hate what they see in others, as that they know others hate what they see in them: and all recognize in one another what they detest in themselves, selfishness and impotence, agony, terror and despair."[12]

The garbage world portrayed in *Joker* is very much like Merton's vision of Hell. It's a place where love is a delusion, where even the weak despise one another and no power protects the strong from random violence. Worst of all, it's a Hell created and sustained by everyone in it, with each denizen giving the other the damnation they deserve and never they grace they so desperately need.

Like all visions of Hell, the one provided by *Joker* spurs repentance. Not just in a spiritual sense, but in a real and practical sense, as the viewer rejects the movie's bleak worldview and works to prevent it from manifesting in reality. Confident in the knowledge that, because of God's forgiveness, we don't get what we deserve, we can replace the stink of trash with "the aroma of Christ to God among those who are being saved and among those who are perishing; to the one a fragrance from death to death, to the other a fragrance from life to life" (2 Cor 2:15–16).

9. Finger and Kane, "Joker."

10. Miller, *Batman*; and Moore and Bolland, *Batman*.

11. Merton, *New Seeds of Contemplation*, 150.

12. Merton, *New Seeds of Contemplation*, 149.

THE MONSTER INSIDE ME

The terrifying Carnage is ravaging San Francisco. The combination of an alien symbiote and serial killer Cletus Kasady (Woody Harrelson), Carnage can live up to his name unabated unless someone stops him. And the only thing that can stop him is Eddie Brock (Tom Hardy) and his symbiote Venom (a CGI creation voiced by Hardy).

But at the end of Act Two of *Venom: Let There Be Carnage*, Eddie and Venom are separated. What holds the two apart, preventing them from stopping the greater monster? Hurt feelings.

Hiding inside of Eddie's one-time fiancée Anne (Michelle Williams), Venom refuses to bond with his former partner, growling instead, "I'm not talking to him." Through Anne, Venom demands an apology, which stupefies Eddie. "Right now?" he asks incredulously, before sneering, "Fine, I will be the bigger of us." After several aborted attempts to find the right tone and level of honesty, Eddie finally breaks down. "I was a loser before I met you. And now I am someone. All right? You made me special."

With a few more apologies, Venom finally decides to return to Eddie. The moment may end with a hug between Anne and Eddie, but the true reconciliation is between Eddie and Venom.

Comic book fans going into *Venom* and its sequel expected something different from the movie adaptations. After all, the Venom of the comics is deeply immersed in Spider-Man's story, as the symbiote first appeared as a black suit worn briefly by Spidey. After Spider-Man discarded the suit, the symbiote bonded with Eddie Brock and become the dangerous Venom, who debuted in full in 1988's *The Amazing Spider-Man* #300.[13]

Separating Venom from the Spider-Man mythos and making the character into a protagonist necessitated some changes in tone. But few would have expected the movies about an aggressive reporter and an alien goo monster to be romantic comedies. Nevertheless, both Venom films focus more on Eddie and Venom learning how to get along more than they do battles against other, eviler symbiotes. Throughout the movies, Venom and Eddie snipe at and encourage one another, they complain about and miss each other, they hurt each other and make one another stronger.

Often, the two argue about morality. Venom came to Earth with other symbiotes to conquer the planet and consume humans. Bonding with Eddie instilled in Venom a love of Earth, so much that they teamed up to stop symbiote leader Riot (voiced by Riz Ahmed, who also plays duplicitous scientist and Riot host Carlton Drake) from bringing more aliens.

13. Michelinie and McFarlane, *Amazing Spider-Man* #300.

But loving Earth does not mean loving all humans, and Venom still hungers for brains. The most entertaining parts of both movies find Eddie trying to resist Venom's pleas to eat someone, especially a bad person. Both movies end with Venom triumphantly chomping the head off a victim, in scenes that call for audience applause.

More than relationship farces, *Venom* and its sequel play more like comedies about a man dealing with his darkest impulses. Although it occasionally manifests as a gooey black head protruding from Eddie's back, allowing it to look in the eye of its host, Venom most often exists as a voice inside of Eddie's head. After defeating a group of Drake's thugs, Venom growls at Eddie, "Now, let's bite all their heads off, and pile them up in the corner." Sweaty and confused, Eddie asks, "Why would we do that?" to which Venom only answers, "Pile of bodies, pile of heads."

For all its comedic tension, the Venom movies capture a struggle all of us know well. We all deal with impulses and temptations, desires that can be destructive to ourselves and others.

Paul poetically captures this tension in Rom 7:15–20:

> I do not understand my own actions. For I do not do what I want, but I do the very thing I hate. Now if I do what I do not want, I agree that the law is good. But in fact it is no longer I that do it, but sin that dwells within me. For I know that nothing good dwells within me, that is, in my flesh. I can will what is right, but I cannot do it. For I do not do the good I want, but the evil I do not want is what I do. Now if I do what I do not want, it is no longer I that do it, but sin that dwells within me.

In many readings, Paul's declaration is tantamount to a self-hatred, a figurative (and sometimes literal) self-flagellation in the light of God's goodness. But in their commentary on the New Testament, Mitzi J. Smith and Yung Suk Kim remind us that the human body is a gift of God, just like law. Neither of these are inherently evil in Paul's theology and therefore should not be punished.

Rather, argue Smith and Kim, Paul believes that the way out of sin is "by dying to sin," which means "not to follow sin's way." In short, the "only way of undoing sin's power is to die in it," to follow the spirit of Jesus.[14]

With their romantic comedy stylings, the Venom movies show us a character who does not kill the power inside his body, but rather lives with it. Thus, even Eddie's good deeds with Venom, the bad guys they remove from the world through decapitation, are tainted. No matter how special

14. Smith and Kim. *Toward Decentering the New Testament*, 338.

Venom may make him, Eddie will always be lethal, a slave to the appetites and insults that the alien symbiote heaps upon him.

FOUR OR FIVE MOMENTS TO BE AN ANTI-HERO

At the end of *Deadpool*, the "Merc with a Mouth" has finally found his man: Ajax aka Francis (Ed Skrein), the scientist whose experiments gave Wade Wilson (Ryan Reynolds) superhuman healing powers, but also left his body badly burned. Taking the name Deadpool, Wilson spends the film hunting down Ajax to exact his revenge. Along the way, Deadpool meets X-Men Colossus (Stefan Kapičić) and Negasonic Teenage Warhead (Brianna Hildebrand), the former of whom tries to teach him how to be a hero.

Deadpool shrugs off every piece of advice Colossus offers, but when he stands atop of Ajax with a gun pointed at the scientist's head, the Russian mutant tries one last time. "Four or five moments!" Colossus shouts, staying Deadpool's hand. While most people assume that being a hero is a full-time job, Colossus begs to differ: "Over a lifetime, there are only four or five moments that really matter. Moments when you're offered a choice—to make a sacrifice, conquer a flaw, save a friend, spare an enemy."

A gunshot stops Colossus short. Deadpool doesn't care about the moralizing and exclaims, "If wearing superhero tights means sparing psychopaths, then maybe I wasn't meant to wear them."

It's clear that Deadpool isn't a hero, but both *Deadpool* and its 2018 sequel *Deadpool 2* do portray the character as an anti-hero. A foul-mouthed contract killer who gleefully slaughters his opponents, Deadpool fights against guys worse than even he is. That's particularly true in *Deadpool 2*, in which Deadpool forms a superhero team to defend powerful teen Rusty Collins (Julian Dennison) from the time-traveler Cable (Josh Brolin), who comes from the future to kill Collins before he can grow into a supervillain.

Deadpool's wonky morality comes straight from the comics, albeit in a roundabout way. Deadpool first appeared in 1990's *The New Mutants* #98 as a basic assassin, bearing more than a few similarities to Deathstroke the Terminator from DC Comics.[15] In the character's first solo series, initially written by Joe Kelly and drawn by Ed McGuinness, Deadpool became a parody of gritty anti-heroes. Kelly gave Deadpool his signature fourth wall breaks, which were continued by the writers who followed, namely Christopher Priest and Gail Simone. These breaks allowed Deadpool to become

15. Liefeld and Nicieza, *New Mutants* #98 (1990). Written by Rob Liefeld and Fabian Nicieza, drawn and inked by Liefeld, colored by Steve Buccellato, lettered by Joe Rosen.

a true agent of chaos, knowingly skewering superhero tropes with the same abandon he used to skewer his adversaries.

While Deadpool's first cinematic appearance in *X-Men Origins: Wolverine* (2009) erased the self-awareness and comedic elements (despite the fact that he was played by Reynolds), the fourth wall breaking became the defining feature of the character's two solo films. In fact, both Deadpool movies even make direct reference to Reynolds's first abysmal go at the character, including a post-credit sequence in *Deadpool 2* that finds the red-suited mercenary interrupting a scene from *X-Men Origins: Wolverine* and shooting that movie's version of Deadpool.

But those aren't the only inside jokes *Deadpool* lobs at superhero fiction. *Deadpool* cracks jokes about Reynolds's lackluster outing in *Green Lantern*, and makes numerous jabs at Hugh Jackman's performance as Wolverine. The first movie even ends with a post-credit scene that jeers at post-credit scenes, in which Deadpool dons Matthew Broderick's costume from *Ferris Bueller's Day Off* and chides the audience for sticking around. "You were expecting Sam Jackson to show up with an eye patch and saucy little leather number?" he asks, shooing the viewers away.

There's an honesty to the Deadpool movies. By combining knowing references with irreverent ultraviolence, *Deadpool* strips away the façade of goodness in superhero stories. Where movies such as *Captain America* or *Superman: The Movie* cover their "might makes right" ethic with moralizing about helping others and sticking up for the little guy, *Deadpool* has no such pretensions. The movies reduce superhero stories to their core elements, in which guys in costumes gleefully beat one another up.

The limit of our own goodness is a common theme in the New Testament, especially Paul's epistles. As we saw in Rom 7, Paul considers our works to be constantly tainted by selfishness. He makes that point earlier in the letter, when he quotes Ps 14 to say, "There is no one who is righteous, not even one" and goes on to declare that "all have sinned and fall short of the glory of God" (Rom 3:10, 23).

Again, Mitzi J. Smith and Yung Suk Kim help us understand this passage. By looking at the grammatical structures of Paul's Greek, Smith and Kim contend that the passage describes not a righteousness from God but a righteousness that is a quality of God, a quality revealed through the person of Christ. Thus, they recommend that we approach Rom 3 with "a three-fold gospel formula: God's righteousness, Christ's faith, and the believer's faith." In Christ, humanity saw the righteousness that is an attribute of God, a righteousness that differs from the Roman Empire. Jesus revealed God's righteousness because he had faith in God, but "Jesus's faith alone is not

enough because God's righteousness cannot be a reality if they do not participate in Christ."[16]

For Paul, this truth isn't a reason to despair. Rather, it's a reason to hope, because knowledge of our shortcomings makes us more aware of God's incessant grace, which God gives to all. This understanding no longer holds us to be heroes, forever searching for our four or five good works. Rather, it leaves us free to pursue justice and spread goodness with all of our ability, and to accept forgiveness when we inevitably fail.

In their gleeful anarchy, Deadpool movies remind us of the shortcomings of heroism. When paired with Paul's letters, that reminder becomes something hopeful. We may fail at our fourth or fifth (or sixth, or seventh, or eighth, etc.) attempts at being a hero. But God's grace is sufficient for these, just as it is sufficient for the failures of others.

THE MEANINGLESS LIE OF A GLORIOUS PURPOSE

In the penultimate episode of *Loki*, Loki finds himself banished to a netherworld populated largely by other variants of himself. A group of these variants—including a boastful hammer-wielding Loki (DeObia Oparei), a Kid Loki (Jack Veal), an older Loki in his classic costume (Richard E. Grant), and even Loki as an alligator—find our Loki and bring him to their secret hideout. No sooner are they settled than more Lokis attack the hideout.

With a hearty laugh, Boastful Loki reveals that he betrayed his comrades to President Loki (also played by Hiddelston), in exchange for the right to be called King Loki. But President Loki declares that he has no plans to give Boastful Loki the crown and will keep it for himself. As the words leave his mouth, other Lokis instigate their own betrayals, as they all have had plans to murder one another for power.

A madcap battle ensues with Loki using duplicitous magic against Loki, until only our Loki, Classic Loki, Kid Loki, and Alligator Loki escape.

"We lie and cheat, we cut the throat of every person who trusts us. And for what?" mutters Classic Loki. "Power! Glorious power! Glorious purpose!" he answers himself, nearly spitting the words out with disgust.

Both comic and tragic, the scene of Lokis betraying other Lokis captures the fundamental point of villain stories. Bad deeds may harm others, but they will always, and most deeply harm ourselves. It's hard to think of a more inglorious fate for what could be a glorious purpose.

16. Smith and Kim, *Toward Decentering the New Testament*, 335.

But as the Bible repeatedly reminds us, we are not bound by our inglorious purposes. Through forgiveness and repentance, we can find our way to a different purpose, one full of hope and love unending.

CREDITS:

Deadpool (2016)
Director: Tim Miller
Screenwriters: Rhett Reese and Paul Wernick

Deadpool 2 (2018)
Director: David Leitch
Screenwriters: Rhett Reese and Paul Wernick and Ryan Reynolds

Venom (2018)
Director: Ruben Fleischer
Screenwriters: Jeff Pinker and Scott Rosenberg and Kelly Marcel

Joker (2019)
Director: Todd Phillips
screenwriters: Todd Phillips and Scott Silver

Loki (2021)
Director: Kate Herron
Showrunner: Michael Waldron

Venom: Let There Be Carnage (2021)
Director: Andy Serkis
Screenwriter: Kelly Marcel

POST-CREDITS:

Theme: The Cost of Sin

Key Biblical Passage: Rom 7:15

Questions:

1. At one time or another, most people feel like Loki, "burdened with a glorious purpose." Is it healthy to feel that way about one's self? What can go wrong with that type of attitude? How do we balance it with Christian love for one another?

2. *Joker* imagines a hell of one's own making, the awful experience of living without kindness or compassion. What is the best response to experiencing a lack of kindness or compassion? How do Christ's teachings help us redeem such an awful world?

3. In the two Venom movies, we see an example of the internal impulses being selfish or cruel. What types of internal impulses do you struggle with? How do you balance them with good impulses, such as showing empathy and care for others?

4. Deadpool struggles with finding those four or five moments to be a hero. What similar moments in your own life can you recall, in which you see an opportunity to do good? What drove you to make the wrong choice in those situations? What drove you to make the right choice?

5. Throughout the Bible, we're reminded that God pays attention to the "wrong" type of people, the bad guys. Which biblical bad guy do you relate with most? What lessons or reminders do you derive from that character's story?

PART III

COMMUNITY OF HEROES

<div align="center">

11

SOME ASSEMBLY REQUIRED

Teenage Mutant Ninja Turtles
—Justice League—Avengers

</div>

And let us consider how to provoke one another to love and good
deeds, not neglecting to meet together, as is the habit of some,
but encouraging one another, and all the more as you see the Day
approaching.

—Heb 10:24-25

Avengers. . . assemble!

—Captain America, *Avengers: Endgame*

To CLOSE OUT HER report on the ninja crime spree gripping New York City, Channel Three News reporter April O'Neil (Judith Hoag) takes a moment to thank the one who stepped in to rescue her from a recent attack.

Looking directly at the camera, April smiles and says, "If he's watching, thanks Raphael."

Raphael is watching, but so are his brothers, who immediately start razzing him. "Hey look!" shouts Donatello (voiced by Corey Feldman). "I think he's blushing!"

An embarrassed Raphael (voiced by Josh Pais) insists that he isn't, but Donatello won't yield. "I think he's actually turning red!"

After hurling his sai at Donatello to shut him up, Raphael channels his embarrassment into anger toward his brother Leonardo (voiced by Brian Tochi), the leader of the foursome. Knowing what's about to happen, Donatello and Michelangelo (voiced by Robbie Rist) make their escape.

"Fight?" Michelangelo asks.

"Fight," affirms Donatello.

"Kitchen?"

"Kitchen."

As the duo makes their way out of the living room, Leonardo and Raphael continue their bickering. In the span of just sixty seconds, Leo and Raph argue about everything from how to save their kidnapped sensei Splinter to their respective attitude differences. Finally, Raph storms out, leaving Leo to sneer, "Go ahead! We don't need ya!"

If there was any question, that short interaction reminds viewers that Leonardo, Raphael, Donatello, and Michelangelo may be teenagers and they may be ninjas and they may be mutants, and they are most assuredly turtles. But most important of all, they're brothers.

MARVELOUS TEAM-UPS

Directed by Steve Barron, *Teenage Mutant Ninja Turtles* is an incredibly rare superhero movie. Where most entries during the first wave of superhero movies featured characters from newspaper strips or Marvel and DC standouts, the Teenage Mutant Ninja Turtles were relatively new. Frustrated cartoonists Kevin Eastman and Peter Laird designed the Turtles as a parody of Daredevil, and first released the quartet's adventures in 1984's *Teenage Mutant Ninja Turtles* #1, a black and white comic they produced and published themselves, under the name Mirage Publishing.[1]

The Turtles were almost an immediate success, launching an immensely popular toy line and cartoon series, as well as several films. The 1990 movie spawned two sequels—*Teenage Mutant Ninja Turtles II: The Secret of the Ooze* and *Teenage Mutant Ninja Turtles III*—followed by an animated reboot simply called *TMNT* and two live-action movies produced by Michael Bay, *Teenage Mutant Ninja Turtles* and *Teenage Mutant Ninja Turtles: Out of the Shadows*.

The films released during the first and second waves of superhero movies were also rarities because they are team-up films. No other movies from the first wave featured teams, and the second wave had only *Mystery*

1. Eastman and Laird, *Teenage Mutant Ninja Turtles* #1.

Men, *The League of Extraordinary Gentlemen, X-Men, Fantastic Four,* and their respective sequels.

It's pretty easy to see why. In the days before new DCEU and MCU movies released every other month, the general public was really only aware of Spider-Man, Superman, and Batman. Team movies had to introduce viewers to several new characters just to get the story going, potentially overwhelming audiences with a jumble of powers, personalities, and origin stories. The X-Men films worked by focusing on Wolverine (Hugh Jackman), but no team movie connected with audiences until *The Avengers.*

Team movies might be a relative newcomer to superhero movies, but they have a long history in superhero comics. Ever since DC Comics put together B-list heroes like Flash, Green Lantern, and Doctor Fate in the Justice Society of America, readers couldn't get enough of seeing their favorites join forces. After the Justice Society's debut in *All-Star Comics* #3, DC put A-listers Superman, Batman, and Robin together in the series *World's Finest.*[2] Green Arrow and his sidekick Speedy joined a ragtag group of heroes—including the cowboy Vigilante, Sir Justin the Shining Knight, and the trench-coated Crimson Avenger—to become the Seven Soldiers of Victory in *Leading Comics* #1.[3] Timely got into the act in 1946 by putting Captain America and Bucky, the Human Torch and Toro, the Sub-Mariner, the Whizzer, and Miss America together in the All-Winners Squad.[4]

In fact, team-up comics were essential for the revitalization of the superhero genre following the post-World War II drop-off. After some success reimaging the Flash and Green Lantern, DC Comics editor Julius Schwartz put them alongside longtime lesser heroes Aquaman and Wonder Woman, as well as new creation the Martian Manhunter, to form the Justice League of America. After their introduction in *The Brave and the Bold* #28, the team enjoyed immediate success and soon jumped to their own series, where they were quickly joined by new members such as Superman, Batman, Green Arrow, and Black Canary.[5]

So popular were the Justice League that Timely publisher Martin Goodman directed his editor Stan Lee to make some new heroes in a similar mold, a decision that led to the creation of the Fantastic Four in 1961 and the beginning of Marvel Comics. A few years later, Lee and artist Jack Kirby more directly followed the Justice League approach by putting their most

2. Fox and Hibbard, "First Meeting of the Justice Society of America."

3. Weisinger and Papp, "Blueprint for Crime."

4. Finger and Shores, "Crime of the Ages!"

5. Fox and Sekowsky, "Starro the Conqueror."

popular heroes—Thor, Iron Man, Hulk, Ant-Man, and the Wasp—together in the Avengers, whose first issue debuted in 1963.

Since then, superhero team-ups have become the norm. Adolescent heroes come together in the Teen Titans, Young Justice, or the Young Avengers. *The Brave and the Bold* joined Batman with another DC hero each month, much like *Marvel Team-Up* and *Marvel Two-in-One* paired Spider-Man and Fantastic Four's the Thing with different Marvel heroes.

In all these variations, team-up stories give us a chance to see how much more can be accomplished when people, no matter how great, come together for a joint purpose. They also remind us how difficult it can be to put aside egos for the greater good.

THE BLESSED COMMUNITY

Christianity is inherently communal. The creation story features not only God speaking in communal terms—"Let us make humankind in our image" (Gen 1:26)—but also God acknowledging the necessity of living with others: "It is not good that the man should be alone" (Gen 2:18). Throughout the Hebrew Scriptures, prophets speak of collective praise and collective sin, driven by God's oft-repeated covenant, "they shall be my people, and I will be their God" (Ezek 14:11).

This tradition continues into the New Testament. While the Gospels do include examples of Christ separating himself from the crowd, those exceptions prove the rule that Jesus worked in a community, from the twelve disciples with whom he lived to the great commission, which commands followers to "make disciples of all nations" (Matt 28:19). The first Christian church emphasized community, holding "all things in common" and spending "much time together in the temple" (Acts 2:43, 46). The writer of Hebrews puts it best when they tell readers, "And let us consider how to provoke one another to love and good deeds, not neglecting to meet together, as is the habit of some, but encouraging one another, and all the more as you see the Day approaching" (Heb 10:24–25).

The biblical emphasis on community might come as a surprise to some Christians, who think of salvation as a personal relationship with Jesus. But as Thomas Merton reminds us, there is no clear difference between self and other, especially in light of God's commandments. "The best way to love ourselves is to love others, yet we cannot love others unless we love ourselves since it is written, 'Thou shalt love thy neighbor as thyself,'" Merton writes. "But if we love ourselves in the wrong way, we become incapable of loving anybody else. And indeed when we love ourselves wrongly we hate

ourselves; if we hate ourselves we cannot help hating others."[6] Thus, loving others is not just a commandment God has for us, but also the best way to become ourselves.

With their portrayal of great deeds done when even the most powerful people come together, superhero team-up films can be a valuable example for the church. Watching the *Justice League* and *Avengers* movies, we can better imagine the challenges facing a group of strong personalities coming together, and the amazing things they can accomplish.

UNITE THE POWERS

On a fundamental level, all superhero stories are about power. But none are so solely focused on power like those told by director Zack Snyder, particularly his magnum opus, appropriately titled *Zack Snyder's Justice League*.[7]

Snyder packs the four-hour film with elaborately composed slow-motion shots to spur the audience toward maximum awe. The camera looks up at Wonder Woman (Gadot) as she methodically hurls herself over an attacker, staring down at monster and audience member alike. Red light tears through an otherwise colorless space to highlight the blasts Batman (Affleck) redirects to destroy swarming creatures. Slow-motion shots capture Superman (Cavill) tossing aside his assailants, letting us gawk at every rippling muscle on his toned body.

The heroes in *Zack Snyder's Justice League* may opine about hope and resilience, but the movie is really interested in their raw strength. In fact, the sheer power of the individual characters drives us to ask, why do the six members of the Justice League need to team up? What does Superman need from a super-speedster like the Flash (Ezra Miller)? What does Batman need with the machine man Cyborg (Ray Fischer)?

The short answer is that an even greater force threatens Earth. That force is Darkseid (voiced by Ray Porter), an intergalactic warlord who learns that Superman's death in *Batman v Superman: Dawn of Justice* has rendered Earth vulnerable. Darkseid sends his lieutenant Steppenwolf (Hinds) with

6. Merton, *No Man Is an Island*, xvii.

7. Snyder began working on a version of *Justice League* as a continuation of the story he began in *Man of Steel* and *Batman v. Superman: Dawn of Justice*. But after a family tragedy forced him to withdraw, Joss Whedon was hired to finish the film. The *Justice League* that released theatrically in 2017 consisted of new material shot by Whedon along with Snyder's footage, color-timed and re-edited to create a lighter tone. *Zack Snyder's Justice League*, released to the streaming service HBO Max in 2021, is considered the definitive cut of the film.

a legion of minions to find three cosmic items called Mother Boxes, which will allow him to invade our planet.

Much of the movie's first three hours consist of Batman recruiting members of the team, warning them of Steppenwolf's plans. But nothing demonstrates the necessity of the team like a scene during the movie's climax.

In the center of ravaged Chernobyl, Wonder Woman and Aquaman (Momoa) try to hold off Steppenwolf while Batman directs Cyborg and the Flash in disabling the last Mother Box. Despite their herculean strength, Aquaman and Wonder Woman fail to stop their enemy, and Steppenwolf charges toward Cyborg, his battle axe raised high. With a resounding clang, the battle axe lands not on Cyborg, but on the chest of Superman, who has been revived from the dead and has arrived to aid his comrades. "Not impressed," smirks Superman, who begins pummeling Steppenwolf.

As expected, Snyder shoots the scene in a way that emphasizes Superman's power. The scene is nearly devoid of all light and color, save the crackling electricity coming from Steppenwolf's axe. The camera pans slowly over to watch Superman blow his freezing breath on the axe, sending ice creeping along the weapon, until he smashes it and leaves Steppenwolf empty-handed.

It's a literally awesome scene, one that asks viewers to be amazed at Superman's unrivaled strength. But that only underscores the point that a team is so important, even for the amazingly powerful. Superman is playing his part, allowing the Flash and Cyborg to do their jobs. No matter how great each individual member unquestionably is, the Justice League only succeeds because they work together.

Throughout *Zack Snyder's Justice League*, characters frequently use the word "unity," from the goal of connecting the three Mother Boxes to Batman's mission to bring the heroes together. No matter how powerful each member may be, they're even greater when they unify.

Unity is also an important biblical theme, one that gets mentioned throughout the epistles apostles wrote to churches. In Romans, Paul urges readers, "Do not think of yourself more highly than you ought, but rather think of yourself with sober judgment, in accordance with the faith God has distributed to each of you." Using the language of bodies, Paul tells each member to work according to their abilities, because "in Christ we, though many, form one body, and each member belongs to all the others" (Rom 12:3–5).

This tactile, bodily metaphor helps underscore the way God's body has real and perceivable impact on the world. In its communal activities, the church continues what Mark Lewis Taylor calls the "kinetic dimension of

Jesus' life and work, his penchant for being implicated in peoples' movements." For that reason, "Christendoms that eschew political movements and see them somehow contrary to what being a follower of Jesus is all about . . . miss the mark badly."[8] In the same way God took on a body to live among creation, so also do we continue this incarnation by using our bodies to join with other people.

But that can't happen if we refuse to come together. Despite its emphasis on the earth-shaking abilities of its individual members, *Zack Snyder's Justice League* is ultimately a story about the desperate need for even the most awesome individuals to put aside their pride and work with each other. Only then can we effectively seek justice, an awesome work indeed.

TEAM OR TIME-BOMB?

The ninety-minute mark of *Avengers: Age of Ultron* finds the titular heroes on the midst of collapse. The most pressing threat is not the rampaging android Ultron (voiced by James Spader), but Ultron's creator, Tony Stark (Downey).

Haunted by a vision of his teammates defeated and the planet in ruins, Stark has spent the movie trying to create a more comprehensive defense system, to put "a suit of armor around the world." But when Ultron becomes self-aware and decides that the only path to peace is the eradication of all humanity, the Avengers begin to doubt one another.

Those divides only grow when Stark takes a second attempt at creating an android, this time by uploading his artificial intelligence system Jarvis into a synthetic body developed by Ultron. As the process completes, the tensions reach a boil and Avengers take to fighting one another. Captain America (Evans) hurls his shield at Stark, who blasts Cap with repulsor beams. Hawkeye (Jeremy Renner) takes Pietro Maximoff (Aaron Taylor-Johnson) by surprise. Wanda Maximoff (Olsen) uses her hex powers to destroy Stark's lab until Bruce Banner (Ruffalo) threatens to Hulk out. With a crack of thunder, Thor (Hemsworth) arrives to blast the experiment with bolts of lightening.

This hardly the first time the Avengers have argued with one another, and it will hardly be the last. *Captain America: Civil War* is a whole movie about the team dividing into warring factions, and the group doesn't completely reunite until the end of *Avengers: Endgame*. Even the team's first adventure in *The Avengers* consists largely of the five main members arguing

8. Taylor, *Executed God*, 129.

with one another. "We're not a team, we're a powder keg!" observes Banner in one of their first dust-ups.

And yet, there's no denying that the Avengers are an effective superhero team, one who saves the day again and again. The Avengers films underscore an important truth about community, one that's just as important as the "unity" theme advanced by *Zack Snyder's Justice League*. Communities are inherently fractious and contentious. Being together does not, cannot, mean being the same.

Take the team's first big hero shot in *The Avengers*. Chitauri warriors surround the heroes and screech from atop New York buildings, readying their next wave of attack. As Alan Silvestri's stirring score kicks in, the camera circles around the heroes as they fall into formation, their backs initially together and then all looking up in the same direction.

That shot can be seen as an instance of unity. They've put aside the squabbling and egos that separated them in the first two acts and now know how to be a team. They've overcome their differences and finally become the Avengers.

But right before that shot, we saw the team still arguing with each other, each with different agendas. Thor wants to arrest his brother Loki, who brought the Chitauri to New York, and return him to Asgard. Hawkeye wants revenge on Loki for controlling his mind. Captain America and Iron Man both think they deserve to lead, and Black Widow still mistrusts the Hulk because of an earlier encounter. In fact, the moment is immediately followed by the heroes all going off to play their respective parts in the battle, doing things differently but together.

This community of difference drives the movie's second bravado shot, a long unbroken take which tracks the individual Avengers doing different things in the battle. Black Widow shoots away the aliens who were tailing Iron Man, who lands next to Captain America to reflect a beam off his shield before flying past a building on which Hawkeye stands, firing an arrow that sends an alien ship crashing into the beast being battered by the Hulk, who is joined by Thor, who delivers the final blow.

While Paul's body metaphor in Rom 12 is certainly about unity, it's also a reminder that unity requires that we recognize the differences between one another.

Nothing better demonstrates this truth then the establishment of the Christian church. First Corinthians lays out a vision of the church in corporeal terms, comparing the church to a body with many members "and all the members of the body, though many, are one body" (1 Cor 12:12). For Paul, the unity of the body makes arguments about importance impossible:

The eye cannot say to the hand, "I have no need of you," nor again the head to the feet, "I have no need of you." On the contrary, the members of the body that seem to be weaker are indispensable, and those members of the body that we think less honorable we clothe with greater honor, and our less respectable members are treated with greater respect; whereas our more respectable members do not need this. But God has so arranged the body, giving the greater honor to the inferior member, that there may be no dissension within the body, but the members may have the same care for one another. If one member suffers, all suffer together with it; if one member is honored, all rejoice together with it. (1 Cor 12:21–26)

In their commentary on the New Testament, Mitzi J. Smith and Yung Suk Kim note that bodily metaphors were common among Roman stoics. This imagery taught that "the lower classes must stay in their place without complaining," a point they reinforced by threatening the bodies of those who transgressed, most famously with the use of crosses.[9]

Paul's language, then, is inherently revolutionary. Instead of a hierarchy enforced by violence, the church of Christ is one of equality enforced by care. Furthermore, the fact that Paul used the metaphor of the body under the shadow of the Roman Empire reminds us that our bodies are vulnerable, only increasing the need for care.

As Christians, our great power to disrupt the language of domination and oppression ties directly to our great responsibility to care for others. The operating structure for that work is the church, the Body of Christ doing the work of Christ on Earth, caring for the wounds it may receive.

For all of their heroic moments, the Avengers movies tend to be about the team learning to accept its differences. That acceptance can be found as Avengers: Age of Ultron heads into its third act. The scuffle between the heroes only ends with the reveal of the creature in Stark's experiment, a synthetic man called the Vision (Paul Bettany).

After coming online, the Vision explodes violently from his birthing cradle. The Avengers stand ready to fight this new creature, should it take after its forerunner Ultron. But instead of fighting, the Vision turns contemplative, quietly watching through a window before making his pronouncement. Acknowledging both his respect for Ultron and the need to destroy it, Vision insists the team puts its mistrust behind.

"We have to act now," Vision declares, looking at the differing figures standing together. "And not one of us can do it without the others."

9. Smith and Kim, *Toward Decentering the New Testament*, 317.

That line could also apply to the Christian church, as we believers also have to act now to do God's good works. And just like the Avengers, not one of us can do it without the others.

LOSING TOGETHER

Despite the rousing imagery from the "Battle of New York" sequence of *The Avengers*, the most striking moment in the MCU may be the end of *Avengers: Infinity War*. That movie brings together not only the Avengers, but also Black Panther (Boseman), Dr. Strange (Cumberbatch), and all the Guardians of the Galaxy, to prevent the Mad Titan Thanos from gathering the six infinity stones and wiping away half of all living things. The heroes fought hard, but it wasn't enough. With all six stones in his gauntlet, Thanos (Josh Brolin) snaps his fingers and disappears. Thunder rolls in the distance and before the Avengers can figure out where he's gone, Cap's best friend Bucky (Stan) calls out, "Steve?" Stumbling towards his comrades, Bucky slowly turns to ash and blows away with the wind.

One by one, several other heroes disappear in the same way. Falcon (Mackie) turns to dust while trying to crawl back to his feet. Wanda leans back and peacefully accepts her fate. Light-years away, on a distant planet, the second group of heroes experiences the same horror. "C'mon man," mutters Star-Lord (Chris Pratt), after watching his fellow Guardians Drax (Dave Bautista) and Mantis (Pom Klementieff) crumble. Spider-Man (Holland) stumbles toward Stark, begging to be spared and whispering "I'm sorry" before turning to dust himself.

For MCU fans, the end of *Infinity War* is both terrifying and exhilarating. Many could not believe that MCU chief Kevin Feige would kill off these beloved characters. Even those well-versed in superhero fiction, where death and resurrection is a monthly occurrence, were shocked that the movie would end with Thanos triumphant, the heroes defeated.

The scene is so surprising, so infused with loss, that it's easy to miss what a communal moment it is. We're so focused on who's gone that we take for granted those who still remain. In fact, each of the dustings occurs in trios or pairs. Okoye (Gurira) grasps the arm of Black Panther as her king turns to dust. Rocket Racoon (voiced by Bradley Cooper) stumbles toward the fading Groot (voiced by Vin Diesel), muttering "No, no."

In the final shot of the sequence, the survivors gather together. They have questions, and they have fears, but there's no answer, nothing they can say to make this right. The camera pushes on a forlorn and beaten Captain

America, who speaks the only words that one can find in the midst of such defeat: "Oh, God."

The final two *Avengers* movies tell the story of losing. They're about a community coming together, fighting together and each other, and then experiencing loss. But they're losses they suffer with each other.

The Bible is full of examples of people who express their suffering, in a practice called "lament." While the "personal nature of lament is important," write Grace Ji-Sun Kim and Graham Hill, "lament is best when it's both individual and corporate."[10] To that end, Hill and Kim provide examples of what corporate lament can do, not only allowing members to share one another's burdens, but also drawing attention to public confessions and the possibilities of change. Through corporate lament, people can do a different kind of good work, acknowledging injustice and calling for change.

When Stark and the Guardian Nebula (Karen Gillan) reunite with the team in *Avengers: Endgame* after months in space, he unleashes a fury of anger at Rogers. Emaciated and weak, an IV attached to his withered arm, Stark loses his cool and spits, "I needed you. As in past tense. And that trumps what you need. It's too late, buddy." Standing up to rip away the equipment keeping him alive, Stark haughtily reminds Rogers and the others that he warned them of this, that he tried to keep everyone safe by putting a suit of armor around the world.

More than just the latest battle between Captain America and Iron Man, Stark's complaint captures the fullness of their connection. Stark needs to grieve and vent, and Rogers demonstrates his friendship by letting him do that, even if it's against him. "I said, 'We'd lose,'" Stark says to Rogers, reminding him of their disagreement about security plans; "You said, 'We'll do that together, too.' And guess what, Cap? We lost. And you weren't there."

For all the passion of Stark's accusations, he's not exactly accurate. Cap wasn't on the same planet as him during their fight with Thanos, but he was part of the battle. But Cap doesn't bring that up now. He doesn't rush to defend himself or to push back on Stark's claims. Even when Stark directs anger at him, Cap takes it.

That's part of what it means to lose together. Not necessarily that one should allow one's self to be abused—that's clearly not the nature of the duo's relationship. Rather, that you let another person be not okay, that you accept all of their messiness and hurt.

More importantly, Rogers is there with him now, listening to Stark rave and vent his anger. They are, very much, losing together. And that's a good thing.

10. Kim and Graham, *Healing Our Broken Humanity*, 46.

THE POWER THAT BINDS US

The spat between Raphael and Leonardo did not end with the two brothers coming back and apologizing. Rather, midway through *Teenage Mutant Ninja Turtles*, Raph gets jumped by Foot Clan Ninjas. He's beaten senseless, but his brothers manage to retrieve him and escape to April O'Neil's family farmhouse. After days of convalescence, Raph awakens, and he and Leo patch up, and the quartet begins acting like brothers again.

The full healing doesn't happen until a few days later. With his argument with Raph behind him, Leo's mind is now clear enough for more effective meditation. From this serene state, Leo senses the presence of Splinter, a connection that fills him with a joy he cannot keep for himself.

Despite their grumbling and joking, the other Turtles join Leo around a campfire to follow his meditation technique. As the quartet closes their eyes and breathes together, the flames of the fire change from orange to blue. Standing between them is the image of Splinter (voiced by Kevin Clash), their beloved leader and father.

"I am proud of you, my sons," he states, giving them the encouragement they so desperately needed. "Together, there is nothing your four minds cannot accomplish. Help each other, draw upon one another, and always remember the true force that binds you—the same as that which brought me here tonight, that which I gladly return with my final words." Splinter's message echoes between the four Turtles and peace descends on them as their teacher reveals their connection: "I love you all, my sons."

As the Turtles open their eyes again, they understand the power that allows them to do so many amazing things. It's not their training or their strength, but their love for one another. Even when they are at each other's throats, the Turtles are brothers, bound by love.

That's an important lesson the church could learn if they have ears to hear four teenage turtles.

CREDITS:

Teenage Mutant Ninja Turtles (1990)
Director: Steve Barron
Screenwriters: Todd W. Langen and Bobby Herbeck

The Avengers (2012)
Director: Joss Whedon
Screenwriter: Joss Whedon

Avengers: Age of Ultron (2015)

Director: Joss Whedon

Screenwriter: Joss Whedon

Avengers: Infinity War (2018)

Directors: Joe and Anthony Russo

Screenwriters: Christopher Markus and Stephen McFeely

Avengers: Endgame (2019)

Directors: Joe and Anthony Russo

Screenwriters: Christopher Markus and Stephen McFeely

Zack Snyder's Justice League (2021)

Director: Zack Snyder

Screenwriter: Chris Terrio

POST-CREDITS

Theme: Community

Key Biblical Passage: Heb 10:24–25

Questions:

1. The Teenage Mutant Ninja Turtles are unusual characters, even among superheroes. But their familial bond makes them among the most relatable. Who do you consider your family? How do you interact with this family? How do you handle the good times and the bad times?

2. *Zack Snyder's Justice League* reminds us that even awesome heroes need other people. Have you ever benefited from the help of someone else, even when it was something you were good at? How can unity among unique individuals advance the work of the church?

3. In the first two *Avengers* movies, Earth's Mightiest Heroes are always on the verge of imploding. Is there value in continuing to be part of such a fraught group? Is there value in cutting ties with this type of group? How can you tell the difference?

4. *Avengers: Infinity War* and *Avengers: Endgame* both show the beauty of losing together. Can you provide an example of a time in which other people ministered to you when you were in need? Can you provide an

example of a time when you ministered to someone else in this way? What were the risks and rewards of these experiences?

5. The writer of Hebrews tells Christians to continue meeting together and encouraging one another. How do these movies remind us of the difficulties in meeting together? How do they remind us of the benefits of meeting together?

12

NOT OF THIS WORLD

X-Men

In the same way, let your light shine before others, so that they
may see your good works and give glory to your Father in heaven.

—MATT 5:16

I'm looking for hope, old friend.

—PROFESSOR CHARLES XAVIER, *X-MEN*

A HIGH-PITCHED TONE PIERCES the air and the X-Men drop to the ground.
Their worst nightmare has come true. Their teacher, the powerful telepath
Charles Xavier (Patrick Stewart) and his supercomputer Cerebro, have be-
come a weapon. They clasp their heads in their hands, writhing as their
beloved mentor tears apart their minds.

The attack is the work of the maniacal General Stryker (Brian Cox),
a soldier who has dedicated his life to eradicating all mutants. Born with
amazing powers that set them apart from humanity, mutants are feared by
people like Stryker, who believes that mutants are threat that must be dealt
with pre-emptively. Making a weapon of his own son Jason (Michael Reid
MacKay), an illusion-creating mutant, Stryker has fooled Xavier into using
Cerebro to find all mutants and destroy them, thinking that he's helping
them.

The only hope for the X-Men is their arch-enemy Magneto (Ian McKellen), the one-time friend of Xavier who has devoted his life to mutant supremacy. Donning a special helmet that makes him immune to Xavier's telepathy, Magneto summons his mastery of magnetism to rip open a metal vault.

Inside, Magneto finds his old friend and ceases Xavier's unintentional attack, saving the lives of the mutants.

But that's not where *X2: X-Men United* ends.

"How does it look from there, Charles?" Magneto asks imperiously. "Still fighting the good fight? From here, it doesn't look like they're playing by your rules."

Magneto's comments serve to mock Xavier and his dream of helping humans and mutants live in harmony. Magneto believes that there can only be enmity between the two, and that safety for mutants will only come when they dominate humanity.

"Maybe it's time to play by theirs," Magneto observes, before using his powers to rearrange Cerebro's panels. Now, instead of finding and killing all mutants, Xavier is unintentionally finding and killing all humans.

Instead of using his abilities to build a better world, Magneto has chosen to emulate the humans he hates.

THE STRANGEST HEROES OF ALL

For people who love superhero movies, it can be daunting to make the jump to comic books. Where movies and television shows have a fairly straightforward continuity and appear in easy-to-follow entries, comics are a confusing mishmash of series, reboots, and revisions.

And the most confusing characters of all are the X-Men.

They didn't start out that way. The X-Men made their debut in the 1963 comic book *X-Men* #1.[1] Written by Stan Lee and drawn by Jack Kirby, the issue followed a team of teenagers studying at Xavier's School for Gifted Youngsters, under the tutelage of Charles Xavier, aka Professor X. More importantly, the comic introduced the concept of "mutants," people born with amazing abilities, which made them the object of fear and hatred by the general public. Most of the original X-Men stories pit the team against evil mutants such as Magneto, the master of magnetism.

Although the series had enough fans to avoid cancelation, it never sold as well as Spider-Man or the Avengers. And that's where things get confusing. After publication of the sixty-sixth issue of *X-Men* in 1970, the comic

1. Lee and Kirby, *X-Men* #1.

merely reprinted old stories.[2] In 1975, Marvel published a special entitled *Giant-Sized X-Men*, which introduced some of the most popular characters on the team: the Kenyan weather goddess Storm, the German acrobat Nightcrawler, and the foul-tempered Canadian Wolverine.[3]

Giant-Sized X-Men revitalized interest in the main *X-Men* comic, especially under new writer Chris Claremont. Supercharging the approach that Stan Lee and Jack Kirby established in early Marvel Comics, Claremont changed superhero comics forever. X-Men stories combined soap-opera melodrama with over-the-top adventures about time-travelers, shapeshifters, and alien empires.

Working with some of the medium's greatest artists—including Dave Cockrum, John Byrne, and Bill Sienkiewicz—Claremont created epic, and often very perplexing stories. Clones, robot doppelgängers, and alternate reality versions of characters regularly appeared, while plotlines stretched across series and years.

Yet, despite its convoluted structure, X-Men became an undeniable hit. Retitled *Uncanny X-Men* in 1978 the comic became the top seller for nearly every month of the 1980s and 1990s. When Claremont launched a new series, simply titled *X-Men*, in 1991, the first issue sold more than 8.2 million copies, setting a still-unbroken record for single-issue sales.[4]

The team's popularity spilled off the comic book page and into other media. The X-Men made regular appearances in cartoon shows and video games, ultimately starring in their own programs, starting with the wildly popular 1992 series *X-Men*.

But the X-Men became household names with the release of their first feature film in 2000. Directed by Bryan Singer, *X-Men* was only the third Hollywood film featuring Marvel characters, following the flop *Howard the Duck* and the surprisingly successful, but decidedly more niche, *Blade*.[5] Despite numerous budget cuts and deviations from the comic (i.e., the team

2. Thomas and Buscema, *X-Men* #66.

3. Wien and Cockrum, *Giant-Sized X-Men* #1.

4. Claremont and Lee, *X-Men* #1.

5. For all its progressivism, the *X-Men* film franchise has been tarnished by several bad actors. Serious and credible allegations of sexual assault against minors have been brought against Bryan Singer, who directed the four most prominent films in the series. Several actresses have accused *X-Men: The Last Stand* director Brett Ratner of sexual assault and harassment. Problems continued even after both men were removed from the franchise, as *The New Mutants* indulged in racism by casting white and light-skinned actors to play Black characters and by including several slurs for Native peoples. See: French and Potter, "Bryan Singer's Accusers Speak Out"; Kauffman and Miller, "Six Women Accuse Filmmaker Ratner"; Simon, "New Mutants' Director on Whitewashing."

traded their yellow spandex for black leather), *X-Men* was a blockbuster smash.

Much of the success can be attributed to the performances. Respected Shakespearean actors Patrick Stewart and Ian McKellen played friends and rivals Professor X and Magneto, young Academy Award winner Anna Paquin played runaway teenager Rogue, and nineties staples Halle Barry and Famke Janssen appeared as Storm and Jean Grey. But the real breakout was Australian theater actor Hugh Jackman as Wolverine, skillfully combining prickly irritation with surprising sensitivity.

For the next twenty years, the X-Men were mainstays of superhero cinema. The original film spawned six sequels, including the prequel series that starred James McAvoy and Michael Fassbender as young Professor X and Magneto, three solo Wolverine films, two Deadpool movies, and *The New Mutants*. Even if the quality of these movies waned, there's no question that the X-Men set the stage for superhero movies, long before the MCU started with *Iron Man*.

FEARED AND HATED

"Children of the atom, students of Charles Xavier, MUTANTS—feared and hated by the world they have sworn to protect. These are the STRANGEST heroes of all!" These words opened nearly every issue of the *Uncanny X-Men* published through the 1990s.

The bombastic prose not only captures the central appeal of the X-Men, the thing that's kept them popular despite their convoluted history, but also the appeal of the characters for Christians. Scripture is full of calls for God's followers to distinguish themselves from the exploitation, grasp for power, and love of violence that runs so many parts of the world. As Paul writes in Rom 12:2, "Do not be conformed to this world, but be transformed by the renewing of your minds, so that you may discern what is the will of God—what is good and acceptable and perfect."

That will of God can be seen in everything from choosing a tiny nomadic nation as God's people to the beatitudes Jesus expressed in the Sermon on the Mount. While these distinctions necessarily require Christians to avoid certain activities others consider normal, they do not, as some believers suggest, require isolation or avoidance. Rather, they require complete immersion within the world that God so loved, to be a city on the hill and the salt of the world. In that way, Christ teaches, our light will "shine before others, so that they may see your good works and give glory to your Father in heaven" (Matt 5:16).

Jesus gets at this idea in his final prayer for his followers, recorded in John's Gospel:

> I have given them your word, and the world has hated them because they do not belong to the world, just as I do not belong to the world. I am not asking you to take them out of the world, but I ask you to protect them from the evil one. They do not belong to the world, just as I do not belong to the world. (John 17:14–16)

In this passage, Jesus directly ties being apart from the world's ways to being within the world. Christians can only witness to God's love if they enact that love in the world, showing others a way other than pursuit of power and domination. Because this other way threatens those who have power in the world, the world hates Christians and the power they preach. Nothing demonstrates this fact better than the way the Roman Empire crucified Jesus for preaching about a kingdom over Caesar. And yet, nothing better demonstrates the futility of worldly power like Jesus's resurrection.

With this fantastic realization that not even death can conquer Christ followers and the mission to show the world a better way, Christians run the risk of being feared and hated by those who like the current way.

With their stories about welcome for the outsider, service to enemies, and encouragement for the broken, the *X-Men* films help Christians visualize our mission, protecting a world that wants nothing to do with us.

EXTENDING A BETTER WELCOME

On the run from invading soldiers, Rogue, Wolverine, and Pyro (Aaron Stanford) retreat to the suburban childhood of home of teammate Bobby Drake (Shawn Ashmore). While his parents and younger brother are shocked to see him in their house with such motley company, they're even more surprised to learn that Bobby is a mutant. Bobby's mother (Jill Teed) and father (Alfred E. Humphries) try to explain their discomfort with the "mutant problem," until Rogue encourages him to show them his abilities.

Bobby reaches out and touches his mother's coffee cup, instantly making the liquid solid. The tinkling music and lightly sweeping camera movement indicates wonder on the film's part, begging us to be amazed at Bobby's powers. But the shot cuts to Bobby's brother Ronny (James Kirk) leaving the room in disgust, indicating that the family has no respect for the person Bobby has become.

"Have you tried not being a mutant?" asks Bobby's mom, unaware of how offensive the question is.

As many critics have noted, this scene from *X2: X-Men United* is an analogy for a queer person's "coming out" process. Indeed, for some, "the premise of 'mutation' is best understood as a metaphor for non-mainstream sexualities, for doing so unlocks a wide variety of critical (and, one hopes, meaningful) observations."[6]

The scene captures the central hook of the X-Men franchise, one that drives all of the films: for mutants, to be yourself is to risk rejection and persecution, even by those who love you. The X-Men's visit to the Drake home ends when Ronny calls the police. The event makes for an exciting action sequence, in which bullets ricochet off Wolverine's metal skull and Pyro blows up police cars. But it ends with Bobby looking up at his home one last time before leaving with the X-Men. The shot/reverse shot begins with the camera pulling away from Bobby and ends with his family, staring down at him through a window, separating themselves from their son and brother.

Similar scenes of rejection recur throughout the *X-Men* films. Time and again, we see people refuse mutants, not because of anything they've said or done, but simply because of who they are. For those who have themselves been rejected for who they are, these scenes carry powerful resonance.

But the films also contain scenes of welcome, acceptance for the rejected and the outsider, simply because they are human. Take the first scene of Wolverine first meeting the team in *X-Men*. When Wolverine awakes in Charles Xavier's mansion, angry and disoriented, the Professor leads him not away from the young students in his charge, but to his office, where he's teaching a group of children.

Xavier shows no fear of Wolverine, for himself or the children. He doesn't even get angry when Wolverine mocks him, suggesting that the wheelchair-bound Xavier's superhero name should be "wheels." Infusing warmth and kindness into his patrician demeanor, Stewart emphasizes the welcome he's extending to this stranger.

These two instances highlight contrasting ways of treating others who are different.

In his memoir *Does Jesus Really Love Me?*, gay Christian Jeff Chu describes his journey to churches around the United States and the discussions about homosexuality he finds there. Some affirm homosexuality as compatible with Scripture and others do not. But what Chu finds most is "a country that deeply wants to love, but is conflicted about how to do so" and a church that is "far more divided than [he] imagined, led in large part by cowardly clergy who are called to be shepherds yet behave like sheep."[7] Rid-

6. Earnest, "Making Gay Sense of the X-Men," 216.

7. Chu, *Does Jesus Really Love Me?* 8–9.

ing beneath these cowardly acts are the fear of losing the money and status that comes from taking a stand on the issue.

The language that Chu uses underscores the failures of the clergy people to uphold the mission Jesus gave the first pastor when establishing his church. John 21:15–19 describes Jesus's meeting with Peter after his resurrection before his ascension. Mirroring the denials of Christ that Peter made during the crucifixion, Jesus gestures to the other disciples and asks Peter three times, "do you love me more than these?" Each time, Peter answers in the affirmative, and each time, Jesus gives Peter a variation of the same command: "Feed my sheep."

To be sure, much is involved in the feeding that Jesus describes. But one of the most important parts, indeed, the first part that Peter does when leading the young church in Acts, is extend welcome. Filled with the Holy Spirit, Peter preaches God's love for the world, manifested in the works of Christ and his resurrection from death. Among the various peoples in attendance, "each one heard them speaking in the native language of each" (Acts 2:6).

When Peter speaks to the people in their own language, he sets a model for all pastors to feed their sheep. He doesn't demand fealty or similarity, but blesses their difference, offering welcome.

That same contrast can be found in the first two X-Men films, which show us two ways of treating the hated and feared. Do we condemn them or welcome them?

With Bobby Drake's story, we see the pain and isolation that comes from rejecting others. But we also see how the group who accepts him, and Wolverine, becomes stronger for it, richer for having extended welcome to someone that others fear. At its best, the church takes a similar approach, bringing in the rejected and becoming better for it.

BEING THE BETTER (X)MEN

The first X-Men movie opens with an audacious scene, in which the powers of young Magneto aka Erik Lehnsherr (Brett Morris) manifest as his mother is dragged away in a Nazi death camp, his magnetism pulling down an iron fence as he desperately screams.

The prequel film X-Men: First Class continues that tradition, not just by extending the sequence where Lehnsherr (now played by Bill Milner) is tortured and studied by a Nazi called Schmidt (Kevin Bacon). Telling the story of Xavier (McAvoy) and Magneto (Fassbender) meeting in their

twenties and forming the X-Men in the early sixties, *First Class* puts the team at the center of the Cuban missile crisis.

The movie climaxes with a scene of mutant derring-do and teamwork, as the X-Men gather on a beach to stop Schmidt, now revealed to be the evil mutant Sebastian Shaw. Shaw wants to provoke American and Soviet forces into a nuclear war, hoping that it will wipe out humanity and allow mutants to reign.

The X-Men succeed, but not in the way they hoped. They prevent the war, but Magneto kills Shaw and turns against the humans, convinced that they will never accept mutants. Magneto uses his powers to turn the assembled navies' missiles against them, sending a salvo of explosives toward the boats.

A horrified Xavier tries to stop his old friend. "Erik, you said yourself we're the better men," he pleads. "This is the time to prove it."

While it's hard to justify Magneto's pretensions toward mutant domination, its equally hard to claim he's wrong about humanity. After all, the Americans and Soviets do come together, not in peace, but in launching their missiles at the mutants on the beach.

This is a far cry of the presentation in earlier in the scene, when the X-Men worked together to save the humans. Vaughn leans into the bombastic imagery of the comic books that inspired the film, while composer Henry Jackman's score turns brazenly heroic. We see delight fill the eyes of Banshee (Caleb Landry Jones) when he uses his sonic powers to launch himself across the beach to rescue Havok (Lucas Till). Mystique (Jennifer Lawrence) thrills at tricking the evil Azazel (Jason Flemyng) long enough to save Beast (Nicholas Hoult). Xavier calms Magneto by reminding that "true focus lies somewhere between rage and serenity," allowing the master of magnetism to lift Shaw's submarine from the ocean.

Within that one scene, the film shows two ways of dealing with adversity. For Magneto, peace can only come by mirroring the power of the militaries that oppress him. But Xavier wants to show the world a better way, one that shares power among humans and mutants in a way that enfranchises all.

According to German theologian Dorothee Sölle, the person of God models neither the consolidation of power nor the denial of power, but the sharing of power. "The Christian assumption that we recognize God most clearly in this figure of someone tortured to death goes completely against our fixation on power and domination," she writes.[8] Instead of the dominating god that demands obedience from his subjects, Sölle sees in Christ a

8. Sölle, *Essential Writings*, 40.

God who wants experience instead of subjection. Good power, she argues, is "shared power, power which distributes itself, which involves others, which grows through dispersion and does not become less."[9]

Sölle sees an example of this power in Christ's resurrection, specifically in empowering "Mary Magdalene, Joanna, Mary the mother of James, and the other women" by revealing to them the good news of Christ's resurrection, of God's resistance to the grave. Instead of returning as a conqueror who razes Rome, Christ demonstrated the power of God by first lifting up the women in his midst, showing power as something for community instead of domination.

In *X-Men: First Class*, Magneto refuses to think in these terms, to his own destruction. Desperate to keep Magneto from attacking the humans, desperate to maintain the peace, Xavier tackles Magneto and the two wrestle while missiles hurl toward the humans. The two fight until the human Moira MacTaggart (Rose Byrne) fires a gun at Magneto. He deflects the bullets, sending one into the back of Xavier, crippling his friend.

At that moment, Magneto sees the true limits of his powers. He may be able to control all of the weaponry the humans might fire at him, but his diminished imagination renders him weak. As indicated by the utter impotence and sorrow crossing his face when he sees the wounded Xavier, Magneto realizes that the only thing he destroyed is his friendship with Xavier. All because he wasn't strong enough to be the better man.

SHOWING A BETTER PATH

Charles Xavier has given up.

That's what a time-traveling Wolverine discovers in 2014's *X-Men: Days of Future Past*. Sent from a dystopian future, Wolverine has come to the 1970s to stop Xavier's close friend Mystique from assassinating mutant-hating scientist Bolivar Trask (Peter Dinklage). If Mystique succeeds, the humans will respond by expanding his program of creating mutant-hunting robots called Sentinels, which in turn leads to a horrible future, in which humans and mutants alike are enslaved.

Wolverine arrives at Xavier's mansion expecting to find the kind and patient mentor he knew, but encounters instead a broken and dispirited man. Bitter and angry, Xavier spends his days hiding in the mansion, where Hank McCoy aka Beast is his only friend. Even worse, Xavier has succumbed to a drug treatment that restores his ability to walk, but also diminishes his telepathy, effectively sacrificing his mutant identity for a form of normality.

9. Sölle, *Essential Writings*, 42.

Days of Future Past is perhaps the most important film in the X-Men franchise, not just because it brings together the original team and the new cast introduced in *First Class*. Nor is it because the film adapts one of the most beloved comic book stories from Chris Claremont and John Byrne.[10]

Rather, *Days of Future Past* perfectly captures the ethos of the X-Men franchise. By virtue of their being outsiders, mutants such as the X-Men know the shortcomings in the world as it is. People like Trask think only in terms of domination and safety, willing to destroy others if it makes them feel secure. Because they've been on the receiving end of such attacks, the X-Men know that safety comes only through welcome and acceptance.

That's the point that the future Charles Xavier (Stewart) tries to impress upon his younger self, when the time-travel shenanigans of Wolverine and Shadowcat (Elliot Page) allow the two to interact.

At first, the younger Xavier sees only snippets from Wolverine's life, all of the things he lost. "I don't want your suffering, I don't want your future!" he bellows, but Wolverine pushes him further, into his own future. The tumult stills and, with a series of dissolves, the younger Xavier finds himself in the wreckage where the future X-Men have taken shelter. Gentle ambient music fills the soundtrack and light radiating through stain-glass windows imbues the room with an almost holy warmth.

"So this is what becomes of us?" the younger Xavier asks of his older self, before sneering, "Erik was right." But the older Xavier refuses to accept that logic, even as he sits in ruins, with the memory of his murdered friends and students still on his mind. "Not if we show them a better path."

The two Xaviers face off against each other, with McAvoy playing the younger version as a man full of fear and anger, while Stewart plays the older version as a man who still believes in others. When the younger Xavier admits that he's suppressed his telepathy because he no longer wants to feel their pain, his older self reminds him of their greatest gift: "to bear their pain without breaking," which comes from his most human aspect—"hope."

When the older Xavier ends the conversation by pleading, "Please, Charles, we need you to hope again," he's not just asking for good feelings. He's asking his better self to look past the destruction and failure around him and see the good that he can do.

That's a very biblical idea of hope, which is tied to faith. Romans 8:24–25 teaches, "For in hope we were saved. Now hope that is seen is not hope. For who hopes for what is seen? But if we hope for what we do not see, we wait for it with patience." In other words, hope is looking past what is seen

10. Claremont and Byrne, "Days of Future Past."

and toward what is not seen, what will be, what we can make. And we can only make it with the other two great gifts, faith and love.

When the older Xavier urges his younger self to show others a better path, he's asking him to do a very Christian work. As Christians, we're commanded not to follow the ways of the world, but to show a better way, one based on love for others and welcome for all. As the very premise of the film attests, only then can we make a better future for ourselves, one in which everyone is safe and secure.

NOT AS ALONE AS YOU THOUGHT

Long before Stryker and Magneto use the computer as a weapon, Xavier shows Cerebro to Wolverine at the start of *X2: X-Men United*.

The lights dim and the camera inches closer to Xavier's face, as he closes his eyes and breathes deeply with the rhythms of the whirring machine. Suddenly, the camera pushes into the panels lining the room, which explode with light, and zooms through to the back of Xavier's head. Surrounding Logan and Xavier are no longer walls but billions of blue lights.

"These lights represent every living being in the planet," Xavier tells Logan. "These white lights are humans," Xavier explains, just as the lights change to red, bathing the two men in crimson; "And these are the mutants." The lights surrounding them spin and move, solidifying into people. Some look like regular people; others look strange and surprising. But as mutants, all of them are different, born with amazing abilities that set them apart from the rest of humanity.

"Through Cerebro, I am connected to them and they to me." The camera pushes onto Xavier's face, marked by a warm and welcoming smile. "You see, Logan? We're not as alone as you think."

Those beautiful images of Xavier connected to everyone, human and mutant alike, may be the most important reminder that the X-Men films have for Christians. We are connected to one another, to all of God's creation. And no matter how scared we get, no matter how much we want to force others to follow our way, that is not God's way.

God so loved the world that God sent Jesus. And Jesus showed us all a better path, one we get to live out every day, for others and for ourselves.

CREDITS:

X-Men (2000)
Director: Bryan Singer
Screenwriter: David Hayter

X2: X-Men United (2003)
Director: Bryan Singer
Screenwriters: Michael Dougherty and Dan Harris, and David Hayter

X-Men: First Class (2011)
Director: Matthew Vaughn
Screenwriters: Ashley Edward Miller and Zack Stenz and Jane Goldman
and Matthew Vaughn

X-Men: Days of Future Past (2014)
Director: Bryan Singer
Writer: Simon Kinberg

POST-CREDITS

Theme: Example

Key Biblical Passage: Matt 5:15–16

Questions:

1. The defining feature of X-Men stories is that mutants are feared and hated, which motivates both Magneto and the X-Men to remake the world in a certain way. Who, in the real world, is feared and hated? How can we benefit from learning from these feared and hated people? What is our responsibility as Christians toward feared and hated people?

2. The first two X-Men films show us different ways of welcoming other people. Why is hospitality so difficult, even for Christians? How does Christ model welcoming others, even others we may fear?

3. In *X-Men: First Class*, Xavier urges Magneto to be the better person with his powers. What powers and privileges do you enjoy? How could

those powers be used to harm other people? How could those privileges be used to spread Christ's gospel?

4. *X-Men: Days of Future Past* suggests that Xavier must endure suffering because that will allow him to show the world a better way. Why do we so often imagine suffering as a necessary part of recognizing problems? How can those who enjoy privileges listen to and learn from those who are hurting without exacerbating that suffering?

5. Anyone who has been rejected knows what it means to feel lonely. But throughout Christ's ministry, we see him intentionally calling the rejected and overlooked people. Where can you find rejected people in your community? How can you show empathy and love for them?

13

SOMETHING GOOD, SOMETHING BAD

Mystery Men—Suicide Squad—Birds of Prey—
Guardians of the Galaxy

For though I am free with respect to all, I have made myself a
slave to all, so that I might win more of them . . . I have become all
things to all people, that I might by all means save some.

—1 COR 9:19, 22

What should we do next: Something good, something bad?
Bit of both?

—STAR-LORD, *GUARDIANS OF THE GALAXY.*

CAPTAIN AMAZING (GREG KINNEAR) doesn't need anyone's help defending
Champion City, the setting for the 1999 comedy *Mystery Men*. With his vast
array of powers, super-gadgets, and winning smile, Captain Amazing has
successfully rid the city of all major threats. He certainly doesn't need the
help of William H. Macy's character the Shoveler ("I shovel well, I shovel
very well"), Hank Azaria's master of silverware the Blue Raja, or Ben Stiller's
Mr. Furious, who has the ability to get very angry.

Even when the trio and their fellow Mystery Men come to rescue Cap-
tain Amazing from the clutches of the evil Casanova Frankenstein (Geoffrey
Rush), the hero refuses to be part of the team.

The Mystery Men break into Frankenstein's lair to find Captain Amazing strapped to a chair, a giant death laser pointing at his head. Mr. Furious and The Bowler (Janeane Garofalo) rush to a series of gadgets, looking for the one that will free Amazing. But when they can't follow his unclear instructions, Captain Amazing grows increasingly frustrated with the Mystery Men, until he breaks down and starts yelling insults.

It's a bad choice. As the frazzled Blue Raja seeks to appease the hero by flipping a random switch, the laser kicks on and blasts Captain Amazing, twisting his head into grotesque shapes before finally burning him to a crisp.

If only Captain Amazing knew how to be a team player.

UNDERDOGS UNANIMOUS

The Mystery Men may be parodies of characters you'd find at DC and Marvel, spinning out of the absurdist indie series *Flaming Carrot Comics*, but they have a lot more in common with most superhero teams than the Justice League or the Avengers.[1] To be sure, publishers love to have a premier super-team in their stable, one that showcases the most popular characters in their universe. But most superhero teams consist of second stringers. In fact, even Marvel held off on bringing its most popular characters Wolverine and Spider-Man into the Avengers until 2004's *New Avengers* #1, filling its ranks with lesser-known figures like Circe, the Swordsman, and Quicksilver.[2]

From a publisher standpoint, this approach makes sense. By placing minor characters next to big hitters, the underdogs gain more attention, and may become viable sellers in their own right. When DC Comics launched a new team with *Justice League* #1 (1987), editorial concerns prevented writers Keith Giffen and J. M. DeMatteis from using the most famous stars, leaving them with only Batman and Martian Manhunter from the usual lineup.[3] Forced to use lesser-known characters like Guy Gardner, Booster Gold, and Blue Beetle, Giffen and DeMatteis brought a fresh comedic approach to the series, making it one of the most influential versions of Justice League.

Teams featuring B- and C-list characters have worked well on animated series, such as the acclaimed *Justice League Unlimited* (2004 to 2006) and *Avengers: Earth's Mightiest Heroes* (2010 to 2012), but the approach has failed to translate to live action. Hoping to capture the cult following garnered by the CBS series *The Flash* (1990 to 1991), Warner Brothers commissioned a *Justice League of America* pilot in 1997 that followed the sitcom

1. Burden, *Flaming Carrot Comics* #16 .

2. Bendis and Finch, *New Avengers* #1.

3. Giffen, DeMatteis, and Maguire, *Justice League* #1.

approach of Giffen and DeMatteis, but the series never came to fruition. Marvel did produce a Netflix adaptation of *The Defenders* in 2017, starring heroes from other Netflix series, such as Daredevil (Charlie Cox) and Jessica Jones (Krysten Ritter). But the series received poor critical and audience reviews, effectively putting an end to the streaming service's original Marvel shows.

However, recent films in the third wave of superhero movies have found an audience for lesser-known hero teams. *Guardians of the Galaxy*, *Birds of Prey*, and *The Suicide Squad* certainly feature well-known headliners, such as Harley Quinn (Margot Robbie) and the Joker (Jared Leto). But they largely consist of characters never-before-seen outside of obscure comic book series. The success of these films has emboldened studios to green-light films like *Eternals*, a strange and meditative movie adapting a minor Jack Kirby creation published by Marvel in the mid-1970s. *Eternals* opened to generally unfavorable reviews, the worst for an MCU movie, but earned more than twice its budget, despite being released during the COVID-19 pandemic. With that type of success, we're bound to see more groups of weirdos on the big screen.

A GATHERING OF MISFITS

In her book *Accidental Saints*, Lutheran minister Nadia Bolz-Weber offers a unique take on the Sermon on the Mount. Bolz-Weber asks us to imagine the Beatitudes as neither "a list of conditions we should try to meet to be blessed" nor "virtues we should aspire to." Rather, she sees them a "lavish blessing of the people around him on that hillside, blessing all the accidental saints in this world, especially those who that world—like ours—didn't seem to have much time for: people in pain, people who work for peace instead of profit, people who exercise mercy instead of vengeance."[4]

Bolz-Weber's reframing of the Sermon on the Mount underscores a quality of God that we see at work throughout Scripture. God doesn't demand the best or the perfect, but rather those who are willing to go. God makes use of anyone around, those with "ears to hear," no matter what their station. We see that principle in the group that Jesus called his disciples, which included fishermen from Galilee and Simon the Zealot, a member of an anti-Roman resistance movement.

As Christ's disciples demonstrate, if willingness is your only criteria, then you're bound to have a pretty ragtag group. For that reason, many of the New Testament epistles taught the young church how to deal with its

4. Bolz-Weber, *Accidental Saints*, 184.

many divisions, from the rich and poor living together to Jews and gentiles attending the same service to everything in-between. One of the most important verses in this series is Gal 3:28, which declares, "There is no longer Jew or Greek, there is no longer slave or free, there is no longer male and female; for all of you are one in Christ Jesus."

Some have read this passage as if Paul argues against differences among church members, as if God condones assimilation as the only path to unity. But as Michelle Ami Reyes reminds us, "the apostle Paul continually emphasizes cultural identities as part of the Christian faith and encourages Christians to respect cultural differences." Going on to interpret 1 Cor 9:19–23, in which Paul declares that he has become "all things to all people," Reyes contends that Paul is "advocating for followers of Jesus to embrace cultural flexibility with the people they meet instead of trying to flatten cultural diversity."[5] Such an approach may result in a group of oddballs, unlike any community that you'll find anywhere else, but that's part of God's "mission to reach the whole world," reflecting "the extraordinary mosaic that emerges from God's hospitality and love."[6]

Movies that imagine heroics from motley gatherings of misfits are crucial for thinking about the diversity of our churches. The superhero teams in this section aren't filled with the best people or people who share one purpose. But they are filled with the people who are present and available, and that's enough to allow them to do great things.

CONSIDER THE RATS OF THE CITY

One of the single most visually beautiful moments in any superhero movie occurs during the climactic battle of 2021's *The Suicide Squad*. It features Harley Quinn (Margot Robbie) as she swims through a viscous liquid of calming yellows and blues, accompanied by a soaring, jangly tune. A bevy of small furry animals follow her, surrounding her while she flashes a Disney Princess smile to the camera. The creatures land on the crimson vines surrounding them, releasing into the water soft explosions of red.

As visually beautiful as the moment may be, it is also conceptually disgusting. Harley is in fact in the eyeball of the gargantuan alien starfish Starro the Conqueror, and the furry creatures are a legion of rats, gnawing on blood vessels.

This mixture of the moving and disgusting are at the center of both *The Suicide Squad* and its predecessor, 2016's *Suicide Squad*. The movies

5. Reyes, *Becoming All Things*, 12–13.

6. Kim and Graham, *Healing Our Broken Humanity*, 25.

adapt a long-running series from DC Comics, which first appeared in its modern incarnation in *Legends* #3, in which supervillains are forced by the US government to serve in Task Force X.[7] Operated by the ruthless official Amanda Waller (Viola Davis), Task Force X is the ultimate example of human life treated as expendable.

That point gets made forcefully in the opening of *The Suicide Squad*, which brings back Harley Quinn, Captain Boomerang (Jai Courtney), and field leader Col. Rick Flag (Joel Kinnaman) from the first film and introduces new characters such as Javelin (Flula Borg) and Savant (Michael Rooker). By the movie's ten-minute mark, we're watching all of these characters, save Harley and Flag, get killed in gory, brutal detail. The opening title sequence, set to Jim Carroll's punk anthem "People Who Died," zooms over the mangled bodies of the dead Squad members, an uncomfortable mix of cruel mockery and resigned acceptance.

As unnerving as it may be, those are hardly the only people whose lives are casually tossed aside in *The Suicide Squad*. The film's climax features an attack by Starro the Conqueror, who secretes smaller Starros which attach themselves to the faces of hundreds of citizens of the fictional Latin American country Corto Maltese, killing them and turning their bodies into vessels for the beast. In a darkly comedic sequence found earlier in the film, Squad members Bloodsport (Idris Elba) and Peacemaker (John Cena) have a competition to determine who is the best killer by murdering soldiers in a camp in the most ostentatious ways. Only when they've decimated everyone do they realize that the camp was full of resistance fighters, hoping to overthrow the island's oppressive military regime and establish democratic leadership.

"Typical Americans," sneers the resistance leader Sol Soria (Alice Braga). "Just run in, guns blazing."

Soria isn't wrong. *The Suicide Squad* is a powerful representation of not only the callousness of America's leadership, but of all worldly powers. Throughout the film, the leaders of the Corto Maltese military leadership talk about how Starro will allow them to beat back dissidents and to earn the respect of the rest of the world. It's no wonder that when the villainous Thinker (Peter Capaldi) shows the Squad members his grotesque experiments on bodies controlled by Starro, he calls the victims "the fodder of powerful men through every age."

"Good God," gasps Flag.

The Thinker responds, "If God existed, wouldn't this be proof that he wasn't good at all?"

7. Ostrander et al., *Legends* #3.

For all the violent glee of *The Suicide Squad*, and all the dour machismo of its predecessor *Suicide Squad*, these films are fundamentally about the evils of worldly power. Time and time again throughout the film, we're reminded that governments maintain power only through treating others as unimportant, disposable. And time and time again, we're reminded that God stands against these governments.

One of the most powerful examples of God opposing a proud government appears in the book of Isaiah, in which the prophet describes God's judgment on Babylon. When "the day of the LORD comes, cruel, with wrath and fierce anger," God will "put an end to the pride of the arrogant, and lay low the insolence of tyrants" (Isa 13:9, 11). Then, those oppressed by Babylon can taunt the once-mighty city, saying,

> How the oppressor has ceased!
> How his insolence has ceased!
> The Lord has broken the staff of the wicked,
> the scepter of rulers,
> that struck down the peoples in wrath
> with unceasing blows,
> that ruled the nations in anger
> with unrelenting persecution. (Isa 14:4–6)

In these and other passages throughout Scripture, we see God as one whose heart is with the little people and whose anger is directed at the proud.

In *The Suicide Squad*, the most prominent little person is Ratcatcher II (Daniela Melchior), the daughter of a Portuguese petty criminal who taught her how to speak to rats. In a flashback sequence, Ratcatcher II remembers asking her father (Taika Waititi) why rats are special.

"Rats are the lowliest and most despised of all creatures, my love," he says with a warm, uncommonly kind smile. "But if they have purpose, so do we all."

When *The Suicide Squad* has its heroic moments, it follows that principle. That's not only why it plays as triumphant the scene when rats devour the eye of a starfish from space, but also when the Squad decides to treat the people of Corto Maltese like humans, not just as collateral damage in global power politics. Those people have purpose. And so do we all.

TAKE THIS BURRITO AND EAT OF IT

After sliding down a candy-colored chute, Harley Quinn and her newfound compatriots land in an abandoned carnival funhouse, teeming with men who want to kill them. The searing guitar riffs of "Barracuda" by Heart kick

in as men charge into a tunnel lined with strobing lights. Harley bashes the baddies with her oversized mallet, while Detective Renee Montoya (Rosie Perez) fires upon attackers sneaking through a hall of mirrors. Black Canary (Jurnee Smollett) leaps along yellow seesaws, launching her assailants into the air and smashing them with a bat. Huntress (Mary Elizabeth Winstead) shoots crossbow bolts from behind oversized white hands to protect teenage pickpocket Cass Cain (Ella Jay Brasco). The gonzo action only stops when Black Canary, frustrated with her hair constantly falling into her face, shouts in anger.

"Hair tie?" offers Harley, tossing a band to her partner so they can continue their defense.

The funhouse scene is a surprisingly communal ending to a movie that purported to be a Harley Quinn solo adventure, set between *Suicide Squad* and *The Suicide Squad*. Loosely adapting the female-centric DC Comics series *Birds of Prey*, *Birds of Prey (and the Fantabulous Emancipation of One Harley Quinn)* opens with a spectacular display of independence. After breaking up with her long-time and highly abusive boyfriend the Joker, Harley sends a tanker truck into the heart of the Ace Chemical plant, filling the sky with flames and fireworks of yellow, pink, and purple.

"It was the closure I needed, a fresh start," thinks Harley as she stares in awe at the beautiful chaos. "A chance to be my own woman."

As this declaration of independence suggests, Harley didn't plan on a team-up. But when all five women become the target of insecure manchild Roman Sionis (Ewan McGregor) and his sadistic henchman Victor Szasz (Chris Messina), they're forced to come together. Sionis has utter contempt for all women, especially for those who inconvenience him in any way. Whatever their differences, the film's five heroes are all women, which makes them targets when men like Sionis want to shore up their power.

With this dynamic at work, *Birds of Prey* offers something rare among not just team-up movies, but superhero movies in general. The film has an over-the-top glee, a burst of excitement, an explosion of energy that comes from the disenfranchised finally finding others with whom they can relate.

Before the "Barracuda" battle sequence, the women realize that they're surrounded by mobs of men, led by Sionis. Cass steps back in horror and asks, "He's after me, isn't he?" But Harley insists that's not the case. Sionis is after all of them. The thin-skinned misogynist hates any woman who refuses to stay in the place that he's designated for them. "So unless we all wanna die very unpleasant deaths," Harley exclaims in her exaggerated Bronx accent, "we're gonna have to work together." Despite some initial misgivings, the women agree, even if that means arming themselves with Harley's goofy contraptions.

That irreverent energy gives significance to even the most mundane acts, such as the burrito and margaritas the women enjoy at the end of the film. After dispatching Sionis, the Birds of Prey retire to a chintzy restaurant and simply share a moment together.

Although it's a far cry from the wine and bread we usually associate with the Lord's Supper, there is a type of communion at work in this meal of gaudy Mexican food. As Kaitlin B. Curtice finds in her book *Native*, our church communion tables are an important place to live out our understanding of God. "If we are to believe that the inclusive love of God is real, we'd better start building a bigger table," she writes. If we want to combat the evils of the world, the systems of "nationalism and homophobia or white supremacy and indifference" that destroy people made in God's image, then "our communion table, a gathering place of community, must really be a table of *communing*."[8]

In *Birds of Prey*, that communing takes the form of not only the women spending time together, but also building one another up, intentionally undoing the belittling favored by men like Sionis.

"No, but seriously, you were very impressive with that bow," Montoya enthuses to Huntress.

When Harley and Black Canary join in by praising her codename, Huntress stumbles through her own compliment. "I really like how you were able to kick so high in those tight pants," she tells Canary, her sincerity compensating for her lack of confidence.

For some, the awkward compliments and bad burritos are hardly the way to celebrate emancipation. But for building a bigger table and recognizing the value of those too often rejected, it's the ideal meal.

WE ARE GROOT

"What did the galaxy ever do for you? Why would you want to save it?"

That question may be posed by a technologically enhanced space raccoon called Rocket, but it raises a good point. Neither Rocket, nor his giant tree of a best friend Groot, nor his interlocuter Peter Quill aka Star-Lord, have lived charmed lives. They've been dismissed by everyone they meet as losers, pushed to the periphery to survive as petty thieves. Their new compatriots Gamora (Zoe Saldana) and Drax have it even worse, reduced to becoming killers after their families were destroyed by either Thanos or his foot soldier, the religious zealot Ronan the Accuser (Lee Pace).

8. Curtice, *Native*, 83–84. Italics original.

But Peter Quill's answer to Rocket is as insightful as it is obvious. "Because I'm one of the idiots who lives in it!" he retorts.

Released in 2014, *Guardians of the Galaxy* was the most unlikely of blockbuster hits. Just two years after *The Avengers* seemed like an unwise gamble, Marvel brought to theaters a group of characters unfamiliar to even die-hard comics readers. To these readers, the Guardians of the Galaxy were freedom fighters battling alien conquerors in the thirty-first century. In 2008, a new team called the Guardians of the Galaxy appeared in the comic book series *Annihilation: Conquest #6*.[9] Although set in the main Marvel Universe timeline, these Guardians were made up of obscure characters, such as the rarely used Star-Lord and Groot, a holdover from Stan Lee and Jack Kirby's pre-superhero monster comics.

Those characters still feel ramshackle and ill-fitting when they made the leap to the big screen in 2014. They begin the movie as loners (except for Rocket and Groot, who work as a duo), each pursuing their own selfish ends. They only work together when Ronan threatens to destroy the universe.

Even then, the Guardians are a volatile bunch, more likely to yell at each other than to spread encouragement. Those fissures become particularly clear in the 2017 sequel *Guardians of the Galaxy: Vol. 2*, in which Peter meets his long-lost father Ego (Kurt Russell). As a near-immortal, vastly powerful alien Celestial, Ego lived alone for centuries as a sentient planet. When his thirst for meaning became too much, Ego created a humanoid body and explored the cosmos, which is how he met Peter's mother, Meredith Quill (Laura Haddock).

At first, Ego seems to be everything that Peter could want, a super-cool dad with amazing powers, who passes those powers onto his son. But soon, Peter learns that Ego lives up to his name.

Walking his son through a cavernous museum devoted to himself, Ego recalls his search for life and the feeling he experienced when he finally met other people. "It was all so . . . disappointing," he admits with a sigh.

An overhead shot captures Peter looking microscopic in the vastness of Ego's museum. Mixing pride with hope and relief, Ego explains to Peter the "profound realization" he gained while on his journeys. He doesn't want to live among others; he wants to engulf them, devour them, replace them with variations of himself. And he needs Peter's power to do it.

The camera spins around Peter as Ego taps him on the chest, filling his son with power. Awe and wonder spread across Peter's face as he looks up at the sky, a dark starfield covering his eyes. Peter can no longer see his

9. Abnett et al., *Annihilation: Conquest #6*.

friends or his place in the world. He can only see himself as an extension of Ego's selfhood.

The self-righteousness and selfishness expressed by Ego is the exact opposite of the way God operates, as demonstrated in Christ. Paul reminds readers of this fact when he describes Christ as one who "was in the form of God," but

> did not regard equality with God
> as something to be exploited,
> but emptied himself,
> taking the form of a slave,
> being born in human likeness. (Phil 2:6–7)

Instead of reducing all creation into the same form, God rejoices in the variation and differences among people and creatures. Through Christ, God urges humanity to follow this example, loving our neighbors as ourselves, but never demanding that our neighbors be like ourselves.

For Dorothee Sölle, God's emptying of God's self reflects the model for our relationship with God. Instead of worshiping God "because of God's power and domination," we can seek to immerse ourselves in God's love. "Here our relationship to God is not one of obedience, but of union; it is not a matter of a distant God exacting sacrifice and self-denial, but rather a matter of agreement and consent, of being at one with what is alive," writes Sölle. "When this happens solidarity will replace obedience as the dominant virtue."[10]

The first *Guardians* film visualizes this solidarity in its climax when Peter snatches the Power Stone after it's dislodged from the hammer of Ronan the Accuser. As seen earlier in the movie, the Power Stone obliterates normal creatures when they touch it, and Peter begins disintegrating as soon as his hand closes around it. Purple plumes of smoke engulf Peter and his body begins to crumble. But before he can succumb, he hears Gamora call, "Take my hand."

Gamora's body begins to burn as soon as her hand clasps Peter's and the Power Stone starts to overcome her, but she refuses to let go. Immediately after, Drax and Rocket follow suit, touching their friends and feeling the burn, but still holding tight.

The power does not consume them. It does not reduce them to singular aspects of the same. By sharing the power in all of their differences, by avoiding the reducing selfishness of Ego, this ragtag bunch of idiots save the galaxy in which they live.

10. Sölle, *Essential Writings*, 49.

WE'RE THE OTHER GUYS

"We're not your classic superheroes. We're not your favorites. We're the other guys. The guys nobody bets on."

Inspiring speeches are a key part of any superhero movie. But they rarely sound like this seemingly self-defeating monologue the Shoveler delivers before the climax of *Mystery Men*. Then again, it's hard to imagine what else the Shoveler could say. After a brief moment of victory, he and his fellow Mystery Men found themselves roundly defeated by Casanova Frankenstein and his goons. With the all-powerful Captain Amazing dead, there's surely nothing that this group of odd-balls can do.

But as the team begins talking about running away and giving up, the Shoveler scoops up a big helping of egg salad and tries to reason with his fellow heroes.

"This is egg salad," he declares, holding it aloft for all to see. "It's loaded with cholesterol, the wife won't even let me touch it. Hardly seems to matter now, 'cause chances are we're already dead." A reverse shot shows the other Mystery Men hanging their heads as they begin to understand the truth of the Shoveler's words. "There's no use waiting for the cavalry, because as of this moment, the cavalry is us."

The Shoveler is right. The best and the favorites can no longer fight this fight. If the citizens of Champion City waited for the "right" heroes to fight their battles, then Casanova Frankenstein will easily win.

So often we can push off our responsibilities under the guise of not being ready, not being the best choice. But with his bowl of sloppy egg salad, the Shoveler has an important message for Christians. God chooses not the best, but the available, not the perfect, but the willing.

The same is true of the Shoveler, who asks his partners, "Do we all gather together and go kick some Casanova butt? Or do I eat this sandwich?"

An egg-salad sandwich is a far cry from bread and wine, but the principle is the same. Bound together over a table, the Mystery Men commune, forming a society of weirdos who do good works. Because if they don't— who will?

CREDITS:

Mystery Men (1999)

Director: Kinka Usher

Screenwriter: Neil Cuthbert

Guardians of the Galaxy (2014)

Director: James Gunn

Screenwriters: James Gunn and Nicole Perlman

Guardians of the Galaxy: Vol. 2 (2017)

Director: James Gunn

Screenwriter: James Gunn

*Birds of Prey (and the Fantabulous Emancipation
of One Harley Quinn)* (2020)

Director: Cathy Yan

Screenwriter: Christina Hodson

The Suicide Squad (2021)

Director: James Gunn

Writer: James Gunn

POST-CREDITS:

Theme: Unlikely Communities

Key Biblical Passage: 1 Cor 9:19–23

Questions:

1. The Mystery Men are joke characters, but they find themselves forced to take on a difficult mission that no one else can do. When have you found yourself part of a group forced to do more than you thought possible? Did your faith play in part in your accomplishments or failures?

2. *The Suicide Squad* suggests that powerful forces, like the American government, treat people as if they are dispensable, without purpose. Why do powerful systems have this attitude? How does the gospel of Christ contradict this attitude? What does that mean for the way we need to treat people who seem to have no purpose?

3. In *Birds of Prey*, various women are forced together because of a common oppressor. Where can you find commonality with people who share your problems? How does solidarity among the oppressed help bring about community and belonging? How can our Christian faith be the glue of this belonging?

4. The two *Guardians of the Galaxy* movies show how five self-involved individuals learn to care about one another and form a community. When have you built an unlikely community with people you wouldn't otherwise be with? Did your faith play any part in constructing those communities?

5. In 1 Cor 9:19–23, Paul affirms differences within the church as part of God's plan for salvation. How can movies about unlikely communities teach us to affirm differences? What parts of church life prevent these differences? How can your church better embrace differences?

LOGAN'S LEGACY OF VIOLENCE

So let us not grow weary in doing what is right, for we will reap
at harvest time, if we do not give up.

—GAL 6:9

We always thought we were part of God's plan. Maybe, maybe we
were God's mistake.

—LOGAN, *LOGAN*

BATTERED, BLOODY, AND BEATEN, his healing factor no longer able to re-
pair his body's numerous wounds, Logan staggers to his feet and pops his
claws. Across him stands his clone, a near-flawless recreation of himself in
his prime. This younger Wolverine has all of Logan's strength and abilities,
including his indestructible adamantium claws.

In a feral state, the younger Wolverine lunges toward his double, snarl-
ing in a berserker rage more violent than any Logan experienced on his
worst day. Logan is no match for beastly self, who thrashes him against a
tree. The only thing keeping Logan alive, the one thing that allows him to
overcome this worst version of himself, is his care for Laura (Dafne Keen)
and the other young mutants he tries to protect.

In his dying moments, Logan finally answers the question that he has
struggled with ever since his claws first popped when he was a child. Having

defeated his feral double, Logan now definitely knows that he isn't a beast, that he's a human, capable of empathy and compassion.

Directed by James Mangold, *Logan* serves as a fitting end to the character whose first appearance in *X-Men* helped jumpstart the second wave of superhero movies. Without the charismatic performance of Hugh Jackman, it's unlikely that *X-Men* would have earned its impressive box office, setting the stage for *Spider-Man* and other entries in superhero movies' second wave, which in turn made the third wave possible. In short, we likely would not have the MCU or the DCEU, let alone this book you're reading, if not for Jackman's ability to find the pathos and decency in a man too often reduced to a mindless weapon.

For that reason, Wolverine is the ideal character on whom to end this study. A superhero who embodies the best and worst that the genre has to offer, Wolverine's film appearances, particularly his closing chapter *Logan*, are vital for examination by Christians who love these movies.

THE BEST AT WHAT HE DOES

For one of the all-time most popular comic book characters, Wolverine had a fairly inauspicious beginning. Created by Len Wein, Wolverine first appeared as a minor antagonist of the Hulk in 1974's *The Incredible Hulk #181*.[1] Dispatched by the Canadian government to take down the gamma-radiated monster, Wolverine spends the issue battling the Hulk and a mystical monster called Wendigo. But by the next issue, he's forgotten, making an impression on neither the Hulk nor the readers.

Even when Wein brought his creation over to the X-Men, where he joined the team in the 1975 breakout issue *Giant-Sized X-Men #1*, Wolverine failed to stand out. In that first adventure with the mutant team, Wolverine was just one of several characters with a bad attitude, alongside the arrogant Japanese warrior Sunfire and the antisocial Native American Warpath.[2] Only when writer Chris Claremont took those characters out of the X-Men did Wolverine begin to develop a personality.

Over the years, his legend would grow, and with it, his popularity. Although his bad attitude never really went away, Wolverine did show a sensitive side, burning with unrequited love for teammate Jean Grey, palling around with best friend Nightcrawler, and serving as a father figure for young women Shadowcat and Jubilee.

1. Wein and Trimpe, *Incredible Hulk* #181.
2. Wein and Cockrum, *Giant-Size X-Men* #1.

Following a wildly successful 1982 solo miniseries by Claremont and Frank Miller, which embroiled Logan in the Japanese world of ninjas and Yakuza, Wolverine got his own ongoing series in 1988, which has continued in one form or another up through this writing.[3] Furthermore, the character has become almost oversaturated, being mandated by Marvel editorial to join not only every team with an "X" in its name, but also the Avengers. A guest appearance by Wolverine is almost guaranteed to sell copies of comics, which is why Marvel doesn't think twice about putting the character into the most unlikely scenarios.

It's not hard to see the basic appeal of Wolverine. Beyond his gruff demeanor and fundamentally cool looking claws, Wolverine is a romantic figure, a character who wrestles with his identity. Even when new stories reveal past sins, Wolverine remains someone who longs to be a decent human being but fears that redemption is out of his reach.

As demonstrated by early scenes in each of his first two solo movies, Wolverine is a character defined by violence. The lone standout scene of 2009's *X-Men Origins: Wolverine* is a montage following Wolverine and his brother and fellow mutant Sabertooth (Liev Schrieber) as they participate in American wars throughout the years. 2013's more somber *The Wolverine* begins with Wolverine protecting a Japanese soldier during the US's atomic strike on Nagasaki. As this latter film suggests, even when doing something fundamentally decent and human, Wolverine cannot escape violence.

THE VIOLENT PATH

Wolverine's irresistible mix of tragic romance and unbridled violence gains greater significance when examined through a Christian lens. As discussed earlier, violence remains the greatest stumbling block for Christ followers who love superhero movies. We've seen how these films unfailingly resolve with a third-act battle, even those that explicitly feature characters pursuing peace.

Before Wonder Woman can persuade Maxwell Lord out of destroying the world in *Wonder Woman: 1984*, she first has to electrocute Cheetah with a power line. Captain America would rather talk down his brainwashed friend Bucky in *Captain America: The Winter Soldier*, but we viewers have a lot more fun when he gives up and starts throwing his mighty shield.

As I hope I've demonstrated, these fight scenes can be understood on a metaphorical level. The mythic nature of superheroes and villains means that their clashes can be representations of worldviews, intellectual debates

3. Claremont and Miller, *Wolverine* and Claremont and Buscema, *Wolverine #1*.

visualized as brightly colored battle sequences. But the loftiest of interpretations can't take away from the fact that these are still fights and the good guy has to beat up the bad guy in the end.

For Christians, this truth means that we'll always have a fraught relationship to superhero stories. If we're going to follow the Prince of Peace, we'll always have to contend with the powers and principalities portrayed in these films, which almost always subscribe to the world's conviction that might make right.

GROWING WEARY, DOING GOOD

Midway through *Logan*, Logan bursts into the hotel room where Laura and Xavier sit on the couch, watching the classic western *Shane*. In his hands, Logan carries copies of X-Men comics read by Laura. In the movie's reality, X-Men comics are fictionalized stories about the real-life mutant team, sensational tales that have about as much in common with fact as dime novels did about Billy the Kid and Jesse James.

"In the real world, people die," scolds Logan. His frustration only grows when he realizes the coordinates that he's been given, which supposedly hold the location of a secret safe area for young mutants, comes directly from one of these X-Men comics. The specific story involved a place called "Eden," where Wolverine brings a group of mutants to live in safety.

Laura is convinced that Logan must take her to Eden, but he refuses.

"It's not real!" he shouts at Laura and Xavier.

But the older man simply responds, in his characteristic calm kindness, "It's real to her, Logan. It's real to her."

When Laura and Logan do follow the coordinates and find an Eden occupied by young mutants, it doesn't prove that the comic books were true. Rather, it proves that the children made it true, using the ideas imagined in the comic book and making them into reality. Through the fantasy of comics, they made their world a better place.

Viewers of superhero movies like *Logan* can follow this lead. We too can see the beautiful parts of the fantasy stories we love and bring them into our world. For Christians, that means paying attention to themes such as a love for outsiders and underdogs, the insistence on diverse communities, and steadfast belief in helping others. Despite their many flaws, despite their concern for corporate interests and intellectual property, despite their emphasis on violence, superhero movies are fundamentally about the difference between right and wrong. Even when they imagine this clash imperfectly, they can still be of use for Christians, who have been instructed

to "not grow weary in doing what is right" (Gal 6:9). By watching these films through a Christian imagination, we can picture ways of improving the world, helping others, and advancing the Kingdom of Heaven.

We don't even need brightly colored tights or adamantium claws to do it.

CREDITS:

X-Men Origins: Wolverine (2009)
Director: Gavin Hood
Screenwriters: David Benioff and Skip Woods

The Wolverine (2013)
Director: James Mangold
Screenwriters: Mark Bomback and Scott Frank

Logan (2017)
Director: James Mangold
Screenwriters: Scott Frank and James Mangold and Michael Green

BIBLIOGRAPHY

Abnett, Dan, et al. *Annihilation: Conquest* #6. Inked by Scott Hanna, colored by Frank D'Armata, lettered by Joe Caramagna. New York: Marvel Comics, 2008.

Adams, Mary McCord. *Horrendous Evils and the Goodness of God.* Ithaca: Cornell University Press, 2000.

Adlakha, Siddhant. "'Iron Man' Built the Foundation of the MCU Using Charm and Military Fantasy." https://www.oklahoman.com/article/feed/9710334/road-to-endgame-iron-man-built-the-foundation-of-the-mcu-using-charm-and-military-fantasy.

Alcalá, Félix Enríquez, dir. *Justice League of America.* Unaired pilot. New York: CBS, 1997.

Alexander, Keith L. "Parents of Young 'Black Panther' Fans Struggle with Telling Children of Actor's Death." *The Washington Post*, August 29, 2020. https://www.washingtonpost.com/local/legal-issues/parents-of-young-black-panther-fans-struggle-with-telling-children-of-actors-death/2020/08/29/879b7280-ea0e-11ea-97e0-94d2e46e759b_story.html.

Alexander, Lexi, dir. *Punisher: War Zone.* Santa Monica, CA: Lionsgate, 2008.

Anderson, Reynaldo, and Charles E. Johnson. *Afrofuturism 2.0: The Rise of Astro-Blackness.* Lanham: Lexington, 2017.

Armas, Kat. *Abuelita Faith: What Woman on the Margins Teach Us about Wisdom, Persistence, and Strength.* Grand Rapids: Brazos, 2021.

Ayer, David, dir. *Suicide Squad.* Burbank: Warner Bros., 2016.

Azzarello, Brian, writer, Lee Bermejo, artist. *Lex Luthor: Man of Steel.* Colored by Dave Stewart. New York: DC Comics, 2005.

Barron, Steve, dir. *Teenage Mutant Ninja Turtles.* Burbank: New Line Cinema, 1990.

Barth, Karl. *Dogmatics in Outline.* New York: Harper Perennial, 1959.

Beaty, Warren, dir. *Dick Tracy.* Burbank: Buena Vista Pictures, 1990.

Bendis, Brian Michael, writer, David Finch, penciler. *New Avengers* #1. Inked by Danny Miki, colored by Frank D'Armata, lettered by Richard Starkings and Albert Deschense. New York: Marvel Comics, 2005.

Bennet, Spencer Gordon, dir. *Atom Man vs. Superman.* Los Angeles: Columbia, 2006.

———, dir. *Batman and Robin.* Los Angeles: Columbia, 1949.

Bennet, Spencer Gordon, and Thomas Carr, dirs. *Superman.* Los Angeles: Columbia, 1948.

Berg, Peter, dir. *Hancock.* Culver City, CA: Sony, 2008.

Bettinson, Gary. *Superman: The Movie: The 40th Anniversary Interviews.* Bristol: Intellect, 2018.

Bilson, Danny, and Paul De Meo. *The Flash.* Aired September 20, 1990 to May 18, 1991, on CBS.

Bird, Brad, dir. *The Incredibles.* Burbank: Walt Disney Studios, 2004.

Bixby, Bill, dir. *The Death of the Incredible Hulk.* Atlanta: New World International, 1990.

———. *The Trial of the Incredible Hulk.* Atlanta: New World International, 1989.

Black, Shane, dir. *Iron Man 3.* 2013; Burbank: Walt Disney Studios, 2021.

Boden, Anna, and Ryan Fleck, dirs. *Captain Marvel.* Burbank: Walt Disney Studios, 2019.

Bolz-Weber, Nadia. *Accidental Saints: Finding God in All the Wrong People.* New York: Convergent, 2015.

Bonhoeffer, Dietrich. *The Cost of Discipleship.* New York: Touchstone, 2005.

Boone, Josh, dir. *The New Mutants.* Los Angeles: 20th Century Fox, 2021.

Boretz, Alvin. *The Amazing Spider-Man.* Aired September 14, 1977 to July 6, 1979, on CBS.

Bowman, Rob, dir. *Elektra.* Los Angeles: 20th Century Fox, 2005.

Boyd, Greg. *Myth of a Christian Nation: How the Quest for Political Power Is Destroying the Church.* Grand Rapids: Zondervan, 2009.

Branagh, Kenneth, dir. *Thor.* Burbank: Walt Disney Studios, 2011.

Broome, John, writer, Gil Kane, penciler. "S.O.S. Green Lantern." *Showcase Comics* #22. Joe Giella and lettered by Gaspar Saladino. New York: DC Comics, 1959.

Burden, Bob. *Flaming Carrot Comics* #16. Colored and lettered by Roxanne Starr. Long Beach: Renegade, 1985.

Burton, Tim, dir. *Batman.* Burbank: Warner Bros., 1989.

———, dir. *Batman Returns.* Burbank: Warner Bros., 1992.

Cannon, Danny, dir. *Judge Dredd.* Burbank: Buena Vista, 1995.

Campbell, Martin, dir. *Green Lantern.* Burbank: Warner Bros., 2011.

Charles, Mark, and Soong-Chan Rah. *Unsettling Truths: The Ongoing, Dehumanizing Legacy of the Doctrine of Discovery.* Downer's Grove, IL: InterVarsity, 2019.

Chu, Jeff. *Does Jesus Really Love Me?* New York: Harper Perennial, 2013.

Claremont, Chris, co-writer, John Byrne, co-writer and penciler. "Days of Future Past." *X-Men* #141–42. Inked by by Terry Austin, colored by Glynis Wein, lettered by Tom Orzechowski. New York: Marvel Comics, 1981.

———, writer, Frank Miller, penciler. *Wolverine* #1. Inked by Josef Rubinstein, colored by Glynis Wein, lettered by Tom Orzechowski. New York: Marvel Comics, 1982.

———, writer, John Buscema, penciler. *Wolverine* #1. Inked by Al Williamson, colored by Glynis Wein, lettered by Tom Orzechowski. New York: Marvel Comics, 1988.

———, co-writer, Jim Lee, co-writer and penciler. *X-Men* #66. Inked by Scott Williams, colored by Joe Rosas, lettered by Tom Orzechowski. New York: Marvel Comics, 1991.

Clifton, Elmer, and John English, dirs. *Captain America.* Los Angeles: Republic, 1943.

Coates, Ta-Nehisi. "Why I'm Writing *Captain America.*" *The Atlantic,* February 28, 2018. https://www.theatlantic.com/entertainment/archive/2018/02/we-who-love-america/553991/.

Craven, Wes, dir. *Swamp Thing.* Los Angeles: Embassy Pictures, 1982.

Cretton, Daniel Destin, dir. *Shang-Chi and the Legend of the Ten Rings*. Burbank: Walt Disney Studios, 2021.

Collis, Clark. "*Nice Guys* Director Shane Black Explains His Obsession with Christmas: 'It's Just a Thing of Beauty.'" *Entertainment Weekly*, May 25, 2016. https://ew.com/article/2016/05/25/shane-black-christmas/.

Collyer, Bud, and Joan Alexander. *The Adventures of Superman*. Aired February 12, 1940 to March 1, 1951 on Mutual Broadcasting System, Citadel Media.

Cone, James H. *The Cross and the Lynching Tree*. Maryknoll, NY: Orbis, 2001.

———. *God of the Oppressed*. Maryknoll, NY: Seabury, 1997.

Coogler, Ryan, dir. *Black Panther*. Burbank: Walt Disney Studios, 2018.

Corea, Nicholas, dir. *The Incredible Hulk Returns*. Atlanta: New World International, 1988.

Curtice, Kaitlin B. *Native: Identity, Belonging, and Rediscovering God*. Grand Rapids: Brazos, 2020.

DeGuere, Philip, dir. *Doctor Strange*. Universal City, CA: Universal Television, 1978.

Derrickson, Scott, dir. *Doctor Strange*. Burbank: Walt Disney Studios, 2016.

Dippé, Mark A. Z., dir. *Spawn*. Burbank: New Line Cinema, 1997.

Donner, Richard, dir. *Superman: The Movie*. Burbank: Warner Bros., 1978.

Dooley, Paul, et al. *The Electric Company*. Aired October 25, 1971 to April 15, 1977, on PBS.

Dozier, William. *Batman*. Aired January 12, 1966 to March 14, 1968, on ABC.

Earnest, William. "Making Gay Sense of the X-Men." In *Uncovering Hidden Rhetorics: Social Issues in Disguise*, edited by Barry Brummett, 215–32. Los Angeles: SAGE, 2008.

Eastman, Kevin, and Peter Laird. *Teenage Mutant Ninja Turtles #1*. Northampton: Mirage Studios, 1984.

Eliot, T. S. "Religion and Literature." In *Selected Prose of T.S. Eliot*, edited by Frank Kermode, 97–106. New York: Farrar, Straus & Giroux, 1953.

Ellis, Warren, writer, Adi Garnov, artist. "Extremis." *The Invincible Iron Man #1–6*. Lettered by Randy Gentile. New York: Marvel Comics, 2005–2006.

Ellsworth, Whitney, and Robert J. Maxwell. *Adventures of Superman*. Aired September 19, 1952 to April 28, 1958, on Motion Pictures for Television.

Englehart, Steve, writer, Jim Starlin, penciler. "Shang-Chi, The Master of Kung Fu!" *Special Marvel Edition #15*. Inked Al Milgrom, colored by Steve Englehart, lettered by Tom Orzechowski. New York: Marvel Comics, 1975.

Evans, Rachel Held. *Inspired: Slaying Giants, Walking on Water, and Loving the Bible Again*. Nashville: Nelson, 2018.

Favreau, Jon, dir. *Cowboys vs. Aliens*. Universal City, CA: Universal, 2011.

———, dir. *Iron Man*. Burbank: Walt Disney Studios, 2008.

Favreau, Jon, dir. *Iron Man 2*. Burbank: Walt Disney Studios, 2010.

Finger, Bill, writer, Bob Kane, penciler. "The Joker." *Batman #1*. Inked and lettered by Sheldon Moldoff. New York: DC Comics, 1940.

———, writer, Bob Kane, artist and letterer. "The Case of the Chemical Syndicate." *Detective Comics #27*. New York: DC Comics, 1939.

———, writer, Syd Shores, penciler. "The Crime of the Ages!" *All Winners #19*. New York: Marvel Comics, 1946.

————, writer, Bob Kane, penciled and inked. "Legend: The Batman and How He Came to Be." *Detective Comics* #33. Lettered by Sheldon Maldoff. New York: DC Comics, 1939.

Fleischer, Ruben, dir. *Venom*. Culver City, CA: Sony, 2018.

Forasteros, JR. *Empathy for the Devil: Finding Ourselves in the Villains of the Bible*. Downer's Grove, IL: InterVarsity, 2017.

Fox, Gardner, writer, Everett E. Hibbard, penciler and inker. "The First Meeting of the Justice Society of America." *All Star Comics* #3. New York: DC Comics, 1940.

————, writer, Mike Sekowsky, penciler. "Starro the Conqueror." *The Brave and the Bold* #28. Inked by Bernard Sachs et al., lettered by Gaspar Saladino. New York: DC Comics, 1960.

French, Alex, and Maximillian Potter, "Bryan Singer's Accusers Speak Out." *The Atlantic*, January 23, 2019. https://www.theatlantic.com/magazine/archive/2019/03/bryan-singers-accusers-speak-out/580462/.

Fritz, Ben. *The Big Picture: The Fight for the Future of Movies*. Boston: Mariner, 2018.

Furie, Sidney J., dir. *Superman IV: The Quest for Peace*. Burbank: Warner Bros., 1987.

Gafney, Wilda C. *Womanist Midrash: A Reintroduction to the Women of the Torah and the Throne*. Louisville: West Minister John Knox, 2017.

Giffen, Keith, co-writer, J. M. DeMatteis, co-writer, Kevin Maguire, penciler. *Justice League* #1. Inked by Terry Austin, colored by Gene D'Angelo, lettered by Bob Lappan. New York: DC Comics, 1987.

Gilbert, Sophie. "The Power of a Skeptical Captain America." *The Atlantic*, April 23, 2021. https://www.theatlantic.com/culture/archive/2021/04/falcon-and-winter-soldier-skeptical-captain-america/618686/.

Gillard, Stuart, dir. *Teenage Mutant Ninja Turtles III*. Burbank: New Line Cinema, 1993.

Goba, Bonganjalo. "What Is Faith? A Black South African Perspective." In *Lift Every Voice: Constructing Christian Theologies from the Underside*, 24–29. Maryknoll, NY: Orbis, 2000.

Gondry, Michel, dir. *The Green Hornet*. Culver City, CA: Sony, 2011.

Goodwin, Archie, writer, Gene Colan, penciler. *Iron Man* #1. Inked by Johnny Craig and lettered by Artie Simek. New York: Marvel Comics, 1968.

Goyer, David, dir. *Blade: Trinity*. Burbank: New Line Cinema, 2004.

Green, Dave, dir. *Teenage Mutant Ninja Turtles: Out of the Shadow*. Hollywood: Paramount, 2016.

Grey, Michael, et al. *Shazam!* Aired September 7, 1974 to October 16, 1976, on CBS.

Gunn, James, dir. *Guardians of the Galaxy*. Burbank: Walt Disney Studios, 2014.

————, dir. *Guardians of the Galaxy: Vol 2*. Burbank: Walt Disney Studios, 2017.

————, dir. *The Suicide Squad*. Burbank: Warner Bros., 2021.

Guterman, Lawrence, dir. *Son of the Mask*. Burbank: New Line Cinema, 2005.

Hartke, Austin. *Transforming: The Bible and the Lives of Transgender Christians*. Louisville: West Minister John Knox, 2018.

Hayward, Jimmy, dir. *Jonah Hex*. Burbank: Warner Bros., 2010.

Hensleigh, Jonathan, dir. *The Punisher*. Santa Monica, CA: Lionsgate, 2004.

Hillyer, Lambert, dir. *The Batman*. Burbank: Columbia, 1943.

Hodges, Mike, dir. *Flash Gordon*. Universal City, CA: Universal, 1980.

Hogan, David, dir. *Barb Wire*. Universal City, CA: Gramercy, 1996.

Holcomb, Rod, dir. *Captain America*. Universal City, CA: Universal Television, 1979.

Hood, Gavin, dir. *X-Men Origins: Wolverine*. Los Angeles: 20th Century Fox, 2009.

Howe, Sean. *Marvel Comics: The Untold Story*. New York: Harper Perennial, 2012.

Hughes, John, dir. *Ferris Bueller's Day Off*. Hollywood: Paramount, 1986.

Hunt, Priscilla. "Holy Foolishness as Key to Russian Culture." In *Holy Foolishness in Russia: New Perspectives*, edited by Priscilla Hunt and Svitlana Kobets, 1–14. Bloomington: Slavica, 2011.

Huyck, Willard, dir. *Howard the Duck*. Universal City, CA: Universal, 1986.

Hyams, Peter, dir. *Timecop*. Universal City, CA: Universal, 1994.

Jackson, Sandra, and Julie E. Moody-Freeman. *The Black Imagination: Science Fiction, Futurism and the Speculative*. London: Routledge, 2013.

Jenkins, Patty, dir. *Wonder Woman*. Burbank: Warner Bros., 2017.

———, dir. *Wonder Woman: 1984*. Burbank: Warner Bros., 2020.

Jenkins, Paul, writer, Andy Kubert, penciler and inker. *Wolverine: The Origin* #1–6. Colored by Richard Isanove and lettered by Richard Starkings. New York: Marvel Comics, 2001.

Johnson, Kenneth. *The Incredible Hulk*. Aired November 4, 1977 to May 12, 1982, on CBS.

———, dir. *Steel*. Burbank: Warner Bros., 1997.

Johnson, Mark Steven, dir. *Daredevil*. Los Angeles: 20th Century Fox, 2003.

———, dir. *Ghost Rider*. Culver City, CA: Sony, 2007.

Johnson, Tre. "Black Panther Is a Gorgeous, Groundbreaking Celebration of Black Culture." *Vox*, February 23, 2018. https://www.vox.com/culture/2018/2/23/17028826/black-panther-wakanda-culture-marvel.

Johnston, Joe, dir. *Captain America: The First Avenger*. Burbank: Walt Disney Studios, 2011.

———, dir. *The Rocketeer*. Burbank: Walt Disney Studios, 1991.

Kanigher, Robert, writer, Carmine Infantino, penciler. "Mystery of the Human Thunderbolt." *Showcase Comics* #4. Inked by Joe Kubert and lettered by Gaspar Saladino. New York: DC Comics, 1956.

Kauffman, Amy, and Daniel Miller. "Six Women Accuse Filmmaker Brett Ratner of Sexual Harassment or Misconduct." *Los Angeles Times*, November 1, 2017. https://www.latimes.com/business/hollywood/la-fi-ct-brett-ratner-allegations-20171101-htmlstory.html.

Keller, Catherine. *Intercarnations: Exercises in Theological Possibilities*. Bronx: Fordham University Press, 2017.

Kim, Grace Ji-Sun, and Graham Hill. *Healing Our Broken Humanity: Practices for Revitalizing the Church and Renewing the World*. Downer's Grove, IL: InterVarsity, 2018.

Kinberg, Simon, dir. *Dark Phoenix*. Los Angeles: 20th Century Fox, 2019.

Larsen, Josh. *Movies Are Prayers: How Films Voice Our Deepest Longings*. Downer's Grove, IL: InterVarsity, 2018.

Lawrence, Francis, dir. *Constantine*. Burbank: Warner Bros., 2005.

Lee, Ang, dir. *Hulk*. Universal City, CA: Universal, 2003.

Lee, Stan, co-writer, Steve Ditko, co-writer, penciler, and inker. *The Amazing Spider-Man* #1. Colored by Stan Goldberg and lettered by Jon D'Agostino. New York: Marvel Comics, 1963.

———, writer, Jack Kirby, penciler. *The Avengers* #1. Inked by Dick Ayers, colored by Stan Goldberg, lettered by Sam Rosen. New York: Marvel Comics, 1963.

———, writer, Jack Kirby, penciler. *The Avengers* #4. Inked by George Roussos, colored by Stan Goldberg, lettered by Artie Simek. New York: Marvel Comics, 1964.

———, writer, Jack Kirby, penciler. *Fantastic Four* #1. Inked by George Klein and Christopher Rule, colored by Stan Goldberg, lettered by Artie Simek. New York: Marvel Comics, 1961.

———, writer, Jack Kirby, penciler. *Fantastic Four* #52. Inked by Joe Sinnott, colored by Stan Goldberg, lettered by Sam Rosen. New York: Marvel Comics, 1966.

———, writer, Steve Ditko, penciler and inker. "Doctor Strange, Master of Black Magic!" *Strange Tales* #110. Colored by Stan Goldberg and lettered by Terry Szenics. New York: Marvel Comics, 1963.

———, writer, Jack Kirby, penciler. *The Incredible Hulk* #1. Inked by Paul Reinman, colored by Stan Goldberg, lettered by Artie Simek. New York: Marvel Comics, 1962.

———, creator. *The Marvel Super Heroes*. Aired September 1, 1966 to December 1, 1996, Syndication. https://www.dailymotion.com/video/x30saqr.

———, creator. *Spider-Man*. Aired September 9, 1967 to June 14, 1970. ABC Television.

———, co-writer, Steve Ditko, co-writer, penciler, and inker. "Spider-Man!" *Amazing Fantasy* #15. Colored by Stan Goldberg and lettered by Artie Simek. New York: Marvel Comics, 1962.

———, developer. *Spider-Man and His Amazing Friends*. Aired September 12, 1981 to November 5, 1983, NBC Television.

———, writer, Jack Kirby, penciler. *X-Men* #1. Inked by Paul Reinman and lettered by Sam Rosen. New York: Marvel Comics, 1963.

Lieber, Larry, co-writer, Stan Lee, co-writer, Don Heck, penciler and inker. "Iron Man Is Born." *Tales of Suspense* #39. Colored by Stan Goldberg and lettered Artie Simek. New York: Marvel Comics, 1962.

———, co-writer, Stan Lee, co-writer, Jack Kirby, penciler. "Thor the Mighty and the Stone Men from Saturn!" *Journey into Mystery* #83. Inked by Joe Simmot, colored by Stan Goldberg, lettered Artie Simek. New York: Marvel Comics, 1962.

Liebesman, Jonathan, dir. *Teenage Mutant Ninja Turtles*. Hollywood: Paramount, 2014.

Liefeld, Rob, co-writer, penciler, and inker, Fabian Nicieza, co-writer. *New Mutants* #98. Colored by Steve Buccellato by lettered by Joe Rosen. New York: Marvel Comics, 1990.

Leitch, David, dir. *Deadpool 2*. Los Angeles: 20th Century Fox, 2018.

Lester, Richard, dir. *Superman II*. Burbank: Warner Bros., 1981.

———, dir. *Superman III*. Burbank: Warner Bros., 1983.

Leterrier, Louis, dir. *The Incredible Hulk*. Burbank: Walt Disney Studios, 2008.

Lewald, Eric, et al. *X-Men*. Aired October 31, 1992 to September 20, 1997, on Fox Kids Network.

Lewis, C. S. *The Problem of Pain*. New York: HarperCollins, 2001.

Lepore, Jill. *The Secret History of Wonder Woman*. New York: Vintage, 2005.

Mangold, James, dir. *Logan*. Los Angeles: 20th Century Fox, 2017.

———, dir. *The Wolverine*. Los Angeles: 20th Century Fox, 2013.

Marshall, Neil. *Hellboy*. Culver City, CA: Sony, 2019.

Martinson, Leslie H., dir. *Batman: The Movie*. Los Angeles: 20th Century Fox, 1966.

Marshall, Lewis, and Iwao Takamoto, prods. *Super Friends*. Aired September 8, 1973 to September 6, 1986, on ABC.

Marston, William Moulton, writer, Harry G. Peter, penciler and inker. "Introducing Wonder Woman." *All Star Comics* #8. Inked by Paul Neary, colored by Paul Mounts, lettered by Chris Eliopoulos. New York: Marvel Comics, 1941.

McGregor, Don, writer, Billy Graham, penciler. *Jungle Action* #21. Inked by Bob McLeod, colored by Phil Rachelson, lettered by Harry Blumfield. New York: Marvel Comics, 1976.

McKay, Chris, dir. *The Lego Batman Movie*. Burbank: Warner Bros., 2017.

Merton, Thomas. *New Seeds of Contemplation*. New York: New Directions, 2007.

———. *No Man Is an Island*. New York: HarperOne, 1983.

Meister, Chad, and James K. Dew Jr. "Introduction." In *God and the Problem of Evil: Five Views*, edited by Chad Meister and James K. Dew Jr., 1–12. Downer's Grove, IL: InterVarsity, 2017.

McCaulley, Esau. *Reading While Black: African American Biblical Interpretation as an Exercise in Hope*. Downer's Grove, IL: InterVarsity, 2020.

Michail, Peter Rida, and Aaron Horvath, dirs. *Teen Titans Go! To the Movies*. Burbank: Warner Bros., 2018.

Michelinie, David, writer, Todd McFarlane, penciler and inker. *The Amazing Spider-Man* #300. Colored by Bob Sharen and lettered by Rick Parker. New York: Marvel Comics, 1988.

Mignola, Mike, co-writer and artist, John Byrne, co-writer. "Mike Mignola's Hellboy." *San Diego Comic Con Comics* #2. Milwaukie: Dark Horse Comics, 1993.

Millar, Mark, writer, Bryan Hitch, penciler. *Ultimates* #12. Inked by Paul Neary, colored by Paul Mounts, lettered by Chris Eliopoulos. New York: Marvel Comics, 2003.

Miller, Frank, writer, David Mazzucchelli, penciler and inker. "Batman: Year One." *Batman* #404–7. Colored by Richmond Lewis and lettered by Todd Klein. New York: Marvel Comics, 1987.

———, writer, David Mazzucchelli, penciler and inker. *Daredevil* #233. Colored by Max Scheele and lettered by Joe Rosen. New York: Marvel Comics, 1986.

———, writer and penciler. *The Dark Knight Returns*. Inked by Klaus Janson and colored by Lynn Varley. New York: DC Comics, 1986.

Miller, Tim, dir. *Deadpool*. Los Angeles: 20th Century Fox, 2016.

Moore, Alan, writer, Brian Bolland, penciler and inker. *Batman: The Killing Joke*. Colored by John Higgins and lettered by Richard Starkings. New York: DC Comics, 1988.

Morales, Robert, writer, Kyle Baker, artist. *Truth: Red, White, and Black*. Lettered by Wes Abbott. New York: Marvel Comics, 2003.

Mulcahy, Russell, dir. *The Shadow*. Universal City, CA: Universal, 1994.

Munroe, Kevin, dir. *Dylan Dog: Dead of Night*. Los Angeles: Freestyle Releasing, 2011.

———, dir. *TMNT*. Burbank: Warner Bros., 2007.

Morrison, Grant. *Supergods: What Masked Vigilantes, Miraculous Mutants, and a Sun God from Smallville Can Teach Us about Being Human*. New York: Random, 2012.

Nagy, Ivan, dir. *Captain America II: Death Too Soon*. Universal City, CA: Universal Television, 1979.

Navarro, José Gabriel. "Share of Consumers Who Have Watched Selected Marvel Studios Superhero Films in the United States as of February 2018, by Age." https://www.statista.com/statistics/807367/marvel-movie-viewership-age/.

Neveldine, Mark, and Brian Taylor, dirs. *Ghost Rider: Spirit of Vengeance*. Culver City, CA: Sony, 2011.

Nieli, Ciro, et al. *The Avengers: Earth's Mightiest Heroes.* Aired September 22, 2010 and November 11, 2012 on Disney XD.

Nolan, Christopher, dir. *Batman Begins* Burbank: Warner Bros., 2005.

———, dir. *The Dark Knight.* Burbank: Warner Bros., 2008.

———, dir. *The Dark Knight Rises.* Burbank: Warner Bros., 2012.

Norrington, Stephen, dir. *Blade.* Burbank: New Line Cinema, 1998.

———, dir. *The League of Extraordinary Gentlemen.* Los Angeles: 20th Century Fox, 2003.

"On Black Panther, Afrofuturism, and Astroblackness: A Conversation with Reynaldo Anderson." *The Black Scholar*, March 13, 2018. https://www.theblackscholar. org/on-black-panther-afrofuturism-and-astroblackness-a-conversation-with-reynaldo-anderson/.

O'Neill, Dennis, writer, Neil Adams, penciler. *Green Lantern / Green Arrow #76.* Inked by Frank Giacoia, colored by Cory Adams, lettered by John Costanza. New York: DC Comics, 1970.

Ostrander, John, co-writer, Len Wein, co-writer, John Byrne, penciler. *Legends #3.* Inked by Paul Reinman, colored by Karl Kessel and Tom Zuko, lettered by Steve Haymie. New York: DC Comics, 1987.

Parker, Bill, writer and colorist, C. C. Beck, penciler and inker. "Introducing Captain Marvel!" *Whiz Comics #2.* New York: DC Comics, 1940.

Peretti, Daniel. *Superman in Myth and Folklore.* Oxford: The University Press of Mississippi, 2017.

Persichetti, Bob, et al., dirs. *Spider-Man: Into the Spider-Verse.* Culver City, CA: Sony, 2019.

Petrie, Douglas, and Marco Ramirez. *The Defenders.* Netflix, 2017.

Pew Research Center. "Religious Landscape Study." https://www.pewforum.org/religious-landscape-study/.

Phillips, Todd, dir. *Joker.* Burbank: Warner Bros., 2019.

Pitof, dir. *Catwoman.* Burbank: Warner Bros., 2004.

Pressman, Michael, dir. *Teenage Mutant Ninja Turtles II: The Secret of the Ooze.* Burbank: New Line Cinema, 1991.

Priest, Christopher, writer, Mark Texeria, penciler and inker. *Black Panther #1.* Colored by Brian Haberlin and lettered by Richard Starkings and Siobhan Hanna. New York: Marvel Comics, 1976.

Pyun, Albert dir. *Captain America.* Culver City, CA: Sony, 1990.

Radomski, Eric, and Bruce Timm. *Batman: The Animated Series.* Aired September 5, 1992 to September 15, 1995, on Fox Kids.

———, dirs. *Batman: Mask of the Phantasm.* Burbank: Warner Bros., 1993.

Raimi, Sam, dir. *Spider-Man.* Culver City, CA: Sony, 2002.

———. *Spider-Man 2.* Culver City, CA: Sony, 2004.

———. *Spider-Man 3.* Culver City, CA: Sony, 2007.

Raphael, Jordan, and Tom Spurgeon. *Stan Lee and the Rise and Fall of the American Comic Book.* Chicago: Chicago Review, 2004.

Ratner, Brett, dir. *X-Men: The Last Stand.* Los Angeles: 20th Century Fox, 2006.

Reed, Peyton, dir. *Ant-Man.* Burbank: Walt Disney Studios, 2015.

———, dir. *Ant-Man and the Wasp.* Burbank: Walt Disney Studios, 2018.

Riesman, Abraham. "Novelist Walter Mosley Talks Luke Cage, Colorism, and Why Spider-Man Was the 'First Black Superhero.'" *Vulture*, October 13, 2016. https://www.vulture.com/2016/10/walter-mosley-on-why-spider-man-is-black.html.

Robichaud, Christopher. "With Great Power Comes Great Responsibility." *Superheroes and Philosophy: Truth, Justice, and the Socratic Way*, edited by Tom Morris and Matt Morris, 177–93. Chicago: Open, 2005.

Reyes, Michelle Ami. *Becoming All Things*. Grand Rapids: Zondervan, 2021.

———. "Black Panther's Vision of Zion." *ThinkChristian,* March 15, 2018. https://thinkchristian.net/black-panthers-vision-of-zion#:~:text=We%20will%20be%20priests%20made,this%20together%2C%20as%20one%20body.

Ross, Stanley Ralph, developer. *Wonder Woman*. Aired November 7, 1975 to September 11, 1979, on ABC and CBS.

Rucka, Greg, writer, Rags Morales et al., pencilers. *Wonder Woman #219*. Inked by Mark Propst et al., colored by Richard and Tanya Horie, lettered by Todd Klein. New York: DC Comics, 2005.

Russell, Chuck, dir. *The Mask*. Burbank: New Line Cinema, 1994.

Russo, Joe, and Anthony Russo, dirs. *Avengers: Endgame*. Burbank: Walt Disney Studios, 2019.

———. *Avengers: Infinity War*. Burbank: Walt Disney Studios, 2018.

———. *Captain America: Civil War*. Burbank: Walt Disney Studios, 2016.

———. *Captain America: The Winter Soldier*. Burbank: Walt Disney Studios, 2014.

Sandberg, David F., dir. *Shazam!* Burbank: Warner Bros., 2019.

Schaeffer, Jac, creator. *WandaVision*. Aired January 15, 2021 to March 5, 2021, on Disney+.

Schumacher, Joel, dir. *Batman Forever*. Burbank: Warner Bros., 1995.

———, dir. *Batman and Robin*. Burbank: Warner Bros., 1997.

Schwentke, Robert, dir. *Red*. Santa Monica, CA: Summit Entertainment, 2010.

Scorsese, Martin, dir. *The King of Comedy*. Los Angeles: 20th Century Fox, 1982.

Scorsese, Martin, dir. *Taxi Driver*. Los Angeles: Columbia, 1976.

Semper, John, and Bob Richardson, developers. *Spider-Man*. Aired November 19, 1994 to January 31, 1998, on Fox Kids Network.

Serkis, Andy, dir. *Venom: Let There Be Carnage*. Culver City, CA: Sony, 2021.

Sholem, Lee, dir. *Superman and the Mole Men*. Los Angeles: Lippert, 1951.

Shortland, Cate, dir. *Black Widow*. Burbank: Walt Disney Studios, 2021.

Siegel, Jerry, writer, Joe Shuster, artist. "Superman, Champion of the Oppressed." *Action Comics #1*. New York: DC Comics, 1938.

Simon, Joe, co-writer, Jack Kirby, co-writer and penciler. *Captain America Comics #1*. Inked by Al Liederman. New York: Marvel Comics, 1941.

Simon, Jordan. "The New Mutants' Director on Whitewashing Character: 'I Didn't Care So Much about the Racism.'" *Shadow and Act*, August 20, 2021. https://shadowandact.com/the-new-mutants-director-on-whitewashing-character-i-didnt-care-so-much-about-the-racism.

Singer, Bryan, dir. *Superman Returns*. Burbank: Warner Bros., 2006.

———, dir. *X2: X-Men United*. Los Angeles: 20th Century Fox, 2003.

———, dir. *X-Men*. Los Angeles: 20th Century Fox, 2000.

———, dir. *X-Men: Apocalypse*. Los Angeles: 20th Century Fox, 2016.

———, dir. *X-Men: Days of Future Past*. Los Angeles: 20th Century Fox, 2014.

Smith, Mitzi J., and Yung Suk Kim. *Toward Decentering the New Testament: A Reintro-duction*. Eugene, OR: Cascade, 2018.

Snyder, Zack, dir. *Batman v Superman: Dawn of Justice*. Burbank: Warner Bros., 2016.

———, dir. *Justice League*. Burbank: Warner Bros., 2017.

———, dir. *Man of Steel*. Burbank: Warner Bros., 2012.

———, dir. *Watchmen*. Burbank: Warner Bros., 2009.

———, dir. *Zack Snyder's Justice League*. Burbank: Warner Bros., 2021.

Soavi, Michele, dir. *Cemetery Man*. Beverly Hills, CA: Anchor Bay, 1994.

Sonnenfeld, Barry, dir. *Men in Black*. Culver City, CA: Sony,1997.

Sölle, Dorothee. *Essential Writings*. Maryknoll, NY: Orbis, 2006.

Spencer, Nick, writer and co-creator, Steve Lieber, artist and co-creator. *The Superior Foes of Spider-Man*. New York: Marvel Comics, 2013–14.

Spellman, Malcolm, creator. *The Falcon and the Winter Soldier*. Aired March 19, 2021 to April 23, 2021 on Disney+.

St. John of the Cross. *Dark Night of the Soul*. Translated by Mirabai Starr. New York: Riverhead, 2002.

Stevens, George, dir. *Shane*. Hollywood: Paramount, 1953.

Story, Tim, dir. *Fantastic Four*. Los Angeles: 20th Century Fox, 2005.

———, dir. *Fantastic Four: Rise of the Silver Surfer*. Los Angeles: 20th Century Fox, 2007.

Sutherland, Hal, dir. "It's All Greek to Me." *The Brady Kids*. Aired December 2, 1972, on ABC.

Szworc, Jeannot, dir. *Supergirl*. London: Thorn EMI, 1984.

Talalay, Rachel, dir. *Tank Girl*. Beverly Hills, CA: MGM/UA, 1995.

Taylor, Alan, dir. *Thor: The Dark World*. Burbank: Walt Disney Studios, 2013.

Taylor, Mark Lewis. *The Executed God*. Minneapolis: Fortress, 2001.

Thomas, Roy, writer, Sal Buscema, penciler. *X-Men* #66. Inked by Sam Grainger and lettered by Artie Simek. New York: Marvel Comics, 1970.

Thurman, Howard. *Jesus and the Disinherited*. Boston: Beacon, 1996.

Tillich, Paul. *The Dynamics of Faith*. 1957. Reprint, New York, Perennial Classics. 2001.

Tillet, Shalamishah. "'Black Panther' Brings Hope, Hype, and Pride." *The New York Times,* February 9, 2018. https://www.nytimes.com/2018/02/09/movies/black-panther-african-american-fans.html.

Timm, Bruce, developer. *Justice League*. Aired November 17, 2001 to May 29, 2004, on Cartoon Network.

———, developer. *Justice League Unlimited*. Aired July 31, 2004 to May 13, 2006, on Cartoon Network.

del Toro, Guillermo, dir. *Blade II*. Burbank: New Line Cinema, 2002.

———. *Hellboy*. Culver City, CA: Sony, 2004.

———. *Hellboy II: The Golden Army*. Culver City, CA: Sony, 2008.

Trank, Josh, dir. *Fantastic Four*. Los Angeles: 20th Century Fox, 2015.

Travis, Pete, dir. *Dredd*. Santa Monica, CA: Lion's Gate Entertainment, 2012.

Usher, Kinka, dir. *Mystery Men*. Universal City, CA: Universal, 1999.

Vaughn, Matthew, dir. *Kick-Ass*. Santa Monica, CA: Lionsgate, 2010.

———, dir. *X-Men: First Class*. Los Angeles: 20th Century Fox, 2011.

Volf, Miroslav. *The End of Memory: Remembering Rightly in a Violent World*. Grand Rapids: Eerdmans, 2006.

Wadlow, Jeff, dir. *Kick-Ass 2*. Universal City, CA: Universal, 2013.

Wallace, Carvell. "Why 'Black Panther' Is a Defining Moment for Black America." *The New York Times*, February 12, 2018.

Wan, James, dir. *Aquaman*. Burbank: Warner Bros., 2018.

Waititi, Taika, dir. *Thor: Ragnarok*. Burbank: Walt Disney Studios, 2017.

Waldron, Michael, creator. *Loki*. Aired June 9, 2021 to July 14, 2021, on Disney+.

Watts, Jon, dir. *Spider-Man: Far From Home*. Culver City, CA: Sony, 2019.

———. *Spider-Man: Homecoming*. Culver City, CA: Sony, 2017.

———. *Spider-Man: No Way Home*. Culver City, CA: Sony, 2021.

Webb, Sam, dir. *The Amazing Spider-Man*. Culver City, CA: Sony, 2012.

———. *The Amazing Spider-Man 2*. Culver City, CA: Sony, 2014.

Welch-Larson, Sarah. *Becoming Alien: The Beginning and End of Evil in Science Fiction's Most Idiosyncratic Film Franchise*. Eugene, OR: Cascade, 2021.

Weldon, Glen. *The Caped Crusade: Batman and the Rise of Nerd Culture*. New York: Simon & Schuster, 2017.

———. *Superman: The Unauthorized Biography*. Hoboken: Wiley, 2013.

Whedon, Joss, dir. *The Avengers*. Burbank: Walt Disney Studios, 2012.

———, dir. *Avengers: Age of Ultron*. Burbank: Walt Disney Studios, 2015.

Weisinger, Mort, writer, George Papp, penciler and inker. "Blueprint for Crime." *Leading Comics* #1. New York: DC Comics, 1941.

Wien, Len, writer, Dave Cockrum, penciler and inker. *Giant-Size X-Men* #1. Inked by Peter Iro, colored by Glynis Wein, and lettered by John Costanza. New York: Marvel Comics, 1975.

———, writer, Herb Trimpe, penciler. *The Incredible Hulk* #181. Inked by Jack Abel, colored by Glynis Wein, and lettered by Artie Simek. New York: Marvel Comics, 1974.

Wilson, David S. F., dir. *Bloodshot*. Culver City, CA: Sony, 2020.

Wincer, Simon, dir. *The Phantom*. Hollywood: Paramount, 1996.

Wink, Walter. *Jesus and Nonviolence: A Third Way*. Minneapolis: Fortress, 2003.

Winn, Albert Curry. *Ain't Gonna Study War No More: Biblical Ambiguity and the Abolition of War*. Louisville: West Minister John Knox, 1993.

Winner, Michael, dir. *Death Wish*. Hollywood: Paramount, 1974.

Wise, David, and Patti Howeth, developers. *Teenage Mutant Ninja Turtles*. Aired December 14, 1987 to November 2, 1996, on CBS.

Witney, William, and John English, dirs. *Adventures of Captain Marvel*. Los Angeles: Republic, 1941.

Wolfman, Marv, writer, Gene Colan, penciler. *Tomb of Dracula* #10. Inked by Jack Abel, colored by Petra Goldberg, lettered by Denise Vladimer. New York: Marvel Comics, 1973.

Wright, N. T. *The Day the Revolution Began*. New York: HarperCollins, 2016.

Wynorski, Jim, dir. *Return of the Swamp Thing*. Burbank: Warner Bros., 1989.

Yan, Cathy, dir. *Birds of Prey (and the Fantabulous Redemption of One Harley Quinn)*. Burbank: Warner Bros., 2020.

Yuzna, Brian, dir. *Faust: Love of the Damned*. Santa Monica, CA: Lionsgate, 2000.

Zahnd, Brian. *A Farewell to Mars: An Evangelical Pastor's Journey Toward the Biblical Gospel of Peace*. Colorado Springs: Cook, 2014.

Zhao, Chloé, dir. *Eternals*. Burbank: Walt Disney Studios, 2021.

SUBJECT INDEX

SCRIPTURE INDEX